painting
now

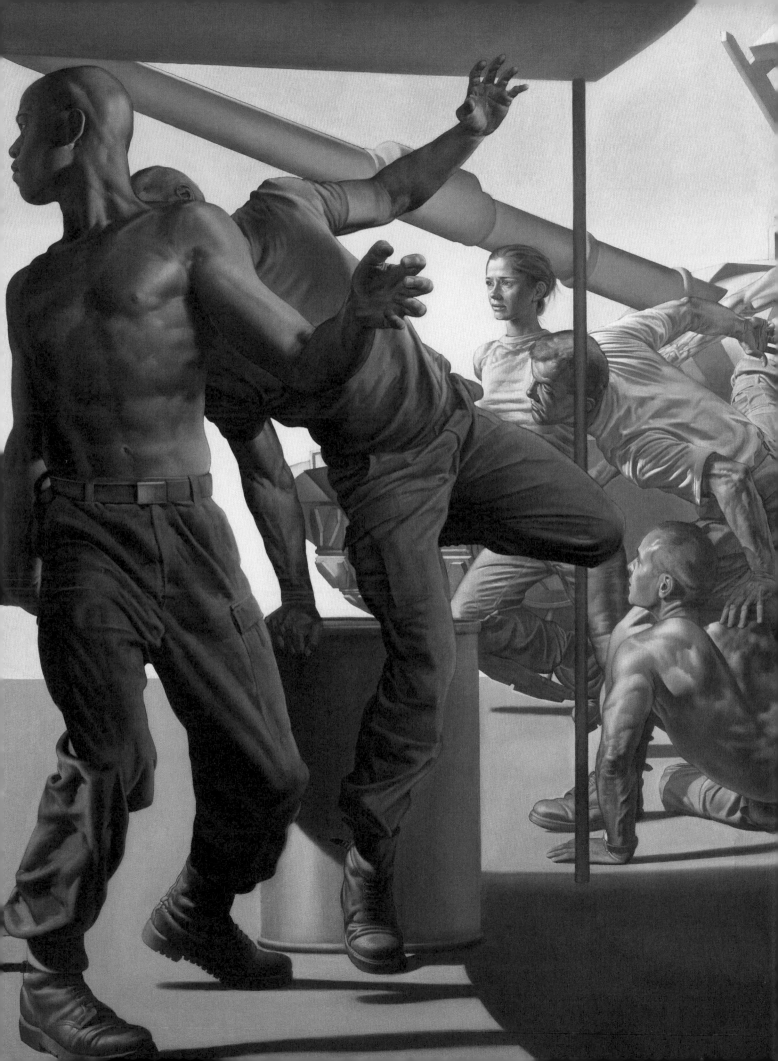

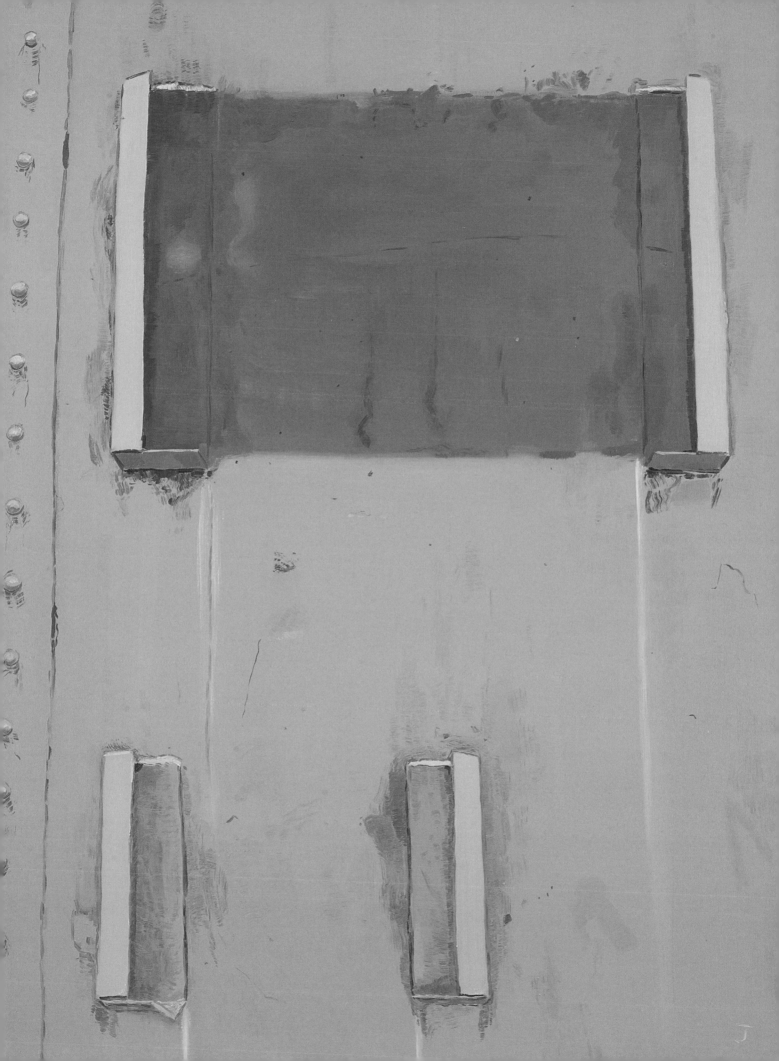

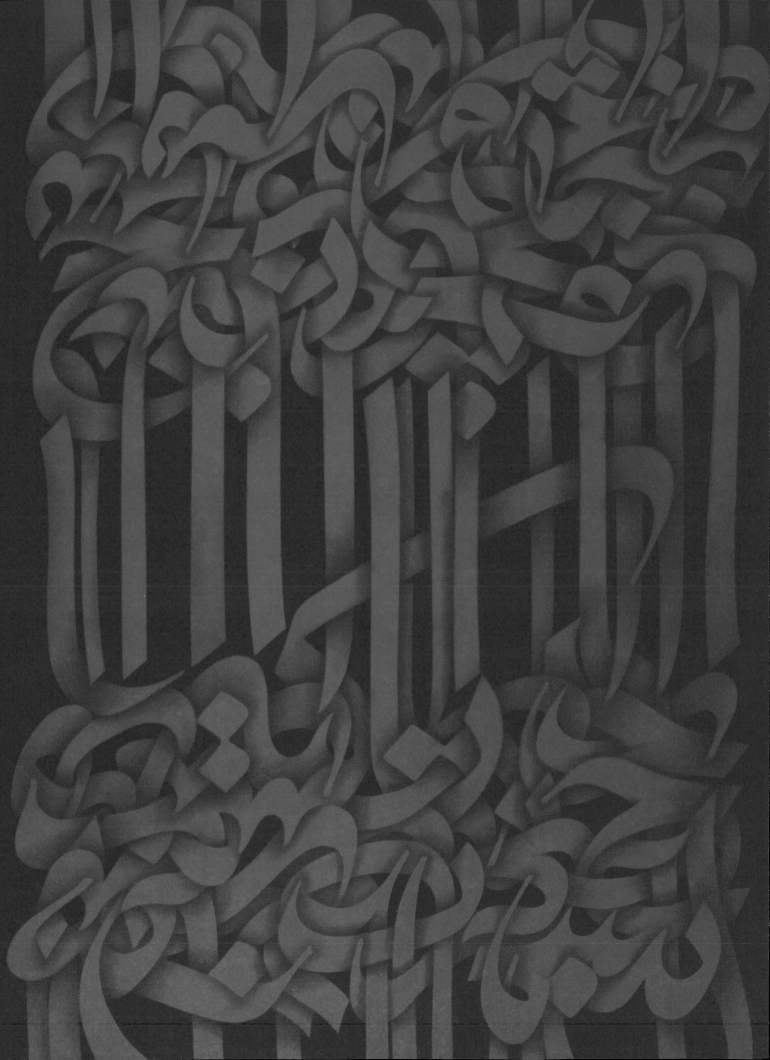

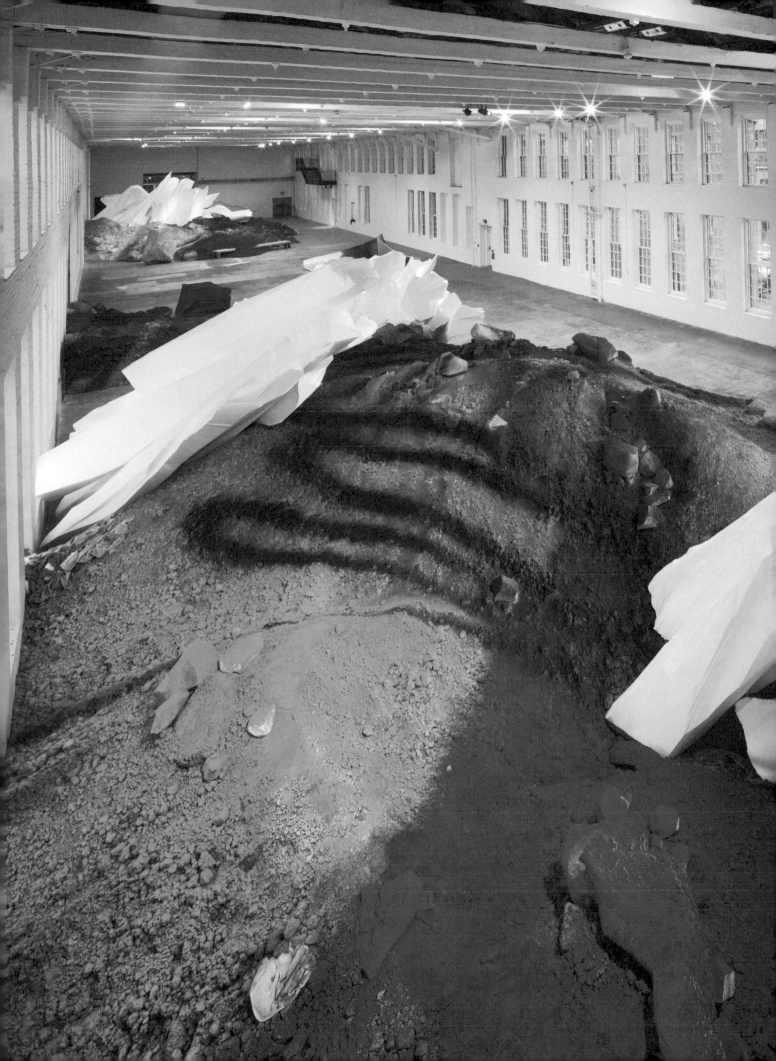

suzanne
hudson

painting
now

Thames & Hudson

On the jacket:
Front: Kehinde Wiley, *The Virgin Martyr St. Cecilia* (detail), 2008.
Oil on canvas, 257.8 × 575.3 cm (101½ × 226½ in.). Courtesy the
artist and Roberts & Tilton, Culver City, CA; Sean Kelly, New
York; Galerie Daniel Templon, Paris; and Stephen Friedman
Gallery, London. © Kehinde Wiley. Used by permission.
Back: Ian Davenport, *Puddle Painting: Dark Grey (after Uccello)*
(detail), 2010. Acrylic on aluminum mounted on aluminum
frame, 148 × 128 cm (58¼ × 50⅜ in.). Courtesy Waddington
Custot Galleries, London. Photo Prudence Cuming Associates,
London. © Ian Davenport. All Rights Reserved, DACS 2015.

All the illustrations in the visual introduction on pp. 2–18 can
be found inside the book: see pp. 125, 201, 121, 137, 195, 88, 199, 39,
122, 62, 84, 163, 136, 104, 31, 57, and 84.

Painting Now © 2015 Thames & Hudson Ltd
Text © 2015 Suzanne Hudson

Designed by Fraser Muggeridge studio

First published in 2015 in hardcover in the United States
of America by Thames & Hudson Inc., 500 Fifth Avenue,
New York, New York 10110

thamesandhudsonusa.com

Library of Congress Catalog Card Number 2014944631

ISBN 978-0-500-23926-1

Printed and bound in China by Everbest Printing Co. Ltd

Contents

Introduction

Painting Now. These two words assert the vitality and relevance of painting in the twenty-first century. For some readers, this declaration will ring true, perhaps obviously so, given the incisive work being done in the name of painting in our own time. As painting remains meaningful, we might ask how, why, and according to what means. The answers to these inquiries constitute the subject of this book.

Yet it needs to be acknowledged straightaway that other readers might well take the title, *Painting Now*, to be a question: Painting, *now*? Long seen as the highest and most prized of the visual art forms, painting has been challenged in the digital age, and even before. The historical primacy of oil on canvas was reviewed with the advent of photography in the nineteenth century and the readymade—the found object nominated as art—in the twentieth. Indeed, Marcel Duchamp's use of the readymade coincided with a decisive abandonment of so-called "retinal" art, his name for painting. These debates gained momentum in the 1960s, in the context of pop art and the application of commercial imagery in the practice of painting, with artists strategically expanding the uses of image culture at large. So decisive was John Baldessari's (b.1931, National City, CA) rejection of the painting practice that had previously occupied him that, in 1970, he razed these earlier works in a crematorium: abandonment of painting became a precondition for conceptual art.

Such considerations came to a head in the 1980s, when certain artists, writers, and curators employed the language of endgame to describe the collapse of modernist painting at the moment of postmodernism's emergence. While these groups did not make claims for the whole of painting, just its production under modernist circumstances, "the death of painting" became glib shorthand for liberal debates about the meaning of art in a commercialized culture. Unable to achieve the quality or weightiness that it once attained, painting was deemed to be over, except as a commercial, décor-oriented trifle complicit with the market, or so the argument went. Other critics more specifically castigated figuration for trading in

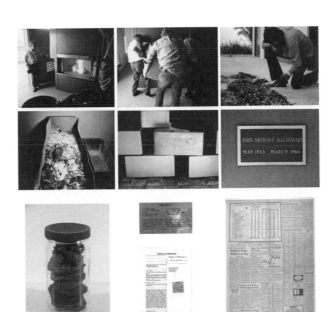

John Baldessari
*Cremation Project, Corpus Wafers
(With Text, Recipe and Documentation)*, 1970
Large jar with cookies, recipe card,
six color photographs, and documentation,
dimensions variable

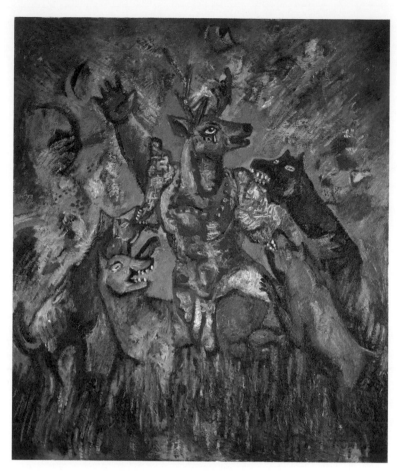

Sandro Chia
Outdoor Scene, 1984
Oil on canvas, 233 × 198 cm
(91¾ × 77¹⁵⁄₁₆ in.)

kitsch, and abstraction for all too readily standing for emptiness of meaning.

Of course, most critical stances on modernist painting were underwritten by a historicism— a relativist understanding of the significance of historical or geographical context to the development of art—that justified the timeliness of a re-appraisal of form. In this light, we might regard the endgame argument of the 1980s as part of this same story, since—while being very much wedded to its own moment—it also involved re-evaluating the logic that had sustained the art practices being called into question. This was especially important given that so much writing about the return of Expressionist painting in the early 1980s (like Sandro Chia's [b.1946, Florence, Italy] paint-smeared, facture-laden canvases) adopted a universalist view. According to this

argument, a trans-historical humanism connected the whole of creativity in paint, from works in caves to those displayed in the white cube, and any avoidance of paint was therefore seen as an insignificant blip. However, the expansion of practice in the 1960s and 70s across media, performances, places, philosophies, and events— in conjunction with the widespread acceptance of photo-based appropriation, explicitly political work, and other forms—meant that the view that painting was bad (retrograde in ideology and means) and conceptual art was good (challenging in ideology and means) became the new orthodoxy.

Nothing in the 1990s contravened this. If anything, the geopolitical events that occurred at the very end of the previous decade—from the fall of the Berlin Wall and the collapse of communism in the Soviet Union and the rest of the Eastern Bloc, to the

tumultuous civil protests in China—begged for more immediate engagement, which often took other artistic forms. In parallel, abject bodily work became typical of identity politics in the wake of the AIDS crisis and the various culture wars played out chiefly in the US. Aesthetic criticism, the return of the language of beauty, and painting itself fought against this, but the ascent of certain kinds of theory, notably feminism, multi-culturalism, and post-colonialism, further fostered pluralism, eliminating the superiority of any particular medium—painting above all, owing to its canonical status.

Even more perhaps, the discrete, studio-made object began to smack of nostalgia, if not outright anachronism, in the context of an emergent global exhibition culture rapidly assimilated post-1989 and encouraged by such factors as festivals and biennials spread across continents, the peripatetic lifestyle of artists, and the rise of commissioned, site based multimedia work. Hence traveling between locales became customary, giving rise to participatory, "relational" art, which took advantage of the absence of conventional institutional frames to develop practices that facilitated social interaction within the exhibition space (such as Rirkrit Tiravanija [b.1961, Buenos Aires, Argentina] cooking curry and sharing it with those present).

The problem with this narrative is that it supposes the separation—even incompatibility—of the material and the conceptual. Conceptual artists believed it was the message that mattered, not the medium, as though thought could be immaterial. But while the concept might be an idea or a method, either way such art retains a formal dimension that is largely unacknowledged. In the 1970s, the assumption that conveying information was the sole or primary objective of representation was the common denominator among media, and this has recently been revived through the model of the network, which puts a premium on communication while downplaying form, except insofar as it might expose the system's workings. As will be maintained throughout, I regard material experimentation as inherently conceptual, meaning that painting, too, is capable of manifesting its own signs, not merely as "process" but as embodied thinking. To say this is neither to reassert the preeminence of painting nor to avow its uniqueness, but to claim that painting has become more, rather than less, viable after conceptual art, as an option for giving idea form and hence for differentiating it from other possibilities. As Glenn O'Brien humorously put it in conversation with Albert Oehlen and Christopher Wool: "Why are all the conceptual artists painting now? Because it's a good idea."

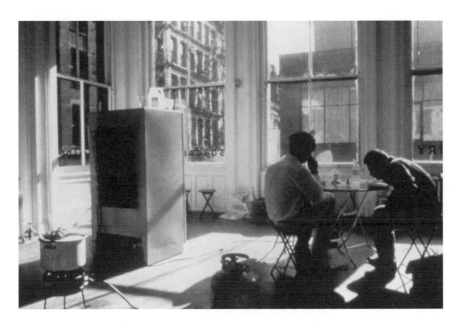

Rirkrit Tiravanija
Installation view of "Untitled (Free),"
303 Gallery, New York, 1992

**Amy Sillman,
in collaboration with Charles Bernstein**
Still from *Pinky's Rule*, 2011
Animated digital drawing on iPhone, 7:38 min.

Francis Alÿs
The Green Line, Jerusalem, 2004
Video documentation of an action

At issue, too, is terminology. I address individuals as "artist" rather than "painter," a decision based on the enormous transformations wrought by post-studio practice, among other factors. In short, the term "artist" is generic while that of "painter" is specific, and the former is now customary in academic and critical contexts, as well as favored by many choosing to work in paint who might also embrace other media. This is true, for example, of Amy Sillman (b.1955, Detroit, MI), who draws, paints, and makes moving-image tableaux with her iPhone and iPad, or, more provocatively, of Francis Alÿs (b.1959, Antwerp, Belgium), who has collaborated with Mexican sign painters (*rotulistas*) to enlarge or otherwise interpret his paintings, walked through Jerusalem's 1948 partition lines leaving a trail of green paint behind him, and collected hundreds of copies of a portrait of the Christian Saint Fabiola.

Moreover, the description "artist" signals a capaciousness, within which painting becomes a choice. Many instances I cite are not paintings, since painting is not being developed in a vacuum but in response to an expanded field that includes both painting *and* other kinds of art (not to mention social, political, and other circumstances entirely outside of art and its media). I do not therefore accept the isolation of painting from other forms of work, which I include to make examples of painting more meaningful. By "painting" I mean to stipulate work that is done with the materials, styles, conventions, and histories of painting as the principal point of reference—as in Raqib Shaw's (b.1974, Calcutta, India) jewel-encrusted dreamscapes and Kristaps Ģelzis's (b.1962, Riga, Latvia) monumental paintings, each of which represents the variability of painting as connected to but exceeding the traditions from which it emerges—whether or not the final artwork consists of a rectangular piece of linen covered in pigment intended to be hung upright on a wall.

As already implied, this is not to deny the medium, but, paradoxically, to defend it as an expansive practice. I also mean to resist modernist notions of medium specificity, whereby painting was understood purely in terms of its material limits (to be fair, even Clement Greenberg and Michael Fried,

Raqib Shaw
Paradise Lost, 2001–13
Oil, acrylic, glitter, enamel, resin,
and rhinestones on birch wood
304.8 × 1828.8 cm (120 × 720 in.)

Kristaps Ģelzis
Installation view of *Artificial Peace*,
Latvian Pavilion, 54th Venice Biennale, 2011

two significant formalist critics known for their circumscribed view of the medium, were also aware of the potential for a broader definition). Similarly, I reject postmodernist ideas that deny medium specificity, in favor of a pragmatic approach in which a painting is tested or evaluated relative to the histories and traditions of the medium. This means that I do not rely on accepted definitions, but suggest that each work asks us to rethink the applicability and meaning of that definition. I thus focus more on method than on pictorial imagery, though forms do, of course, recur. And finally, I avoid clustering artists together on the basis of style, as objects that look alike might have nothing to do with one another, just as images that look different might be powerfully related. Eschewing classification, then, the following chapters are organized by ongoing investigations into, and conversations about, practice.

Beginning with appropriation, the first chapter addresses the adaptation of images from a pre-existing source as the basis for a new work, as in Paulina Olowska's (b.1976, Gdańsk, Poland) paintings based on postcards of home-knitting patterns from late communist-era Poland. Though predating the Internet, appropriation has become one of its inevitable results, with the act of borrowing often made into a theme, or treated as a curatorial act of selection, organization, and framing. The impulse to discover and re-contextualize, rather than to generate, a picture introduces problems of intention: *Why did she pick that? What did she do to it? To what end?* Of course, this also applies to works that are not recycled, and Chapter 2 (Attitude) asks how motive might be communicated through the physical stuff of painting. Can meaning be transmitted clearly from artist to painting to viewer? Does the handmade object guarantee

"Torcik"

Paulina Olowska
Cake, 2010
Oil on canvas, 175 × 125 cm
(68⅞ × 49³⁄₁₆ in.)

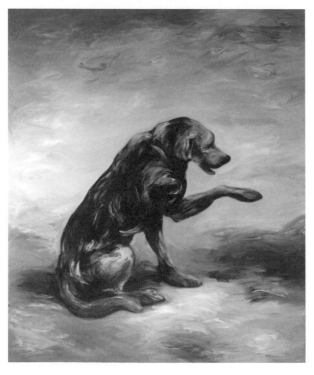

Bénédicte Peyrat
Dog, 2007
Acrylic on canvas, 230 × 195 cm
(90⁹⁄₁₆ × 76¾ in.)

expressivity? Or might contrivance of affect be a substitute for true interiority, and persona for person? Strategies of self-fashioning to frame the artist and his or her work include "bad painting," a term that could involve the outmoded or what lies outside the norms of acceptable taste—what might one make of the dog offered by Bénédicte Peyrat (b.1967, Paris, France)?—as well as appropriations of various historical painting techniques and practices.

Moving more explicitly to matters of procedure, Chapter 3 (Production and Distribution) focuses on how artists make paintings and negotiate complex mechanisms of distribution—that is, how paintings circulate (in galleries and fairs, across continents and the Internet), irrespective of their creators' initial intentions. (Take Chatchai Puipia [b.1964, Mahasarakarm, Thailand], who draws attention to the lives of images across time and place.) Many paintings are painted—at least in part—by someone other than the named author; which is to say, painting now inhabits, to a surprising degree, the industrial space of divided labor so common to conceptual art, as well as to the workshop tradition of apprentices and skilled assistants, and, closer to home, the commercial design studio or architectural firm. By the 1960s, sculpture had achieved separation of concept and realization (when fabrication was contracted out, due to scale or material factors), but painting remained far removed from these changes. This is no longer the case.

Chapter 4 (The Body) pulls back from these systems to look at how the body has remained central to painting, perhaps because of the ongoing desire for human scale, if not necessarily for human agency. The figure is most obviously present in portraiture, nude, and history painting—staples for Marlene Dumas (b.1953, Cape Town, South Africa); these modes are explored alongside abstract paintings, where the body registers through vigorous paint handling that records the physical movement necessary for its achievement. The body also emerges, among other things, as the obdurate counterpart to the virtual sphere, and as the prerequisite for work predicated upon social interaction. Associated with this, Chapter 5 (Beyond Painting) investigates how the body is commonly introduced as a complement to a painting, from

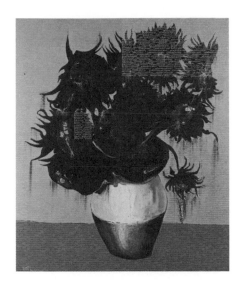

Chatchai Puipia
Vase with twelve sunflowers 120 years after Van Gogh, 2009
Pigments, gold leaf, carbon, and wax on canvas
180 × 154.5 cm (70⅞ × 60¹³⁄₁₆ in.)

Marlene Dumas
Measuring Your Own Grave, 2003
Oil on canvas, 140 × 140 cm (55⅛ × 55⅛ in.)

Lucy McKenzie
Alhambra Motifs III, 2013
Oil on canvas, 270 × 480 cm (106⁵⁄₁₆ × 189 in.)

outside its frame. Painting may, for instance, be treated as a tool for a performance or as the hypothetical or actual backdrop for an event, as in works like Lucy McKenzie's (b.1977, Glasgow, UK) *Alhambra Motifs*, which might be architectural sketches, theater scenery, or independent paintings. In this context, artists negotiate not only questions of what a painting is, but also temporal ones, such as when (and under what circumstances, through actions or in performances) does a painting become a prop. This example alone suggests the "beyond" of the title, but the chapter also studies cases where paintings exist off the frame, in installations, in multiple locations, or in exceptional presentational formats. Finally, looping back to an analysis of art about art with which the discussion of appropriation begins, the last chapter (About Painting) reflects by way of the legacy of institutional critique on paintings about painting—like Florian Meisenberg's (b.1980, Berlin, Germany) framing of the picture plane with curtains that play on bygone expectations of illusionism.

Real as these headings are, they are artificial barriers. Most artists included in one chapter fit just as readily into others, particularly given their range of work, which in many cases cannot be accommodated in this volume. All are involved in appropriation in one way or another. I cannot imagine that any artist does not think about how his or her paintings are made and how they will find an audience, or does not contemplate the nature of painting, even if moving beyond its traditional parameters. To be sure, the frequency with which such inquiries become part of the work's subject relates to my claim that the conceptual overlaps with the material: beyond painting and about painting are two sides of the same coin. "Bad painting" crosses many boundaries, and large numbers of artists ride the line between abstraction and figuration, though this also implies a pedantic distinction that I do not uphold (hence, for instance, my putting abstract artists into the chapter on the body). However, I have attempted to keep related artists together, where feasible.

Attention is inevitably uneven in what aims to be a wide-ranging survey. My blind spots and biases as a critic, long-based in New York and now living in Los Angeles where this was written, will doubtless

Florian Meisenberg
from the series *Continental
Breakfast, Overmorrow at Noon*, 2011
Oil on canvas, 245 × 215 cm
(96⁷⁄₁₆ × 84⁵⁄₁₆ in.)

be evident to those whose primary art world is a different city or continent; that said, this is not a disclaimer and I make no apologies for partisanship. Precisely because of their wide applicability, these chapters offer ways to restart debates around painting that may avoid the impasses of the 1980s, and that, if successful, will help to make sense of, even provide a language for, discussion of artists and paintings not covered in these pages.

Just as globalization is wildly asymmetrical, so is painting, as Konstantin Bessmertny's (b.1964, Blagoveshchensk, USSR) images of cultural clashes (here, Samurai entering a Danish home) reveal. My best efforts at international coverage are certainly not comprehensive, nor would I pretend or want them to be. Some precedents or discourses are more "live" in some regions, cities, or art schools than others, and some traditions (native or otherwise)

resonate where others do not, despite fantasies of a wholly integrated, accessible, and characteristic art world. What I do wish to make intelligible are the connective threads, in the works themselves, but also in the cultures in which they exist. This means that I attend to paintings and their surroundings, be they physical (the walls on which they hang), institutional (the ways that they appear there or are seen—on a screen, in the palm of a hand, or in the residue of a press release), or discursive (the aesthetic, social, and political conventions to which they belong and respond). These priorities are manifested in the choice of images, which comprise single paintings and installations alike. That these images sometimes function in oblique relation to the text is not surprising given that the art investigated is not intended to serve as the illustration of my theses, but as motors to generate them.

If this brief introduction sketches some parameters of medium and its place, I have yet to account for the second word of the title, the emphatic, if elusive, *now*. As Richard Serra and Nancy Holt revealed in *Boomerang* (1974), a video in which Holt's speech was interrupted by her words played back to her with a delay through a headset, the now slips into the past at the moment of its articulation. For Holt, this audible repetition triggered recognition, a mode of self-analysis. This precedent helps me to think about how to grasp the contemporary, in that it not only admits the present as fugitive, crossing into history just as it comes into being, but begs for reflexivity about this process.

Less abstractly, the titular "now" designates the time period considered here: roughly, painting since the turn of the millennium. I had briefly thought to confine the project to work made after 2008. Following the plummeting of global markets in that year's financial crash, many assumed that the economic downturn would provide a corrective accounting for the bloated and overly permissive art world system that fed off the preceding flush years. As it happened, business continued apace, and there was an odd time lag before the effects of a new order were slowly and partially acknowledged, as art spaces began to close, funding diminish, and sales slacken. The year 2008 came to seem a false marker of change, or one that was far from global or irreversible; despite the fact that the recession amplified certain tendencies and muted others, it did not augur a systemic shift. The same must be said of the turn of the century, and the year 2001 more specifically, which was fundamentally arbitrary in so many ways, despite the profundity of the events of that September. As Gabriel Orozco's 2011 *Stream in the Grid* acknowledges, we still live in their aftermath.

Furthermore, all works are anticipated by others; as such, they pose the very real possibility of an infinite regress, which might credibly take us back decades, if not appreciably further. While these instances are alluded to where practical, and certainly matter a great deal, the point of this book is to make sense—in the now—of the just-past. If this is an act of criticism, its history is still to come.

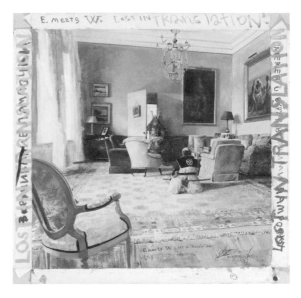

Konstantin Bessmertny
E. Meets W. Lost in Translation, 2011
Oil on canvas, 50 × 50 cm
(19¾ × 19¾ in.)

Gabriel Orozco
Stream in the Grid, 2011
Pigment ink and acrylic on canvas
86.4 × 76.8 cm (34 × 30¼ in.)

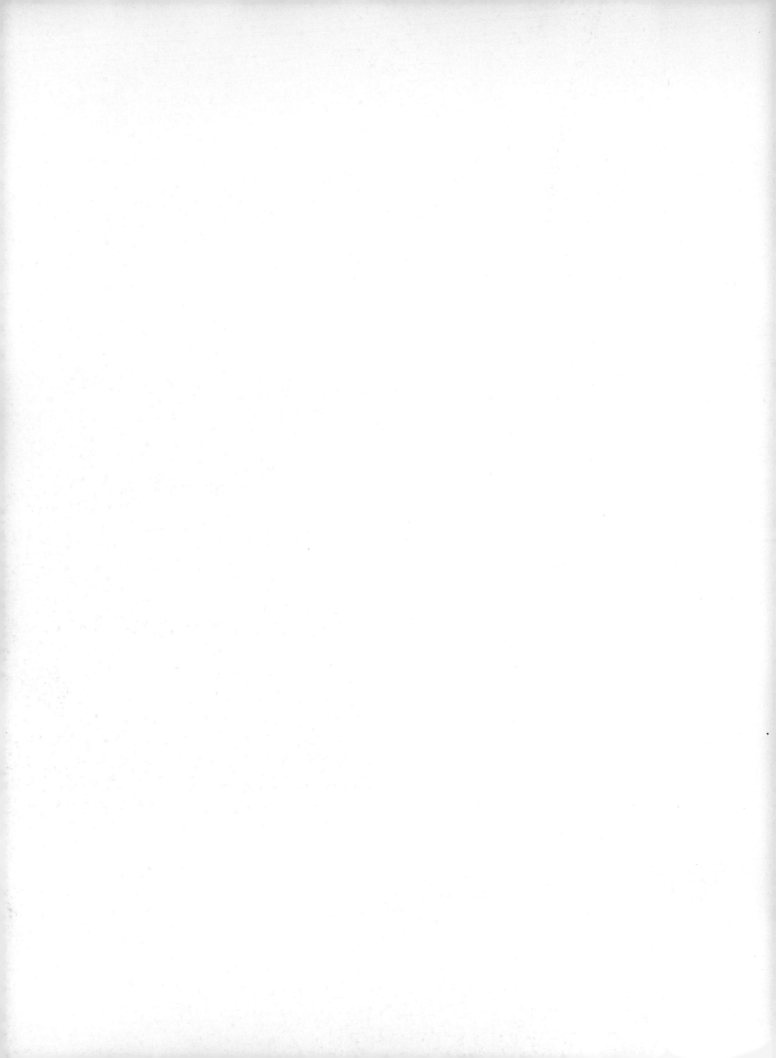

1

Appropriation

Appropriation involves an artist using an existing element—most commonly, a commercial image, piece of art, or some detail of these—to make a new work. This might be a translation in kind, from photograph to photograph, say, or it may involve a conversion (typically, from found object to sculpture, or from photograph to painting). It could also introduce movement through various mechanisms.

Miguel Calderón (b.1971, Mexico City, Mexico) exemplifies the last proposition. Beginning with content screened on Mexican tabloid television, he staged events and photographed them, before employing an artisan (a horse portrait painter) to depict them in paintings. These wound up as part of the backdrop in Wes Anderson's film *The Royal Tenenbaums* (2001), completing a circuit that returned them to moving images. More directly, Anna Bjerger (b.1973, Skallsjö, Sweden) paints from found photographs, emphasizing that the image—discovered in obsolete sources of information, such as antiquated reference books and instruction manuals—has been materially and affectively subsumed into its new context.

1.3

Painters traditionally learned their craft by copying the works of masters, and reinterpreting specific features or motifs. Vik Muniz (b.1961, São Paulo, Brazil) remakes famous paintings out of diamonds, dust, chocolate, caviar, powdered pigment, sand, and junk, before photographing them: Leonardo da Vinci's *Mona Lisa* (c.1503–6) fashioned out of peanut butter and jelly; Caravaggio's *Medusa* (c.1598) reproduced in spaghetti; Jacques-Louis David's *The Death of Marat* (1793) re-assembled from pieces of rubbish; and Vincent Van Gogh's *Wheat Field with Cypresses* (1889) marshaled out of scraps torn from the pages of glossy magazines and books. However, in contrast to the long trail of self-reflexive borrowings that has occurred throughout the history of art, appropriation in the contemporary period relates as much to conditions outside art as to genealogies within it. For Muniz, these two concerns inform one another. Appropriation might be seen as akin to digging through high and low cultural materials—what he deems to be mental refuse bequeathed by a steady stream of visual information. Meanwhile, labor practices provide the motive for many of his works, from an early series of portraits of children on a sugar plantation on the island of Saint Kitts to his film *Waste Land* (2010), a documentary about a massive garbage dump outside Rio de Janeiro.

As it developed in the context of American copyright law in the late 1970s, appropriation involved opposition to private property and, by extension, to the ideology that underpinned the prevailing social and economic order. For many artists at the time, the canon of major works by Western male artists was to be challenged rather than extended, especially by those who took issue with the gender and other inequities underlying art production, as well as with media stereotypes and commercial untruths. Appropriation aimed to dismantle the system of values that supported the identification of masterpieces and was epitomized by the medium of painting, which, as outlined in the introduction, was indicted for its conservatism and for providing trophies for a new and recently wealthy breed of collectors.

Opposed to blue-chip Neo-Expressionist painting, much appropriation during this period happened in other forms, most notably photography, as in the projects of the American artists Sherrie Levine (b.1947, Hazleton, PA) and Richard Prince (b.1949, Panama). Both Levine and Prince re-photographed images taken by others and presented the "new" images as their own, with Levine, for example, reproducing book plates of Walker Evans's government-sponsored Farm Security Administration images of Depression-era tenant workers and their dwellings, and Prince capturing Marlboro cigarette advertisements of American cowboys stripped of brand logos and copy.

1.1

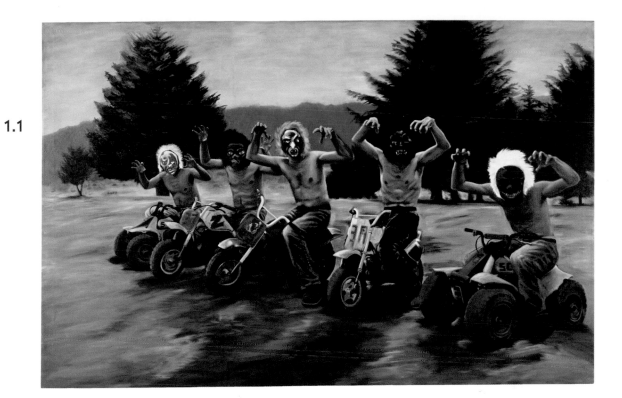

Miguel Calderón
Bad Route, 1998
Oil on canvas, 140.3 × 210.8 cm
(55¼ × 83 in.)

1.2

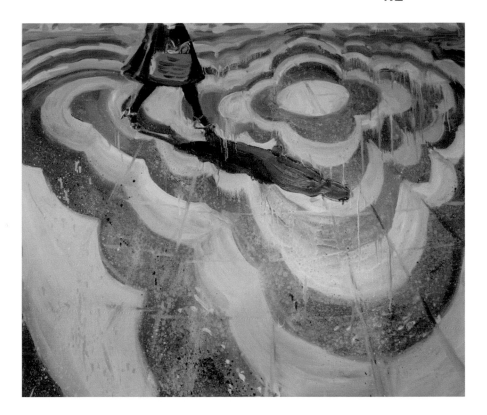

Anna Bjerger
Paving, 2013
Oil on aluminum, 85 × 100 cm
(33⁷⁄₁₆ × 39⅜ in.)

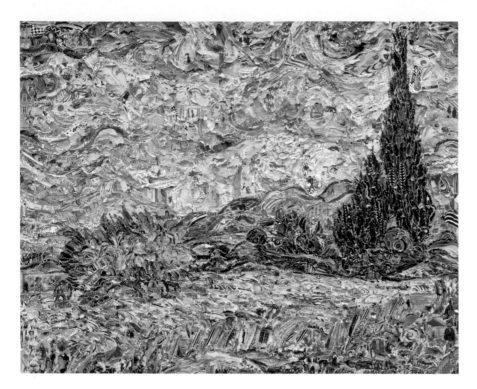

Vik Muniz
*Wheat Field with Cypresses, after
Van Gogh (Pictures of Magazines 2)*, 2011
Digital c-print produced in two editions,
each an edition of 6 plus 4 artist's proofs,
editions in two different sizes,
180.3 × 227.3 cm (71 × 89½ in.) and
101.6 × 128.3 cm (40 × 50½ in.)

1.3

Makiko Kudo
Missing, 2010
Oil on canvas, 227.3 × 363.8 cm
(89½ × 143¼ in.)

1.4

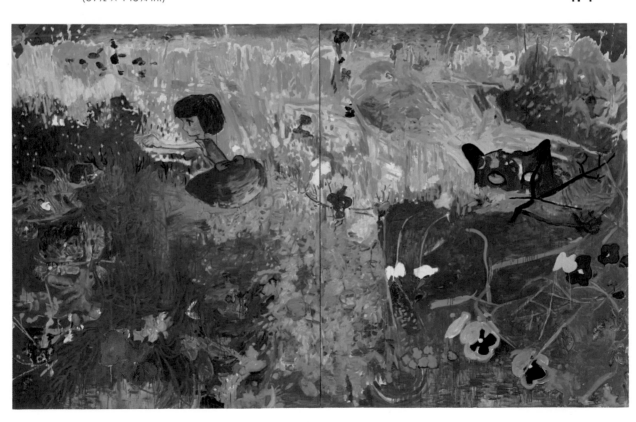

Other artworks from what has been dubbed the Pictures Generation (after a 1977 show in New York curated by Douglas Crimp, entitled simply "Pictures") made their sources clear, since the point was to dismantle and re-contextualize the "original" material, not to create an image from scratch. Although these artists (Prince, Levine, and the others Crimp selected, including Jack Goldstein and Robert Longo) aimed to release the hold of consumer culture on the collective imagination, their attacks were sometimes misunderstood as recapitulating the problems inherent in their critiques.

The a-historical mining of readymade imagery became so widespread that American cultural theorist Fredric Jameson identified "pastiche"—the disorganized and non-hierarchical circulation of quotations without regard to their primary context—as a central theme of postmodernism. Nevertheless, appropriation signified criticality, irrespective of what it actually depicted or to whom it was directed, and asserted the activity of aesthetic transfer as meaningful in and of itself. However, even in an American context, this definition of appropriation is no longer adequate. Moreover, the politics sketched here do not—and likely never did—apply to other parts of the world, where appropriation has become ubiquitous for other reasons. The same goes for the law: for a show at Warsaw's Center for Contemporary Art in 2006, Paulina Olowska (p.27) screened *The Neverending Story* (1984) continuously, 24 hours a day, for free, which was permissible under Polish law and not subject to copyright violation.

While continuing and developing the American context, appropriation can be a starting point for more global histories of art. Makiko Kudo (b.1978, Aomori, Japan) shows young girls amid traditional Japanese imagery of plant and animal life, in dreamlike springtime scenes that closely recall the landscapes of Henri Rousseau, Monet, and Matisse. The ubiquity of all kinds of appropriation, of canonical painting included, has become particularly marked by the deregulatory free-for-all of the Internet, where a near-infinitude of images, clips, and other materials has made appropriation a daily reality for people with access to technology. So total is this media immersion that a work such as *The Clock* by Christian Marclay (b.1955, San Rafael, CA) (2010)—a 24-hour-long video composed of Hollywood film and television fragments, with timepieces visible in each frame, which mark the actual passage of time, shot by shot—might be described as realist. At the risk of suggesting the existence of techno-determinism, the present situation—an inexhaustible archive of found images—assumes that content is both endlessly plastic and appropriation inevitable, though we might ask whether the computer revolution constitutes a difference in kind or merely of degree.

1.4

1.5 Chapter 2 addresses the issue of intention, but given this virtual cornucopia, it is important to consider artists' preferences of what to appropriate. To use one extreme instance of content being as meaningful as the structure of appropriation itself, Wilhelm Sasnal (b.1972, Tarnów, Poland) uses, alongside other mass-media imagery relating to the history of post-communist life in his birth region, as well as snapshots of friends and family, cartoons from Art Spiegelman's iconic comic strip about the Holocaust, *Maus* (1991), in which Jews are depicted as mice, the Germans as cats, and the Poles as pigs. Likewise,

1.6 Mark Bradford (b.1961, Los Angeles, CA) began by painting signs at his mother's beauty shop, before seizing her supplies—like endpapers used for perms—for his art. His large-scale, map-like paintings of city grids are collaged out of posters and detritus reclaimed from the street—commonly advertisements trumpeting a fringe economy (where houses are sold for cash and immigration papers are expedited) and attached to fences encircling still-desolate sites burned out during the 1992 Los Angeles riots that followed the acquittal of police officers seen on video brutally beating Rodney King.

1.7 Or, consider Julie Mehretu (b.1970, Addis Ababa, Ethiopia): through meticulous under-drawings of maps, city plans, civic buildings, palaces and ruins, and accumulations of ink and acrylic marks embedded in strata of translucent acrylic that both build upon, and literally efface, what has come before, she treats as metaphor the processes by which architecture is overtaken by history, and the way the built environment bears the traces of political events. Even before 9/11, Mehretu was creating images expressive of the dynamism of contemporary cities, which seemed to explode into shards across the surfaces of her monumental canvases, leaving certain markers of place intact amid bands of color and passages of geometric abstraction. In the aftermath, her work assumed prescience. In *MOGAMMA (In Four Parts)* (2012), a series exhibited at Documenta (13), Kassel, in the year of its production, Mehretu took on subsequent insurgencies, notably events surrounding the spontaneous uprising in Cairo's Tahrir Square. Here the appropriation of the government building that gives the works their title collapses Egypt's post-colonial past and its 2011 revolution, evoking past architecture and insisting upon its implications for the present.

Calling attention to the content, as well as the form (and often rendering the two inextricable), others have embraced appropriation as a kind of curation. In a press release for a 2008 show at the Andrew Kreps Gallery in New York,

1.8 Ruth Root (b.1967, Chicago, IL) placed thirty-five heterogeneous sources into the form of a mathematical equation, in which Ellsworth Kelly, Josef Albers, and Blinky Palermo were given equal value with items such as bath mats and

1.5

Wilhelm Sasnal
Untitled (Maus), 2001
Oil on canvas, 150 × 150 cm
(59¹/₁₆ × 59¹/₁₆ in.)

1.6

Mark Bradford
Los Moscos, 2004
Mixed media on canvas
317.5 × 483.9 cm (125 × 190½ in.)

1.7

Julie Mehretu
Beloved (Cairo), 2013
Ink and acrylic on canvas
304.8 × 731.5 cm (120 × 288 in.)

Ruth Root
Installation view of the exhibition at
Andrew Kreps Gallery, New York, 2008

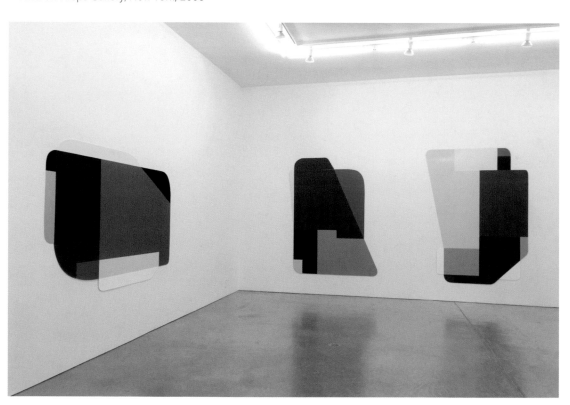

1.8

Pavel Büchler
Modern Paintings No. A45
(cartoon figures in a barn, "Sumie 98,"
Manchester, August 2007), 1997–2007
Reclaimed paint on canvas
114.5 × 113.5 cm (45¹⁄₁₆ × 44¹¹⁄₁₆ in.)

1.9

1.10

Dirk Bell
Far To Close, 2007
Mixed media on canvas, diptych,
each 60.9 × 80 cm (24 × 31½ in.)

Uwe Henneken
The Death of the Corn, 2006
Oil on canvas, 42 × 126 cm
(16$\frac{9}{16}$ × 49$\frac{5}{8}$ in.)

1.11

1.12

Tal R
Lords of Kolbojnik, 2002–3
Mixed media on canvas, 244 × 244 cm
(96$\frac{1}{16}$ × 96$\frac{1}{16}$ in.)

ski socks. All these elements were connected by plus signs, the sum total of which equaled the exhibition, which consisted of wafer-thin aluminum paintings in overlapping colored planes, mounted flush to the wall. Though Root did not include him on her illustrated list, the specter of Marcel Duchamp loomed large. His nomination of a urinal as art through its contextualization within a space dedicated to art (1917), and his identification of the readymade more generally, legitimized the acts of finding and selecting rather than making. Root's paintings are carefully crafted artifacts, but the crux becomes one of selection and exposure of artistic forebears rather than of the art object.

By contrast, others insist on literal reclamation, like Viktor Rosdahl (b.1980, Helsingborg, Sweden), who uses found materials—a broken Ikea tabletop, a shower curtain, or a damaged tarpaulin—as supports for his ruinous, dystopian paintings. Still others retrieve already-painted canvases as the basis for their production, selecting as readymade someone else's art. In this, they highlight their activities as scavengers—curators of a different kind—picking over the remains of past production; they also point to the potential utility of actual recycling and its ethos of reduce and reuse to offset the deleterious effects of commodity production and planned obsolescence. For his series *Modern Paintings* (1997–present), Pavel Büchler (b.1952, Prague, Czechoslovakia) cleans discarded canvases before applying acrylic primer to the surface; thereafter, he peels off the paint, launders the canvases in a washing machine, reattaches the removed paint, and re-stretches the work. Dirk Bell (b.1969, Munich, Germany) uses old, anonymous paintings, often procured at flea markets in Berlin, as the ground for a scrim of white paint or washy, swirling overlays; elsewhere, he cuts into the paintings, excavating a section to incorporate it into another arrangement. While some paintings are modified, others remain in their extant condition, matched with further paintings, or supplemented with sculptural components. Conceptual and physical reclamation become one and the same.

1.9

1.10

Uwe Henneken (b.1974, Paderborn, Germany) also takes "used" canvases as supports for his protagonists named "Vanguard" and "Nihil"—goofy-looking characters derived from World War II-era "Chad" graffiti. American and British servicemen sketched these icons wherever they were stationed, leaving residues of occupation in their wake. Just as public walls became sites to be defiled, the already-worked paintings serve a similar role for Henneken, allowing the artist to differentiate figure from ground. These superimpositions organize his "new" paintings in a variety of ways: deliriously tasteless re-imaginings of art from various moments and locales show the constant shifting of aesthetic preferences to be linked to cultural trends. Instead of

1.11

arguing for a history in which events reach a clearly defined endpoint, Henneken proposes a model of concomitance where nothing really goes away.

1.12 Putting forward another metaphor for appropriation as theme and method, the Copenhagen-based artist Tal R (b.1967, Tel Aviv, Israel) titled a 2003 show at Victoria Miro Gallery in London, "Lords of Kolbojnik," to describe his "group show by one artist," containing paintings, tapestries, and drawings. "Kolbojnik" is slang for the food left over after a collective meal on a kibbutz; the title highlights the potential of what would otherwise be, or has already been, discarded. Notions of cultural waste, broached above, return here in another guise.

1.13 Likewise, Ciprian Muresan (b.1977, Dej, Romania), in the cartoon animation *Untitled (Eating Trash)* (2007), has pictured Radu Comsa (b.1975, Sibiu, Romania) as a bear scavenging garbage, as a testament to the latter's eclectic range. Comsa insists upon the notion of belonging to a community of viewers in which appropriation acts as a mechanism for survival. For a 2010 show at the Sabot Gallery in the Paintbrush Factory in Cluj, Romania, titled "Being Radu Comsa," the artist referenced his peers directly, installing wooden constructions as supports for inset circular paintings that contained details and whole images made by his colleagues, Victor Man, Adrian Ghenie, Marius Bercea, and Serban Savu (p.134). Given the exhibition context, not to mention the successful promotion of these artists since their debut at the 2007 Prague Biennial, Comsa meant the paintings to be identified both with and outside the group, to emphasize that appropriation was the main objective.

Like postmodernism itself, as appropriation becomes both an historical reference—wedded to a specific time period (the 1980s) and cultural context (the US)—as well as a set of maneuvers relative to broader culture, the legacy of its immediate prehistory is also being redrawn: practices once lumped together have become differentiated from one another, as in the case of Elaine Sturtevant (1930–2014), who learned the techniques involved in remaking another artist's work from scratch. In the 1960s she began meticulously to re-create, largely from memory, other artists' paintings, sculptures, and films, a project Sturtevant asserted was anathema to appropriation, despite her close identification with the practice in the 1980s from which she then gained independence.

1.14 In other instances, examination of that period means painting-based appropriation, often disparaged in the 1980s, is now deemed not only viable but desirable. In this light, David Salle (b.1952, Norman, OK) and Peter Halley

1.13

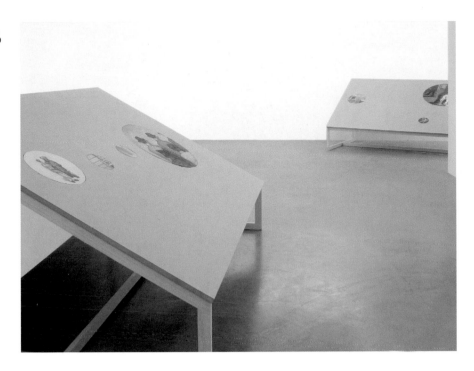

Radu Comsa
Installation view of "Being Radu Comsa,"
Sabot Gallery, The Paintbrush Factory, Cluj, 2010

1.14

David Salle
After Michelangelo, The Flood, 2005–6
Oil and acrylic on linen
228.6 × 470 cm (90 × 185 in.)

1.15

Peter Halley
Clockstopper, 2002
Acrylic, pearlescent and metallic acrylic,
and Roll-A-Tex on canvas
243.8 × 292 cm (96 × 115 in.)

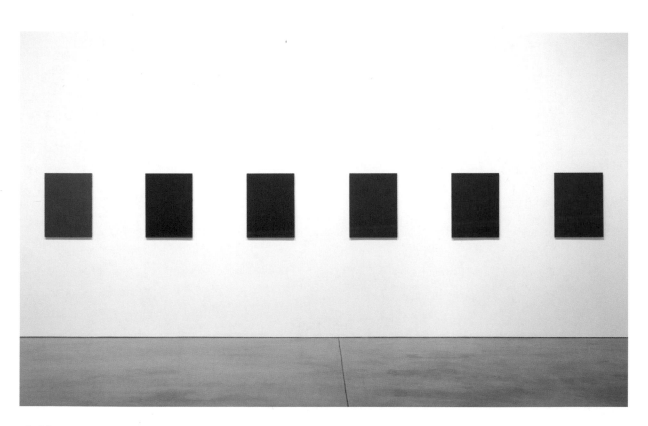

1.16

Sherrie Levine
Gray and Blue Monochromes
After Stieglitz: 1–36, 2010
Flashe on mahogany,
each 71.1 × 53.3 cm (28 × 21 in.)

(b.1953, New York, NY) have prompted reconsideration—the former as a figurative *bricoleur* (an artist who constructs artworks out of random materials), who paints disjointed narratives using eclectic collage-like juxtapositions of art, political events, film, pornography, and other media; and the latter as a staunch opponent of the figurative tradition with which Salle is identified. Halley has painted, and continues to paint, cells and prisons (squares and rectangles, respectively), and conduits (lines) in a palette of Day-Glo paints punctuated with passages of Roll-A-Tex, an industrial paint whose textured appearance recalls stucco. Influenced by French structuralist and post-structuralist theory—to the extent that they have been regarded as illustrative of its key ideas—Halley's diagrammatic paintings expose the use of geometry in the public sphere as an agent of control.

1.15

Meanwhile, Sherrie Levine's concerted attention to the medium of painting has recently acquired greater significance. Started a few years after the photo-based work (p.34), her 1980s compositions (often checkered or striped) recall modernist abstraction, not through specific antecedents such as Piet Mondrian or Barnett Newman, but as a generic decorative scheme stripped of its spiritual transcendence or idealism. Levine's *Knot* paintings, where she colors in the knots on plywood sheets, are wry meditations on the painting as readymade. Following a number of projects involving specific paintings, Levine completed a series of eighteen monochromes based on Alfred Stieglitz's *Equivalents*, his increasingly abstract photographs of the sky. Where the *Equivalents* acted as a pathetic fallacy expressive of his inner state, Levine's surfaces were deterministic, resulting from averaging out the tone of a single print.

1.16

Levine's more intellectual approach conjoins material and cognitive factors. Even though medium specificity is not the goal, it is hardly insignificant that the works are painted. For many artists, the legacy of conceptualism has prompted appropriation, not of a specific image, object, or painting, but of a broader idea of period style. The American artists Blake Rayne (b.1969, Lewes, DE) and Wade Guyton (b.1972, Hammond, IN) (pp.111, 175) both revisit twentieth-century painting, the better to expose their work as mediated by what has preceded it. As Rayne asserts in an artist's statement:

1.17
1.18

> I see the task of my own practice to be that of putting the beliefs attributed to the sign "Painting" to the test by subjecting it to the material conditions of the medium of painting. These material conditions...are for me: modes of distribution and external framing (context); internal procedures of formation (process); and relationships

to other types of images, including those constitutive of a "subject" (performativity).... I have developed an evolving set of procedures by transforming the particular conditions of the medium from definitions to operations. These...include...processes of translation, decontextualization, folding, superimposition, and the following of "scripts" grafted from other sites of cultural production.

For one group of large-scale paintings produced according to predetermined steps, *Untitled 2 through 8 (Dust of Suns)* (2008), Rayne exploited the properties of folding. After selecting and cutting fabric, he marked off the pictorial space and folded the support; he then painted and re-stretched it, before cutting and re-sewing it into three horizontal registers. A nod to the work of Supports-Surfaces—a politically astute group of French artists working in the late 1960s, who used unconventional materials and procedures, including folding, to take apart the tools of painting—Rayne's experimentation with the spray gun similarly eschews lyrical gesturalism and distances him from painted marks.

Like Rayne, and to some extent the artists discussed in Chapter 3, Guyton uses production (process) and distribution (context) to test painting as a medium. In 2002, Guyton began using an office-quality printer to make assisted drawings: computer-generated images (Xs and Us in Blair ITC Medium font predominate), sometimes overlaying source material culled from art, architecture, and design magazines, as well as auction catalogs and monographs. Two years later, he started painting along similar lines, and in 2007 began producing what he calls "ostensibly black monochromes" with a computer and an Epson large-format photograph printer that spits out ink onto pre-primed linen intended for oil. Initially printed on panels up to 44 inches across, and subsequently executed at twice that width (an indication that Guyton folded the fabric in half to fit into the machine), the paintings have vertical midlines abutted by two black or gray slabs of varying density. The goal of each panel is to produce a painting, however imperfect. Despite the uniform process, the results vary according to the amount of ink, overprinting slippages, imperfect syncs, or the printer running askew. Print settings—draft, economy, better, best, worst, black-and-white, color—provide the only mechanisms of control and the images can run to impossible lengths. A project Guyton produced for the Museum Ludwig, Cologne, in 2010, resulted in entire rolls of linen, installed floor to ceiling in a hiccupping pattern of rectangles—all generated by the same size of file, printed ad infinitum, or at least until it fits into the architecture without room to extend further.

These works are based on deliberately subverting an artist's skills. They also return us to Rayne or Guyton as instigator, for the process needs to start with and be legitimized by someone. Denying the sentimentality of the hand, and negating composition, they revel so completely in their formal characteristics that we must ask whether the mechanization of this kind of painting is, in aesthetic terms, a means to an end, as was true for figures such as Ellsworth Kelly or Martin Barré to whom this generation looks (both artists tried to get away from predetermined composition: Kelly took images "already made" in the world—shadows, awnings, bridges—and used sequences of colors determined by chance; Barré focused on mark-making, using the paint tube and spray gun before eventually returning to the brush). The "smell of turpentine" that Duchamp so detested has not proven easy to leave behind, nor have the qualities—composition, image making, creativity, aesthetics— that traditionally come with it. Even with the advent of digital technology, eliminating subjective choice is hard: efforts to undo composition may only deliver it afresh, with external constraints recuperated as pictorial effect.

In another instance of self-imposed rules, as a way of limiting possibilities, R.H. Quaytman (b.1961, Boston, MA) goes through the same process for each series:

1.19

> One: I research some aspect of the place where the paintings will first be seen, whether it be history, architecture, biography, or function of the place.... Two: I often work on one or two small oil paintings (captions) while thinking and researching.... Three: I read poetry.

Programmatic rather than prescriptive, these research-based activities lead to mutable results. Quaytman uses wood panels in one of eight possible sizes, which she brushes with a traditional primer (rabbit-skin glue gesso) before adding layers of other paints and surface items (including Spinel Black, the oil paint developed for making the Stealth Bomber undetectable, and crushed glass); silkscreens of photographs or abstract patterns are also in ready supply. She then organizes her paintings into thematic series conceived as "chapters," which she numbers chronologically: *The Sun, Chapter 1* (2001), *Łódź Poem, Chapter 2* (2004), *Optima, Chapter 3* (2004), *Loft, Chapter 4* (2005), and so on. Each interdependent grouping refers to its constituent members—often by means of hall-of-mirror-like repetitions within the images—and the site of their unveiling, the likely circumstances of their circulation, and the time involved in these processes. Importantly, while stressing the picture plane, her paintings' beveled edges also emphasize the oblique position from which they will be viewed after the exhibition, once secreted away in storage racks.

Despite her governing framework, or perhaps within it, Quaytman's act of appropriation is motivated by personal proclivities, a poignant proposition perhaps exemplified in a work based on Edward Hopper's late painting, *A Woman in the Sun* (1961), which depicts his wife and longtime model standing alone and naked in a shaft of sunlight. Contrarily, Nate Lowman (b.1979, Las Vegas, NV), who first gained notice for his images of bullet holes, revels in hostility towards the objects of his appropriation: the Apple logo, kitsch smiley faces, and modernist paintings. Lowman posits a connection between himself and Andy Warhol—like Duchamp, another godfather of so much painting now, and the subject of an endless parade of exhibitions worldwide that trumpet hybridity over purity and mechanical tools over modernist medium specificity—in many works, including *The Rejects* (2006). His arrangement of sexualized and misshapen produce begs comparison with Warhol's *Tunafish Disaster* (1963), a eulogy for housewives poisoned by tainted cans, though Lowman's target is less contemporary agribusiness than painting as commodity. In this light, the fact that Lowman painted the work with alkyd, a dense, glossy paint, instead of silkscreening it as Warhol did (from the early 1960s on, after a brief attempt at hand-painted pop), imbues the image with a gravity belied by its seemingly humorous content. Lowman refuses iconoclasm and perpetuates a kind of formalism inherent to the abstraction of an appropriated image.

If this brand of appropriation reframes the source but does not abolish the aesthetic—precisely the opposite, in fact—another uses the pictorial possibilities of the screen as a metaphor for vision itself, which often becomes deeply politicized. Maryam Najd (b.1965, Tehran, Iran) veils the image as a surrogate for the body, washing multiple layers of paint over appropriated images, simultaneously obscuring and drawing attention to our yearning to view them. These have included photographic screenshots of television programs and a series of fake self-portraits, in which Najd aligns her identity with images of Margaret Thatcher, Farah Pahlavi, and Osama bin Laden, in a canny take on stereotyping and mass-projection—Iranian equals terrorist— in a post-9/11 world. These last works indicate the priority of media images for Najd (her series *Masquerade* [2009] also centers on images of Iranian protestors demanding the removal of Mahmoud Ahmadinejad from office; under significant threat, they are shown wearing protective masks and scarves to conceal their identity, transforming theatrical accessories into tactical disguises). But Najd also abstracts from abstractions: similar to Levine's process in relation to the Stieglitz photographs discussed above (p.47), her *Non Existence Flag Project* (2010–12) erases the lines and contours of over one hundred national flags, before calculating the percentage of each color used

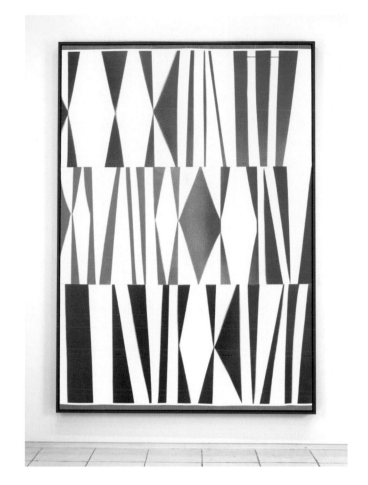

Blake Rayne
Untitled Painting No. 3, 2008
Acrylic paint, gesso, linen, and
lacquer on wood, 232.4 × 167 cm
(91½ × 63¾ in.)

1.17

1.18

Wade Guyton
Untitled, 2010
Epson UltraChrome inkjet
on linen, 213.4 × 175.3 cm
(84 × 69 in.)

1.19

R.H. Quaytman
Distracting Distance, Chapter 16
(A Woman in the Sun – with edges), 2010
Oil, silkscreen, and gesso on wood
63 × 101.6 cm (24¾ × 40 in.)

Nate Lowman
The Rejects, 2006
Alkyd on canvas, 152.5 × 183 × 3.5 cm
(60 × 72 × 1½ in.)

1.20

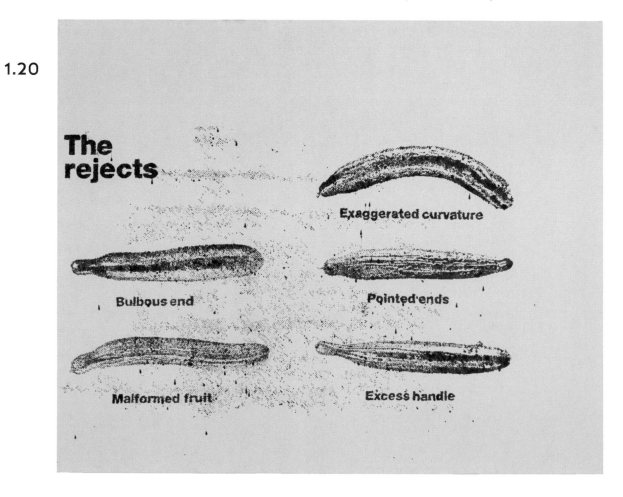

for their design and mixing them in the same proportions to achieve a single hue, which she then uses to paint a monochrome panel for each symbolically deracinated flag.

Thus some artists maintain appropriation as an ongoing political line. Following the collapse of the Soviet bloc, Yevgeniy Fiks (b.1972, Moscow, USSR) began to examine forgotten and repressed histories of the Left, and of a post-Soviet culture bent on eradicating the legacy of those years. Fiks views this recovery as an activist project, in which "interventionist tactics normally applied to physical social space can and should be effectively applied to history." For the oil painting series *Songs of Russia* (2005–7), he appropriated stills from World War II-era Hollywood films about the Soviet Union, which President Franklin D. Roosevelt sponsored to galvanize favorable public opinion towards Stalin at the brief moment when Soviet and American interests coincided. During the onset of the Cold War, these same films became the focus of the House Un-American Activities Committee hearings regarding communist infiltration of Hollywood.

1.22

From 1988 to 1992, José Toirac (b.1966, Guantánamo, Cuba) was a member of the radical artistic group, Grupo ABTV, along with Tanya Angulo, Juan Pablo Ballester, and Ileana Villazón. His more recent productions include mixed-media work relating to Walker Evans's photographs of poverty-stricken Havana in 1933, a video based on a speech Fidel Castro delivered in 2003, and a series of appropriated photographs of Cuban history over which he stamped logos of Western brands: the Apple logo floats above Che Guevara in Alberto Diaz's classic shot, in mockery of the company's endorsement of thinking differently, while the Opium perfume emblem warps a press image of Pope John Paul II shaking hands with Castro, none too subtly conjuring Karl Marx's dictum that "religion is the opiate of the people." Toirac's series of portraits of Cuban leaders was censored for its political implications when scheduled to debut at the National Museum of Fine Arts in Havana in 2007. Made in collaboration with critic and curator Meira Marrero (b.1969, Havana)—the two have worked together since 1994—the series, *1869–2006* (2006), presents a pantheon of men who have held the office of governor or president of Cuba since the time of the first insurgency against the Spanish, chronologically arranged up to the present; the country's uncertain fate is signaled by a lone nail awaiting the next image.

1.23

Less sanguine still is Wang Guangyi (b.1957, Harbin, China), who scorns communism and consumerism by reworking icons of the Cultural Revolution in the guise of American pop. This latter is the default reference for Wang and

1.24

many others, despite the chronological precedence of British pop through the Independent Group, or the Nouveaux Réalistes in France, and so on, which itself says much about the hegemony of American art irrespective of the subject matter. His *Great Criticism* series responds directly to the influx into China of Western luxury goods in the 1990s, and the advertising campaigns that accompanied it. Wang places the triumvirate of idealized revolutionary types—soldiers, peasants and workers—against saturated backgrounds the color of Mao's *Little Red Book*, and in the frame with products from iconic foodstuffs (Coca-Cola, M&Ms), or rarefied brands (Porsche, Chanel). *Great Criticism - Cartier* (2002) gold-plates the figures and, in so doing, shows the visual regimes of Chinese propaganda and Western-style capitalism to be compatible, even indistinguishable, despite their ideological antagonism.

1.25 Rather than indicting a commercial system, Rob Pruitt (b.1964, Washington, D.C.) highlights its obsequious claims for taste and sociability. He is known for his glitter-encrusted paintings of zoo pandas, and for instigating a range of spectacular actions, from offering a buffet of cocaine on a floor mirror to producing an annual art-award ceremony at the Guggenheim Museum in New York and a monument to Warhol in the city's Union Square. His 2010 show at Gavin Brown and Maccarone galleries, "Pattern and Degradation," included designs procured from the fashion designer and socialite Lilly Pulitzer, along with Web photos, which led to a flash-mob demonstration protesting their lack of attribution, and color-saturated canvases inscribed with scribbled lines that capture fragments of human faces and expressions. To complicate matters, these items were placed in the proximity of "People Feeders" (stacks of tires functioning as giant candy and cookie dishes) to say nothing of numerous self-portraits, Op designs, photo-based paintings of cinnamon buns, and cheeky collisions with art history. In sum, the works extended the hangover of pop as a filter of popular culture into the digital age, envisaged at its most radically eclectic, with images, clips, and all manner of media as grist for the appropriative mill.

1.26 A slightly earlier show, conceived by the gallerist Gavin Brown and Urs Fischer (b.1973, Zurich, Switzerland), proposed an exhibition model in which appropriation folded back on itself. Installed at Tony Shafrazi's New York gallery, "Who's Afraid of Jasper Johns?" featured a photographic mural of Shafrazi's recent exhibition, "Four Friends" (Donald Baechler, Jean-Michel Basquiat, Keith Haring, and Kenny Scharf), which captured the installation wholesale: guards, gallery infrastructure, walls, and artworks. Over this full-scale, trompe l'oeil wallpaper hung "real" works by twenty-two artists, ranging from Francis Bacon and John Chamberlain to Jeff Koons (p.86) and

1.21

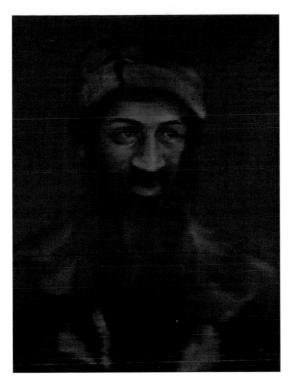

Maryam Najd
Self-Portrait VIII, 2006–7
Oil on canvas, 80 × 60 cm
(31½ × 23⅝ in.)

Yevgeniy Fiks
Song of Russia no. 10, 2005–7
Oil on canvas, 91.4 × 121.9 cm
(36 × 48 in.)

1.22

1.23

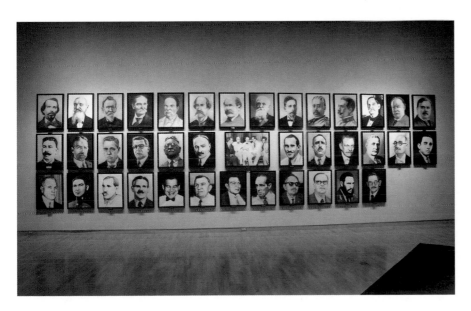

**José Toirac, with
Meira Marrero**
1869–2006, 2006
39 oil paintings on canvas,
wooden frames, metal
identification labels, nails,
dimensions variable

55

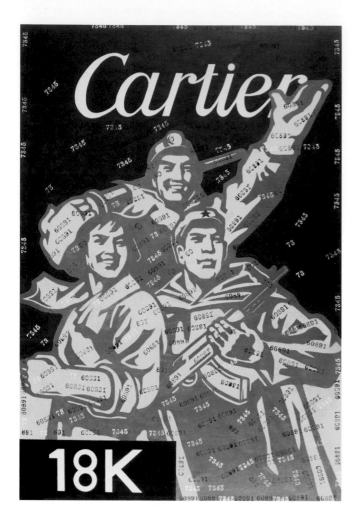

1.24

Wang Guangyi
Great Criticism – Cartier, 2002
Oil on canvas, 300 × 200 cm
(118⅛ × 78¾ in.)

Rob Pruitt
The Kiss After Brancusi, 2010
Acrylic, enamel paint, and flocking
on canvas, two parts: 305.1 × 244.5 cm
(120⅛ × 96¼ in.) and 276.5 × 213.7 cm
(108⅞ × 84⅛ in.)

1.25

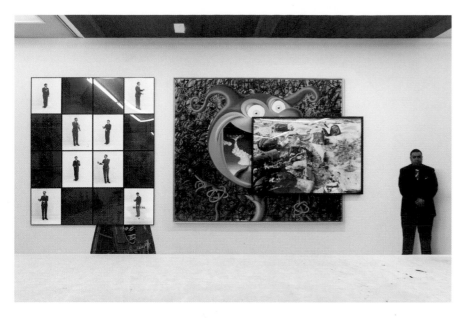

1.26

1.27

Installation view of
"Who's Afraid of Jasper Johns?",
Tony Shafrazi Gallery, New York, 2008.
Wallpaper: Urs Fischer, *Abstract Slavery*,
2008. Wallpaper prints of photographic
reproductions of interior spaces—content,
scale, and lighting determined on
a site-specific basis (1:1 scale color
photographic reproduction of the gallery
space during the previous exhibition,
"Four Friends"), dimensions variable.
Works featured on wallpaper, from left to
right: Gilbert & George, *MENTAL NO. 4*,
1976; Cindy Sherman, *Untitled #175*, 1987.

Urs Fischer
Invisible Problem, 2013
Aluminum panel, aluminum
honeycomb, two-component epoxy
adhesive, two-component epoxy
primer, acrylic primer, gesso,
acrylic ink, spray enamel, acrylic silkscreen
medium, and acrylic paint
243.9 × 182.9 × 3.2 cm
(96 × 72 × 1¼ in.)

57

1.28

Matts Leiderstam
Installation view of
Grand Tour (1997–2007) at
Grazer Kunstverein, Graz, 2010.
Installation with fifteen
tables designed by the artist,
paintings, books, light boxes,
slides, photographs, digital
slideshows and projections,
computer screens, easels,
Claude glasses, and field
scopes, dimensions variable.

Harland Miller
I'm So Fucking Hard, 2002
Oil on canvas, 213 × 310 cm
(83⅞ × 122¹/₁₆ in.)

1.29

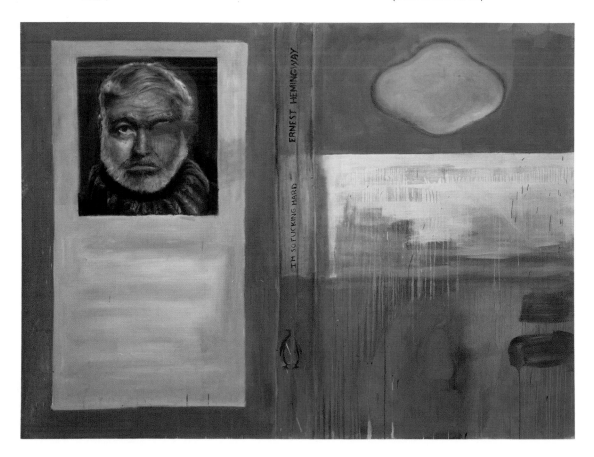

Christopher Wool (p.69), each of which had passed through Shafrazi's hands on the secondary market. A Rudolf Stingel carpet (p.108) covered the floor, while two works by Pruitt bracketed the whole show: *Eternal Bic* (1999), an endlessly burning Bic-lighter-turned-sculpture seen upon entry, and a Viagra-infused waterfall that coursed alongside the front stairs. Amplifying or obfuscating pictures has informed Fischer's more recent foray into paintings as such: enormous aluminum panels of colored and enlarged vintage Hollywood icons, rendered abject. Onto each headshot Fischer silkscreens a commonplace object (such as a beet, mushroom, banana, or a wrench), which blocks the faces and transforms them into clichés, since each occlusion was chosen for being concave or convex, and thereby assigns the obscured subject with a gender.

1.27

Matts Leiderstam (b.1956, Gothenburg, Sweden) assumes the possibility of reframing not only a specific image or style, but the whole of art history. He exhaustively researches an artist or image type, such as Nicolas Poussin or the prehistoric landscape, and builds an archive around it. The resulting exhibition might have optical instruments (color filters, magnifying glasses, field scopes, slide projections, and computer animations) and his own hand-painted reproductions of paintings, for use with other items of study (catalogs, books, light boxes, slides, and photographs), which the viewer is invited to peruse and put to use. *Grand Tour* (1997–2007), first shown in connection with the 1997 Venice Biennale and variously configured in other locations, including Magasin 3 (Stockholm, Sweden), might be the most complete realization of Leiderstam's approach, sprawling over a decade and a range of materials. Inspired by the origins of cultural tourism, the artist became impressed by the fact that stops along the circuit for wealthy young men of the eighteenth century, who were ostensibly gaining knowledge of connoisseurship in the service of collection building, match those in modern gay travel guides. Leiderstam highlights the eroticism latent in grottos, deserted landscapes, and public parks, as well as in more obvious examples of the classical nude, in a kind of cruising within the remnants of the past.

1.28

Related in a different way to reading what is hidden in plain sight, the British artist and writer Harland Miller (b.1964, Yorkshire, UK) has based numerous paintings on the covers of vintage books, beginning with the Penguin imprint and moving on to Pelican and Allen Lane—all of which were priced cheaply to ensure mass distribution in their respective heydays. Each of Miller's paintings follows the format of the classic design template, with the logo, title, and press mascot separated into color-coded horizontal registers—a classification system that once denoted genre, preserved here as decorative scheme. Miller equates the artifact of the paper book with modernist painting, which might be seen as

1.29

expressing a misbegotten nostalgia for both. Yet his pithy, sometimes directly hostile, inventions of names skewer the ethos that pervaded both spheres of cultural production, and the gender politics that serviced them. To wit: *I'm So Fucking Hard* (2002), a send-up of Ernest Hemingway, famously over-identified with his masculinist fiction.

1.30 Others, like William Daniels (b.1976, Brighton, UK) and Caragh Thuring
1.31 (b.1972, Brussels, Belgium), have turned to earlier moments to make claims for the mutability of sources, arguing for the formal and other perversities afforded by the rampant conversion of cultural artifacts. Daniels reconstructs well-known paintings into maquettes composed of scavenged quotidian materials, which he puts to use as a model for his own painted works. Muted in tone and flattened into cardboard planes, they recall the faceting of Cubism as much as the imagery that was their ostensible source (in the case of *The Shipwreck*, Turner's 1805 painting of the same name). Thuring's five paintings on unprimed linen, *1, 2, 3a, 3b, 4* (all 2009), flirt with legibility as pastoral scenes. On account of their blank spaces—the passages left empty in one painting but not in another—it is only in aggregate that the images resolve into a whole referencing their source: Manet's *Déjeuner sur l'herbe* (1863), itself based on Titian's *The Venus of Urbino* (1538). Although not random, Thuring's choice of Manet serves primarily as a pretext for the artist's experimentation.

1.32 Silke Otto-Knapp (b.1970, Osnabrück, Germany) finds sources closer to the present. Her paintings of avant-garde dance (such as Bronislava Nijinska's 1923 ballet *Les Noces*, and a studio shot of Yvonne Rainer) are taken from found photographs, whose muted palettes she evokes through translucent washes. Forgoing realism, she carefully effaces shadows, highlights, and other fine details, to accentuate a dancer's pose, costume, or the space that enfolds
1.33 them in the course of rehearsal and presentation. Andrew Grassie (b.1966, Edinburgh, UK) voraciously ranges across the centuries, fashioning photorealistic tempera studies of gallery interiors where his works are exhibited and the studio in which they were produced. In a 2007 show at Maureen Paley, London, Grassie installed paintings depicting the gallery's exhibitions in the previous year during their installation, with each work hung in the same spot in the gallery from where he took the photograph on which it is based. He has also indulged the possibilities of making his own exhibition, as in 2005 when he curated an imaginary display of works from the Tate gallery's collection by Matisse, Stubbs, Henry Moore, and others—greatest hits in a show that never was.

William Daniels
The Shipwreck, 2005
Oil on board, 30 × 40 cm
(11¾ × 15¾ in.)

1.30

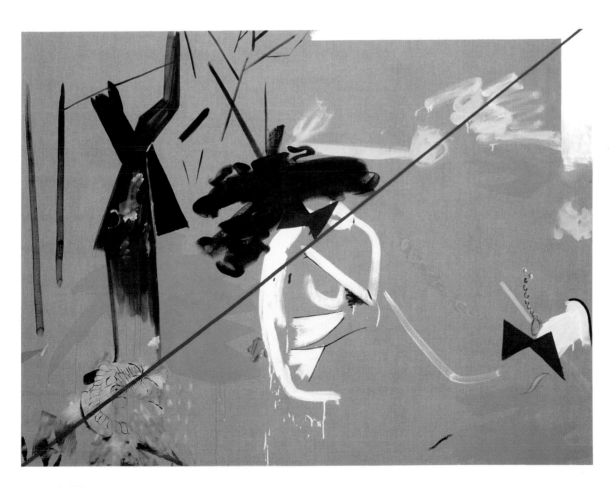

1.31 **Caragh Thuring**
1, 2009
Oil, gesso, and acrylic
on linen, 145 × 192 cm
(57 × 75⅝ in.)

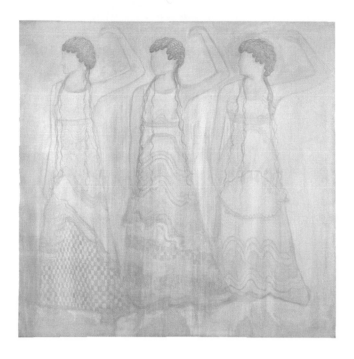

Silke Otto-Knapp
L'Apres Midi d'un Faune, 2004
Watercolor and gouache
on canvas, 101 × 101 cm
(39¾ × 39¾ in.)

Andrew Grassie
The Making of the Painting, 2004
Tempera on paper on board
12 × 18 cm (4¾ × 7¹⁄₁₆ in.)

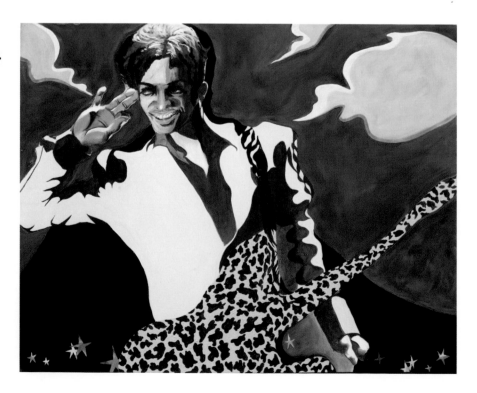

Rui Matsunaga
Jaguar Prince, 2005
Oil on canvas, 102 × 128 cm
(40³⁄₁₆ × 50³⁄₈ in.)

Jun Hasegawa (b.1969, Mie, Japan) paints women traced from the outlines of men's magazines: once relocated in her stage-set-like compositions, the figures appear marooned, effectively unhinged from the site of their first appearance. Pushing even further into a fabulist dimension, Rui Matsunaga (b.1968, Ube, Japan) turns ordinary tabloid and mass cultural images of animals and people—like Prince Rogers Nelson (aka: The Artist Formerly Known as Prince)—into contemporary folklore. Founded on mythology and cartoon animation, Matsunaga's characters evoke spirits and ghosts, such as the jaguar in shamanic culture who mediates between different worlds, while the ambiguous narratives in which they act take on the vivid, sometimes hallucinogenic, character of science fiction.

1.34

To return, finally, to the legal issues raised at the beginning of this chapter, a pivotal concern has become whether seeing the appropriated artwork so visibly—fantastically—altered matters. An issue since the 1970s, this became topical anew in 2011, when a federal court judge in Manhattan ruled that Richard Prince (p.34) broke the law when he appropriated the French photographer Patrick Cariou's images of Rastafarians in Jamaica, published a decade before, for a body of collages and paintings. In 2013 this verdict was appealed and—with the exception of five of the thirty works—overturned in Prince's favor because his paintings "have a different character" from Cariou's photographs. Whatever the merits of this judgment, the case (finally settled in 2014) shattered the fiction of appropriation as collaboration between consensual—or at least unconcerned—parties, and not only in North America. Many have argued for the social potential promised by the utopianism of the digital universe, or of open work systems, and founded notions of a globalized art world upon them. However, connected to the perpetual shuttling of images, objects, designs, styles, materials, and techniques, we must also note a retrenchment into claims for single authorship, personal sovereignty, and differentiation. In the following chapter we return to questions of intention and the degree to which they reveal themselves formally in an image, whether appropriated or otherwise.

2

Attitude

Painting now commonly bespeaks an attitude rather than a unique artistic personality—or at least attempts to do so, as the discussion of deskilling in the previous chapter suggests. This chapter considers various strategies of self-presentation that artists use to frame themselves and their work by means of procedural and stylistic devices, ranging from the anti-aesthetic stance of "bad painting" to the historically conditioned uses of Western and non-Western painting methods and practices. As defined by the Oxford English Dictionary, the word "attitude" encompasses fitness, adaptation, and disposition, the last directly relating to the fine arts, as in the posture of a figure in statuary or painting. My use of the term also refers to behavior or a manner of acting. The *enfant terrible*, snotty teenager, precocious slacker, disaffected hipster, quirky conceptualist, and worldly cerebral are some well-worn types. The Young British Artists (YBAs), whose position in the 1990s was consolidated by their education, exhibition, and patronage by the London-based collector and advertising executive Charles Saatchi, are testament to the effectiveness of marketing and artistic ego.

The shaping of an artist as public personality is also the hallmark of a mediagenic culture. For three months in 2010, Marina Abramović (b.1946, Belgrade, Yugoslavia) sat silently in a chair in the atrium of the Museum of Modern Art, New York, for *The Artist is Present*, a performance extending over some 700 hours. Abramović appeared impervious from a distance, though many museum visitors who took the invitation to approach her were overtaken with emotion. So moved were they by this encounter that scores of testimonial-like portraits now comprise a website, Marina Abramović Made Me Cry. For cynics, rather than prompting empathy, these images of tear-streamed faces parodied the modern notion of achieving self-validation through art and confirmed an instance of celebrity legitimizing itself through the faux-generosity of communion. However interpreted, *The Artist is Present* confirmed a widespread yearning for the kinds of affective connection ostensibly lost in our daily lives, and claimed an aesthetic space in which this might occur.

Even artists who operate at some remove from such publicity mechanisms remain implicated in this phenomenon (hence their rejection, in certain cases, of choice as an extension of a privileged self), while others manipulate the system to great effect. This condition is fabulously satirized in the work of Jayson Musson (b.1977, New York, NY), more commonly known as Hennessy Youngman. Donning hip-hop apparel and speaking in clichés, Musson, as Youngman, hosts an episodic Internet series, Art Thoughtz (2010–present), in which he introduces concepts relating to art practice. Thus, while some artists have ceded person for persona, insisting that the artwork is not reducible to the artist (and vice versa), for others it is more a matter of repositioning painting or raising questions about its privileged place within Western modernism. Through mechanical means and the incorporation of readymade materials and processes, they dissociate themselves from the production process and undermine preconceived composition, the role of the hand, and technical skills once considered fundamental. This suggests reflection on the different possibilities for painting and its function.

Nonetheless, choosing to deflect intentionality also implies its presence, or even that of an "abstract animism," as a review of Pia Fries (b.1955, Beromünster, Switzerland) dubbed her thickly covered canvases of roiling paint. As if to subvert interpretation centered on the artist, for Documenta 2007, Nedko Solakov (b.1957, Cherven Briag, Bulgaria) exhibited *Fears*, produced in the same year. The work consisted of a suite of "real" and fictive drawings that presented individual anxieties as depersonalized, even collective. In refusing to convey specific interiority—the suggestion of a connection

2.1

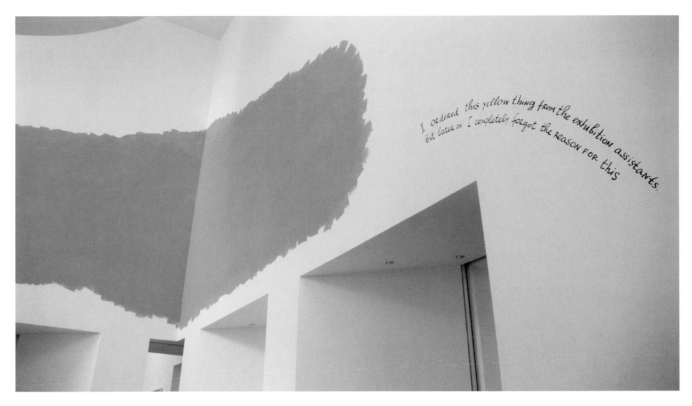

I ordered this yellow thing from the exhibition assistants but later on I completely forgot the reason for this

2.1

Nedko Solakov
Installation view of _The Yellow Blob Story_
(from the project "The Absent-Minded
Man," 1997–present) at the "Emotions" solo
exhibition, Kunstmuseum Bonn, 2008.
Yellow paint, handwritten text
on wall, dimensions variable.

2.2

Wangechi Mutu
This You Call Civilization, 2008
Mixed media, ink, and collage on Mylar
248.9 × 132.1 cm (98 × 52 in.)

2.3

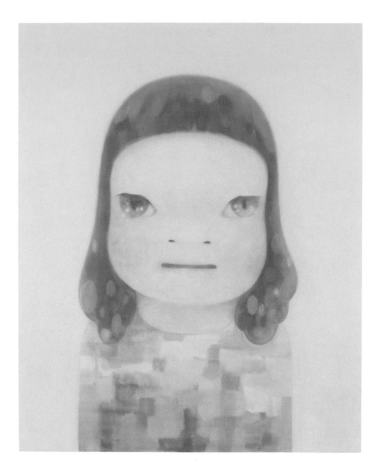

Yoshitomo Nara
Miss Spring, 2012
Acrylic on canvas, 227 × 182 cm
(89⅜ × 71⅝ in.)

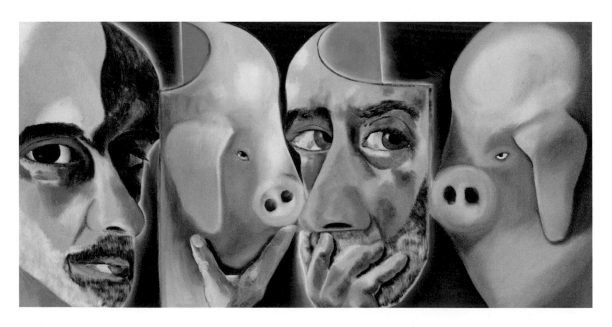

2.4

Francesco Clemente
*Self-Portrait With and
Without the Mask*, 2005
Oil on linen, 116.8 × 234.3 cm
(46 × 92¼ in.)

between the psyche and a drawn or painted surface—Solakov prevented any interpretation of artistic identity relative to biography. In *The Yellow Blob Story* (2008), a wall painting completed by a gallery assistant given control over form, he went further in upending notions of uniqueness, mocking painting's heroic pretensions and undercutting the centrality of the author.

Wangechi Mutu's (b.1972, Nairobi, Kenya) fantastic hybrids—warped amalgams of plants and animals, pornography, medical diagrams, and black women—stand in for the human condition, and, although the artist insists on separation between herself and the images she creates, critics have questioned whether they disclose her experience of the African Diaspora. Even less successful in warding off readings based on his life story, Yoshitomo Nara's (b.1959, Hirosaki, Japan) work is frequently discussed as a confessional product of his latchkey past, despite his use of a flat graphic style (*kowa kawaii*, or "creepy cute") to evoke childhood innocence and a rather more diffuse condition of loneliness. **2.2**

2.3

For Francesco Clemente (b.1952, Naples, Italy), a painter who matured through Arte Povera and first-generation conceptual art but was popularized via Italian Transavanguardia of the 1980s, identity constituted a central theme. His self-portraits lay personal mythology and shifting identities onto bodies that are malleable, or suggest a state of becoming gendered or even human. Admittedly, Expressionism had been attacked for exploiting authorial emotion—for treating painting as a physical act signifying both sensation and intention—yet even a work heavy with nominally personal content, or painted in the gestural style long synonymous with it, does not necessarily convey sentiment or authenticity; indeed, it might suggest an ongoing need for connection, on account of being unfulfilled. **2.4**

Albert Oehlen (b.1954, Krefeld, Germany) and Christopher Wool (b.1955, Chicago, IL) both use gestural painting for a sustained inquiry into painterly conventions. Begun in 2008, Oehlen's *Fingermalerei* (Finger Painting) jam together hackneyed figuration and garish abstraction. Oehlen applies paint to the canvas with his bare hands, meaning that touch—that would-be guarantee of aura through directness of bodily and, by extension, psychic, imprint—becomes the primary agent in building the painting's surface. Yet no less visible are the collaged advertising posters, text fragments, and crudely printed digital images that he often affixes to the white-primed canvases, before adding oil in drips, globs, and murky stains, in a drab palette that recalls the color of early American Abstract Expressionism. Careful to distance himself from his predecessors' grating sincerity, Oehlen executes marks from the playbook of mid-century painting that look spontaneous but **2.5**

are carefully planned. Any jokey inclusions of slivers of bikini-clad girls, playing cards, or sausages, as well as letters or whole words, play against the painted sections without contravening or confirming the tone of the whole.

2.6 Wool has moved beyond both the sign-like paintings that gained him notice in the 1980s—black-and-white compositions featuring blocky, stenciled words shorn of punctuation (SELLTHE/HOUSE S/ELLTHEC/AR SELL/THEKIDS) and sometimes vowels (TRBL)—and his early canvases composed of repeating marks made by rubber stamps and house-painting rollers. In the early 1990s, Wool took up the silkscreen. At this time, he began to appropriate his own earlier compositions as the basis for newer ones, which might involve dripping, linear tracery executed with a spray can. More recently he has incorporated digital technology into his process, and his working method has become sufficiently complex to inhibit recovering steps in the process or perceptual distinctions between printed or painted marks. In paintings exhibited at the 54th Venice Biennale, the dark masses he placed at the center, which resembled Rorschach blots, enhanced the visual drama of the whole while deliberately obstructing it.

2.7
2.8
2.9 A similar equivocation about the painterly act and what it communicates underlies Charline von Heyl's (b.1960, Mainz, Germany) fusion of gestural painting and conceptual art (a strategy common to many younger New York painters, including Jaya Howey [b.1973, Pompton Plains, NJ] and Patricia Treib [b.1979, Saginaw, MI], whom she has mentored). Von Heyl's big, energetic works avoid a signature style in favor of intense color and pattern—splashes, stripes, diamonds, barbed wire, and orbs. Though visually assertive, they are difficult to analyze, particularly since she often reverses figure and ground, adding in backgrounds at the end with a fine brush.

This refusal to reveal the work's methods and meaning, and to equate her own interiority with the painted mark, owes much to von Heyl's rejection of the cult of celebrity promoted in 1980s Cologne by artists represented by the gallerist Max Hetzler and, above all, by the jocular machismo of Martin Kippenberger (1953–1997). Known for his alter-egos, multiple guises (characters include the Spiderman, the Egg Man, and the Frog), and wide-ranging practice—from wonky sculptures of lampposts to a gas station purchased during a trip to Brazil in 1986—in which he lampooned the art establishment and its products, Kippenberger had a profound influence.

His series of twelve paintings based on photographs, *Lieber Maler, male mir...* (Dear Painter, paint for me...) (1981–83), chronicles the amblings of its subject,

2.5

Albert Oehlen
FM 58, 2011
Oil and paper on canvas
200 × 230 cm
(78¹¹⁄₁₆ × 90⅝ in.)

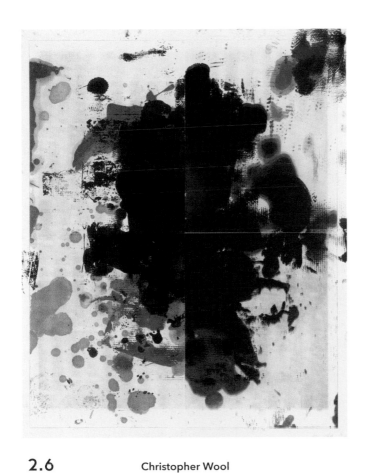

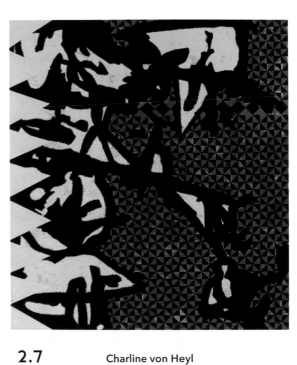

2.7

Charline von Heyl
Big Zipper, 2011
Acrylic and oil on canvas
218.4 × 198.1 cm (86 × 78 in.)

2.6

Christopher Wool
Untitled, 2012
Silkscreen ink on linen
304.8 × 243.8 cm
(120 × 96 in.)

2.8

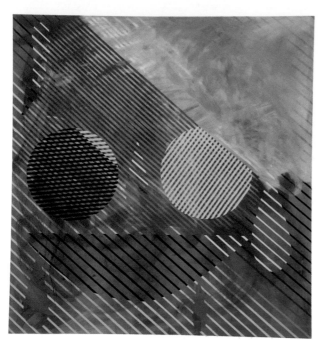

Jaya Howey
Happy Hardcore, 2009
Oil on canvas, 180.3 × 170.2 cm
(71 × 67 in.)

2.9

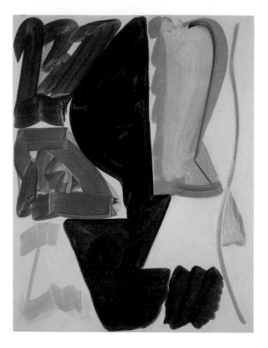

Patricia Treib
Garb, 2012
Oil on canvas, 167.6 × 127 cm
(66 × 50 in.)

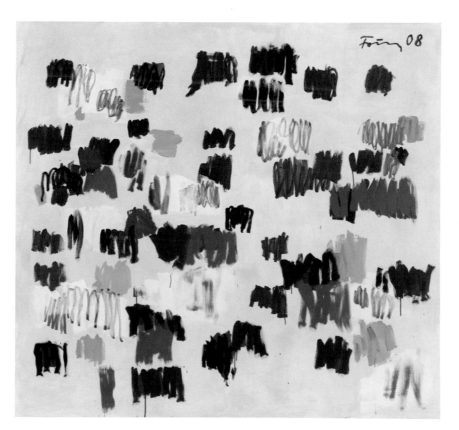

2.10

Günther Förg
Untitled, 2008
Acrylic on canvas, 260.5 × 280 cm
(102⁹⁄₁₆ × 110¼ in.)

2.11

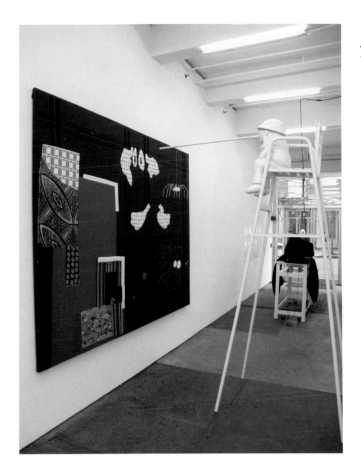

Cosima von Bonin
Installation view of "The Juxtaposition of Nothings," Petzel, New York, 2011

Michael Krebber
Installation view of *Das politische Bild* (1968/2010) at Galerie Buchholz, Berlin, 2010
Oil on canvas mounted on cotton
98.3 × 126 cm (38¾ × 49⅝ in.)

2.12

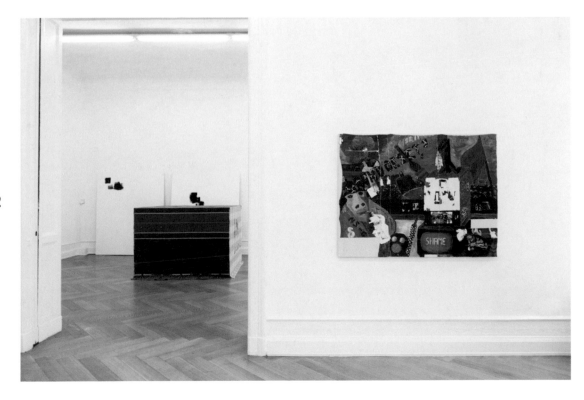

2.13

André Butzer
Nicht fürchten! (2)
[Don't Be Scared! (2)], 2010
Oil on canvas, 221 × 280 cm
(87 × 110¼ in.)

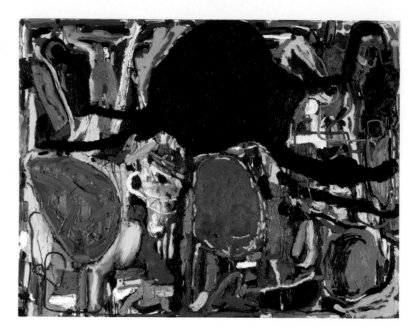

2.14

Anselm Reyle
Little Yorkshire, 2011
Mixed media on canvas, steel frame,
effect lacquer, 69 × 89 × 4 cm
(27³⁄₁₆ × 35¹⁄₁₆ × 1⁹⁄₁₆ in.)

from a bar crawl through the streets of Düsseldorf to a couch abandoned on a New York street corner. Importantly, Kippenberger collaborated with a commercial artist ("Mr. Werner," a Berlin-based film-poster painter) to execute the works, thus opposing the fetishization of the painterly gesture in contemporary Neo-Expressionism and creating new roles for his protagonists. Reveling in a kind of bathos reinforced by his death from alcohol-related liver cancer at the age of forty-four, Kippenberger intoned that one's life should be the basis for one's art, a credo that embraced self-invention as aesthetic lifestyle.

Günther Förg (1952–2013) is still recognized for the sensuous, rough-hewn paintings of monochromatic bands on lead made during the decade he spent close to Kippenberger, when the Hetzler cohort's bad-boy antics were at their most pronounced. Förg's later abstract canvases are unencumbered by this relationship, but remain in tune with Kippenberger's preoccupation with selfhood. With their prominent signature displayed in the top corner of each panel, the works investigate identity, and, more significantly, in their riotous color swatches and brushwork, embrace the elemental act of painting. But like Cy Twombly's scrawl, which merely implies real syntax, Förg's atomistic marks evoke the activity of art-making as an arrangement of colors and shapes without cohering into a legible composition. **2.10**

Also inspired by Kippenberger, Cosima von Bonin (b.1962, Mombasa, Kenya) began her career by proclaiming herself "the artist" among her circle of friends. A declaration that she has spent the last decades fulfilling, this act reflects her interest in the social field that surrounds the artist and her objects. In the 1990s, von Bonin collaborated with critics, musicians, and other artists, inviting them to contribute photos, paintings, or performances to her solo shows; and in a 2010 exhibition at the Kunsthaus Bregenz she hosted, among other things, a concert by Moritz von Oswald and his Trio, and screened a series of films on the Austrian writer and poet Thomas Bernhard. Like Sigmar Polke (equally well known in this circle), who famously refused to attend his own openings, insisting that his paintings existed independently of him, von Bonin's withdrawal into her peer group constitutes a deliberate act of removal. **2.11**

Collaboration can be understood as implicitly challenging notions of single authorship, but von Bonin has also made artworks under her own name that include used textiles. She sources printed fabrics, felt, dishcloths, and wool blankets to manufacture her so-called *Lappen* (rags)—collaged, painting-like panels emblazoned with appropriated images—as well as to tailor costumes for

performances and fabricate oversized plush toys. Yet she shies away from directly articulating meaning through these enigmatic objects, instead allowing it to be conveyed through mechanisms such as speech, social norms, and codes of display. A 2011 show at Friedrich Petzel, New York, featured a sculpture of Pinocchio, a recurring character in her work, which she used as an emblem of exaggeration and deceit; she then enacted these themes by subtitling a dark fabric wall work with a fictional Web address.

2.12 Kippenberger's assistant, Michael Krebber (b.1954, Cologne, Germany), has commandeered elements of other painters' signature styles, such as Polke's readymade surfaces and Georg Baselitz's inverted figures, and even appropriated the manufactured textiles favored by von Bonin. (In his case, patterned bed-sheets and blankets have been attached to stretchers without the addition of paint, though they can also provide the background for motifs such as a prancing horse, evocative of German Romanticism.) A show in London at Maureen Paley in 2007, "London Condom," recalled Kippenberger in its use of canvases produced by a professional signwriter. These paintings form part of a larger series first shown at Daniel Buchholz, Cologne, under the title "Respekt Frischlinge" (Respect Fledglings), and at Chantal Crousel, Paris, as "Je suis la chaise" (I am the chair). Krebber titled each of these uniformly sized black-and-white panels imprinted with text from a recent lecture, "Puberty in Painting," in the language native to the country in which they were shown.

Although Krebber turned to painting in the early 1990s, these works are only part of his heterogeneous output, which is often less about personality than its institutional framing. However, Krebber frequently withholds as much as he produces. At the Secession, Vienna, in 2005, he disregarded exhibition conventions and left a large space vacant, thereby calling attention to the architectural envelope that structures the display of artworks. (His titling of the same body of work in multiple languages to reflect its transit through the international art system might be considered a similar strategy.) In a text accompanying a 2010 show at Daniel Buchholz, Berlin, Krebber further challenged custom:

> "Miami City Ballet" [the Berlin show] shall be the first stop in, or the downbeat of, a series of "new" exhibitions following a lengthy period of inactivity.... I should like to perform in this exhibition that it doesn't matter what I do, whether it is good or bad, or that it conforms however to whatever criteria [*sic*]—the fact that I call myself an artist is enough here.

2.15

**Michael Frank and
Louise Reilly Sacco**
Cover of the catalog to
seventy "masterworks" in the
collection of The Museum of
Bad Art, 2008

2.16

Installation view of "Bad Painting,"
New Museum, New York, 1978

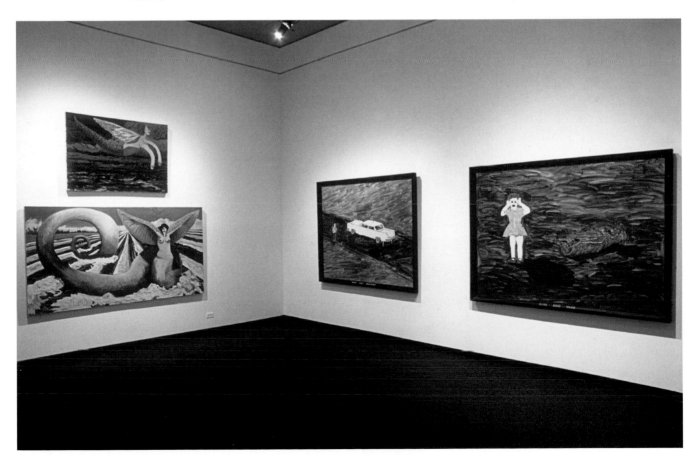

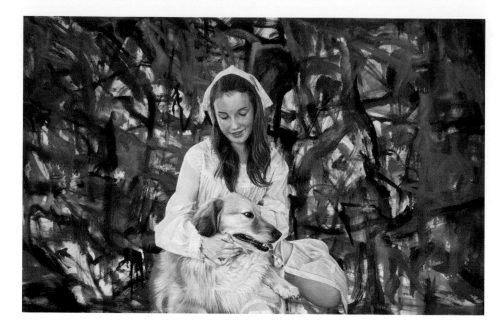

2.17

Jim Shaw
Oist Children Portrait (Girl & Dog), 2011
Oil on canvas, 119.4 × 185.4 cm
(47 × 73 in.)

2.18

Mike Kelley
Horizontal Tracking Shot of a
Cross Section of Trauma Rooms, 2009
Acrylic on wood panels, steel, video monitors,
Roku media players, SD video cards, wiring,
and video mounts, 243.8 × 487.7 × 61.1 cm
(96 × 192 × 24¹/₁₆ in.), video
high-definition NTSC, 8:51 min.

Krebber courts failure by limiting production and shunning a consistent approach; but in producing anything at all, he exposes himself to the possibility of it being deemed good or bad—whether or not he cares one way or the other (his reference to "performance" hedges his bets). In "Miami City Ballet" he included a history painting, *Das politische Bild* (The Political Picture) (1968/2010), which he made as a teenager and salvaged the year of the show, meaning that it was created before Krebber became an "artist." John Armleder (b.1948, Geneva, Switzerland), whose vertiginously eclectic practice has employed everything from flower-encircled scaffolding, abstract painting, wallpaper, fluorescent lights, mirrors, silver Christmas trees, limbs, stuffed animals, piles of coal, and disco balls, has also exhibited grade-school doodles, including a mountain landscape that he made at fourteen. Once involved in Fluxus, and a founding member of the Groupe Ecart, Armleder has long accommodated all media without concession to coherence of style, or distinctions of good and bad. By comparison, Oehlen tried to make calculatingly bad paintings early on in his career, abandoning the project once these works became indistinguishable from the Expressionism he was trying to oppose.

Other instances of deliberately bad painting one could cite include Werner Büttner's (b.1954, Jena, Germany) defiling of academic Surrealism. Brooke McGowen (b.1953, Chicago, IL) paints black-light paintings of copulating figures, while in an equally adolescent gesture, Dan Colen (b.1979, Leonia, NJ) sticks chewing gum to oversize canvases. André Butzer (b.1973, Stuttgart, Germany) crosses Walt Disney with Edvard Munch, which results in garish landscapes populated with grotesque characters—manifestations of his so-dubbed "science fiction expressionism." Anselm Reyle (b.1970, Tübingen, Germany) has spoken of his rebellion against good taste, which he frames as an Oedipal act against his parents, particularly his mother, who painted abstractly in the then-modish style of mid-century *tachiste* painters such as Antoni Tàpies and Emil Schumacher. Known for his subversion of modernist formalism, Reyle produces lavishly oversized, shiny, bright paintings composed of abstract stripes and silver foil, as well as mixed-media sculptures, neon installations, and paintings alluding to other bad art: a recent example of the latter depicted a forlorn Yorkshire terrier, in a reference to Jeff Koons's (b.1955, York, PA) (p.86) giant topiary, *Puppy* (1992). Then there is "The Museum of Bad Art," founded in 1994, which collects amateur art for showcasing both online and in its Boston galleries: the criteria for inclusion is that these works have "a special quality that sets them apart in one way or another from the merely incompetent."

2.13

2.14

2.15

2.16 The title originally derives from a show, "Bad Painting," curated by Marcia Tucker, founder of the New Museum, New York, and was more recently revived in the 2008 exhibition "Bad Painting, Good Art," held at the Museum of Modern Art in Vienna, which brought together over twenty artists, including Francis Picabia, Magritte, and Asger Jorn, who had rejected the notion of good taste decades earlier. In 1978 Tucker argued that despite the name it was, in fact, good painting that thwarted conventional taste, through its mixing of high and low references and preference for irreverent content. When juxtaposed with orthodox ideas—whether traditional Western values or the more immediate classicizing tendencies of Minimalism—the work stopped short of implicating them; it was faux-naïve, but neither subservient nor deliberately bad (like Oehlen's efforts at aping Expressionism, or Krebber and Armleder's broader assaults), and implied the freedom to dismantle traditional systems of value through taking up a disparaged style.

Objects under consideration for qualification as "bad painting" are not consistent in type, as the terms—kitsch, vernacular, amateur—and their application change over time and even within a single milieu. Mutability of taste—bad bad paintings as opposed to good bad paintings—became the **2.17** subject of Jim Shaw's (b.1952, Midland, MI) "Thrift Store Paintings," a curatorial project-cum-artwork begun in 1990, which championed the outmoded. Shaw scoured flea markets and junk stores for paintings admissible to his ersatz pantheon of art. Already rejected—hence their being lost to second-hand stores and yard sales—these paintings reveal the ephemeral predilections of American middle-class taste, and painting as folk art. While Shaw, a consummate insider, has also faked his own thrift-store paintings, most of his specimens were made without awareness of the modernism his collection explicitly set out to question.

2.18 The American artist Mike Kelley (1954–2012) also displayed an irreverence that grew in fervor without disqualifying sincerity. Eschewing easy condescension, Kelley preserved the meaning of the abject, outdated, or discarded, using figurines and mass cultural materials that referenced his blue-collar Detroit childhood. Shaw, a friend of Kelley's who was also a member of the 1970s band Destroy All Monsters (with Kelley, the group comprised another University of Michigan art student, Lynn Rovner, and filmmaker Cary Loren), made his own down-market excursions for cast-off stuffed animals and handmade afghans to populate Kelley's found-object assemblages. Although much of his work was in the form of performances, installations, and films, Kelley returned many times to monochrome painting. His *Timeless Paintings* (1995) reveal an interest in mid-century imagery, which he extended a decade later

in a further instance of his assault on the banal brutalities of family life and the social landscape. A 2009 show at Gagosian Gallery, New York, called "Horizontal Tracking Shots," comprised large, multi-part polychromatic panels that evoke television color bars while also assuming the look and function of a stage set: from behind the façade of one freestanding panel, three monitors alternated monochrome screens with videos depicting ungainly and often merciless childhood scenes found on YouTube.

Kelley staged his challenge on normative values from inside the system, in order to provide bad painting with its legitimacy and assumed integrity. The same can be said of Carroll Dunham (b.1949, New Haven, CT), whose work—from **2.19** early cartoon-like paintings on wood veneer to later raunchy compositions of figures with phallic noses and gaping orifices—contrasts the cloying colors of pop with the abjectness of their subjects. Also engaged in the politics of representation, Los Angeles-based Tala Madani (b.1981, Tehran, Iran) paints **2.20** luscious canvases depicting hirsute, barely clad men who objectify themselves and each other and engage in rituals of torture and idolatry. But there are plenty of artists working in local traditions, who have not been assimilated into a "global" art system—the kinds of artists Calderón employed to paint his pictures (p.33), or whom Shaw discovered after they were lost. If bad painting is good painting so long as the viewer knows that the artist knows the difference, what happens in cases where the artist's attitude cannot be presumed?

For one thing, although so many of the artists discussed above deliberately hamper their facility, skill—based on learning particular ways of thinking and making—is still taught and prized. The recurrence of style can serve other functions, chief among them to cater to an international market through highly motivated uses of past techniques. The US-based artist Tsherin Sherpa **2.21** (b.1968, Kathmandu, Nepal) studied traditional *thangka* painting under the guidance of his father, Master Urgen Dorje, a renowned artist from Ngyalam, Tibet. Although he later painted monastery murals in Nepal, Sherpa's work now depicts less obvious subjects given this pedigree: spirits transplanted to new-age Buddhist centers in California. In contrast, Dedron (b.1976, Lhasa, **2.22** Tibet), remains in Lhasa, where she was born and trained, and preserves the structure and sometimes the iconography of traditional Tibetan art while rejecting its aesthetics, which she revises according to modernist principles.

Through an inventive approach to the calligraphy in which he was classically trained, and experimentation with contemporary graphic design, Mohammad Ehsai (b.1939, Ghazvin, Iran) manipulates Islamic texts and script into visual **2.23** motifs that resonate with Shi'i symbolism and Western abstraction: notations

2.24 can turn into a dense and almost illegible thicket of form. For Shahzia Sikander also (b.1969, Lahore, Pakistan), the stylized, highly technical Indian and Persian miniature painting that formed the basis of her studies at the National College of Arts in Lahore, Pakistan—a school founded in the nineteenth century by Lockwood Kipling, father of *The Jungle Book* author Rudyard Kipling, to train local artists—provides the foundation for her work, which juxtaposes Hindu and Muslim iconography, and has included performances exploring issues of cultural stereotypes and dislocation. (One such piece entailed Sikander wearing a veil in public, something that she did not do prior to living in the US.) In her paintings, murals, digital animations, and installations—like that exhibited in the 2013 Sharjah Biennial in the United Arab Emirates, based on the silhouettes formed by the stylized hairstyle of worshippers of the Hindu god Krishna—Sikander emphasizes the effects of larger ideological structures, whether the imperial legacy bequeathed to a region or the inherited history of an art form. Similarly self-referential

2.25 in his use of traditional paper scrolls, Ha Manh Thang (b.1980, Thai Nguyen, Vietnam) depicts himself and his girlfriend on Vietnamese chairs, but wearing sunglasses and with cosmetic bottles arranged behind her.

2.26 Lest this wielding of skill as a mechanism for critiquing traditional cultural values is seen as only happening outside the West, Lisa Yuskavage (b.1962, Philadelphia, PA), John Currin (b.1962, Boulder, CO), and Will Cotton (b.1965, Melrose, MA) are similarly invested in upholding painting as a site of expertise for other ends. Though capable of painting photo-realistically, they tend to distort reality, mixing technical facility with risqué subject matter. But their facility in creating compositions, modeling forms, building up glazes, or varnishing a surface confuses when used to depict figures with bulbous protrusions, nudes fondling one another, or sugary landscapes, and raises the question, also broached by Shaw and Kelley, Dunham and Madani, of whether transgressions of taste are more disturbing than sexual deviation.

Yuskavage's coupling of technical mastery with anatomical boldness results in pneumatic female nudes, who despite their over-developed breasts and swollen abdomens, resemble pubescent, doe-eyed children. Carefree in their self-absorption—so total that they grope themselves unselfconsciously or spread their legs with abandon—her characters populate homey interiors or quixotic theatrical landscapes. But for all Yuskavage's attention to detail, the scenes do not proffer resolved narratives, perhaps tempting viewers to impose their own moral judgment. Implicit in her portrayals is the issue of whether making women available to the gaze promotes lasciviousness, and whether we, as spectator, become complicit in this process, which might more accurately be

2.19

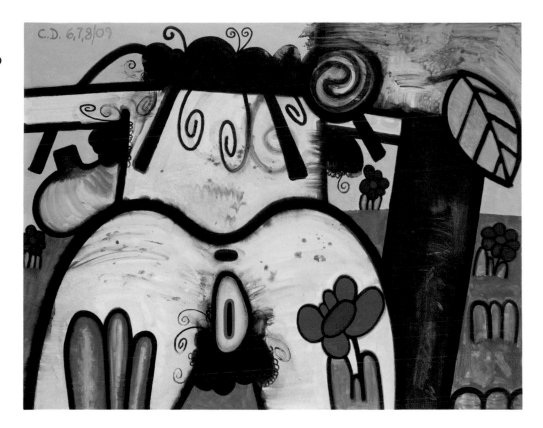

Carroll Dunham
(Hers) Night and Day #1, 2009
Acrylic on canvas, 129.5 × 167.6 cm
(51 × 66 in.); framed 136.5 × 174.6 cm
(53¾ × 68¾ in.)

2.20

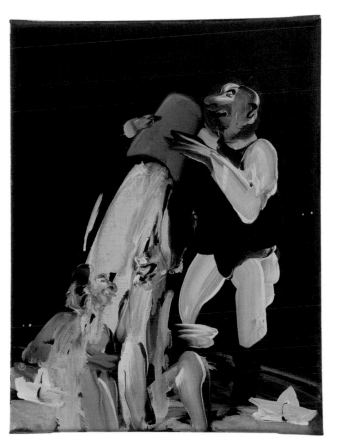

Tala Madani
Waterworld, 2008
Oil on canvas, 40.6 × 30.5 cm
(16 × 12 in.)

2.21

Tsherin Sherpa
Peace Out, 2013
Gold leaf, acrylic, and ink on paper
56 × 56 cm (22 × 22 in.)

2.22

Dedron
Down Below the Snow Mountain, 2009
Mineral pigments on Tibetan paper
54 × 38 cm (21 × 15 in.)

2.23

Mohammad Ehsai
Loving Whisper, 1973–2008, 2008
Oil on canvas, 300 × 184.5 cm
(118⅛ × 72⅝ in.)

described as embarrassment in relation to bodily ideals. Her figures could also be seen in relation to the long history of representation of the female figure in art, so often stereotyped as saint or sinner, goddess or witch.

Yuskavage's classmate at Yale University, John Currin, shares her sympathy for the misshapen physiognomy that has become her trademark, though his strangely proportioned figures are more obviously deformed by a skewed formalism—the attempt to draw badly but paint perfectly—rather than just a cruel act of nature. This is despite his use of live models to flesh out scenes taken from pin-ups, mid-century films, stock photo catalogs, and Internet porn sites. His early works—anodyne yearbook-style faces that double as veiled self-portraits, sick girls languishing in bed, women with water-balloon breasts barely contained by tight sweaters, posing with or without significantly older male companions—raised objections which have been partly quelled by Currin's mastery of paint and flaunting of art historical sources: Old Master and Mannerist works were particularly important, as were those by Gustave Courbet and Norman Rockwell, among countless others.

Currin's first show in 1992 elicited a now-infamous review in the *Village Voice*, urging readers to boycott it on account of its sexism. His exhibition at Gagosian Gallery, New York, in 2006, only furthered the cause when he titled several scenes of group intercourse after Northern European cities— Rotterdam, Copenhagen, Malmö—designating the nationality of the nudes. He has since pulled back from these prurient fantasies. As with some of his paintings from the late 1990s and early 2000s, which depict such subjects as women preparing a Thanksgiving turkey and men making pasta, he has revisited the theme of bourgeois satire.

Although in 2009 Will Cotton produced a number of paintings based on Thomas Cole's epic cycle of allegorical landscapes, *The Course of Empire* (1833– 36), his work has tended to trumpet a kind of amorality unburdened by affairs of state. In 1996 he built an arrangement of foodstuffs in his studio, from which he constructed excessive painted worlds of molten chocolate, mountains of cake, peppermint hedges, and lollipop trees, then conflated this cornucopia of gastronomic desire with other fleshly pleasures by introducing lanky female models, sometimes posing supine, like languid salon nudes, on cotton-candy clouds. Because the items decay so quickly, Cotton bases his works on digital videos of maquettes. More recently, he has expanded this culinary conceit, fusing notions of gastronomic and aesthetic taste further by producing saccharine portraits of women wearing meringue and other candy headdresses. Cotton names the pop singer Katy Perry as a muse, for whom he

illustrated the 2010 album *Teenage Dream*, and also served as artistic director for her music video, *California Gurls*.

A "let them eat cake" mentality pervades this work and aids its circulation as a luxury good that gains credibility through association with pop, while at the same time presenting itself as a sophisticated articulation of this same consumer world. In one sense innocuous, even a guilty pleasure, the candy-land paintings have come to represent unapologetic frivolity. Though **2.29** in comparison to the schlocky opulence of Jeff Koons's seventeen sculptures scattered around the lavish rooms and gardens of the Château de Versailles in 2008—such as an aluminum red lobster hanging alongside a crystal chandelier in the Mars Salon—Cotton's "bad" paintings are decidedly circumspect.

Questions of intent, however, registered differently after the collapse of the financial market, leaving some artists as casualties. As curator Paul Schimmel proposed in relation to the 2007 sale at Sotheby's, New York, of *White Canoe* (1990–91) by Peter Doig (b.1959, Edinburgh, UK) for $11.3 million (the then-auction record for a living European artist). Doig—known for his dreamlike landscapes that appear suspended in time, and figurative scenes that often dissolve into abstract motifs—went from being "a hero to other painters to a poster child of the excesses of the market." In this climate, whether the artist meant to appeal to the market or not was a matter of some importance. For instead of a government, corporation, or even an individual agent, the market itself has now become the prime target, albeit a moving one. Consequently, questions of psychological depth and sincerity still attend discussions of intention as much as finished artworks. To cite just one notable example, **2.30** the writing around the British artist Merlin James (b.1960, Cardiff, UK), known for his historical-genre paintings that frequently picture domestic architecture and flotsam from the past, turns on the matter of attitude. Is the work a return to a shop-worn humanism or an ironic critique of this very tradition?

The distinction between humanism and critique matters because irony positions many artists as "critical," in opposition to the market and its excesses, meaning that irony becomes an act of earnestness and protest—chiefly against offering trifles to the idle rich, or the one per cent, to use the language of the Occupy movement. (Labor issues within the art world proper are also significant concerns for artists, through organizations such as the Occupy Arts & Labor group and Working Artists and the Greater Economy [W.A.G.E.].) This applies regardless of artists' potential or actual commercial

2.24

Shahzia Sikander
Pleasure Pillars, 2001
Vegetable color, dry pigment,
watercolor, ink, and tea on wasli paper
30.5 × 25.4 cm (12 × 10 in.)

Ha Manh Thang
Artist and Artist's Girlfriend, 2007 (detail of diptypch)
Acrylic and collage on paper scroll
255 × 83 cm (100⅜ × 32¹¹⁄₁₆ in.)

Lisa Yuskavage
Pie Face, 2008
Oil on linen, 121.9 × 102.2 × 5.1 cm
(48 × 40¼ × 2 in.)

2.26

2.27

John Currin
Hot Pants, 2010
Oil on canvas, 198.1 × 152.4 cm
(78 × 60 in.)

2.28

Will Cotton
Cotton Candy Cloud, 2004
Oil on linen, 190.5 × 254 cm
(75 × 100 in.)

2.29

Jeff Koons
Lobster, 2003
Polychromed aluminum, coated steel chain,
147 × 94 × 43.5 cm (57⅞ × 37 × 17⅛ in.)

Merlin James
Two Poplar Trees, 2009–11
Acrylic on canvas, 57.5 × 90.5 cm
(22⅝ × 35⅝ in.)

2.30

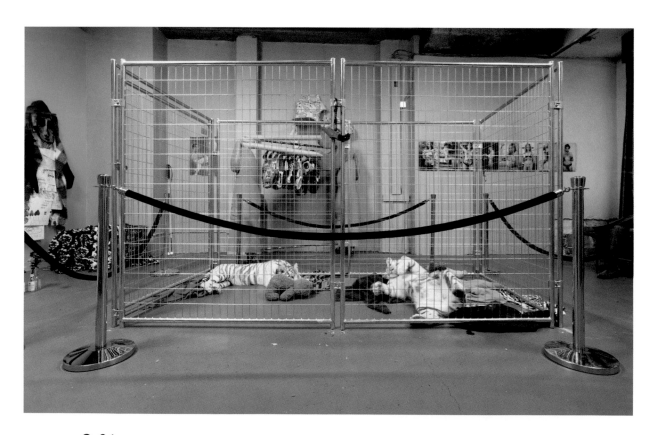

2.31

Bjarne Melgaard
Installation view of "IDEAL POLE.
Repetition Compulsion
by Bjarne Melgaard,"
Ramiken Crucible, New York, 2012

success, and one might well take an oppositional stance out of an entrepreneurial motive. To the point of taboo-breaking publicity stunts, witness the brutal, expressive paintings and installation works of Bjarne Melgaard (b.1967, Sydney, Australia), such as those in his "IDEAL POLE" show at Ramiken Crucible, New York, in 2012, which contained live tiger cubs and art made by psychiatric patients at Bellevue Hospital, to say nothing of his polyvinyl sculpture of a contorted black woman under a chair, photographed for public consumption with Russian collector Dasha Zhukova gamely perched atop. Hence, rather than autonomy from the market or culture industry, what matters here is securing a platform from which to reroute imagery and meaning, as we will now consider.

2.31

3

Production and Distribution

That people make art and send it into the world is unremarkable. Yet the changing nature of how art is produced, exhibited, and sold is a central issue, especially given an international market needing to stock galleries and fill biennials. Some artists welcome the behemoth that is the art-industrial complex, exploiting its potential for large-scale fabrication and vast channels of dissemination; others resist its demands, citing a system that sees paintings as commodities as the basis of a critique that often takes the form of deliberate exacerbation or ceased production. A notable example of this phenomenon might be David Hammons (b.1943, Springfield, IL), who for his *Bliz-aard Ball Sale* (1983) notoriously set up shop as a street vendor in downtown Manhattan, selling fast-melting snowballs priced according to size. At the other end of the spectrum, Alexander Vinogradov (b.1963, Moscow, USSR) and Vladimir Dubossarsky (b.1964, Moscow, USSR) toiled on an "endless painting," a madcap conjunction of subjects drawn from Socialist Realism and consumer culture, which slip from one to the other. All artists raise questions in different formats about prevailing market conditions and audience experience.

3.1

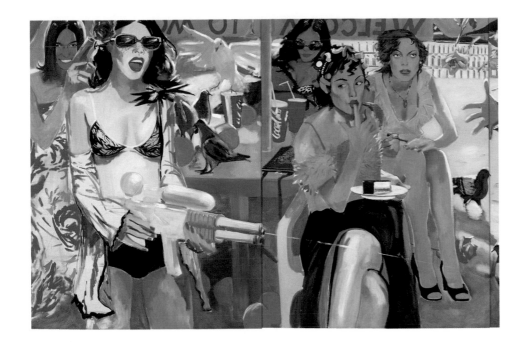

**Alexander Vinogradov
and Vladimir Dubossarsky**
Installation view of
Our Best World, 2003

3.1

3.2

Olivier Mosset
Installation view of *Untitled* (2010)
at Leo Koenig Gallery, New York, 2011
Polyurethane on canvas, forty parts,
each 121.9 × 121.9 cm (48 × 48 in.)

3.3

Nyoman Masriadi
Masriadi Presents–
Attack From Website, 2009
Acrylic on canvas, 200 × 300 cm
(78¾ × 118¼ in.)

3.4

Damien Hirst
Ferrocene, 2008
Household gloss on canvas
(4-inch spot), 91.4 × 132.1 cm
(36 × 52 in.)

94

Something of a stalwart, Olivier Mosset (b.1944, Bern, Switzerland) has
remained committed to questioning painting as a compromised entity by
continuing to paint. Through his affiliation with B.M.P.T., a group of
conceptually driven painters formed in Paris in the 1960s, Mosset and his
peers—Daniel Buren, Michel Parmentier, and Niele Toroni (their initials are
reflected in the collective acronym)—sought to democratize art and defy
modernist ideas of authorship and the value of originality (see pp.69–76) by
signing each other's works and repeating compositions. Since then, Mosset has
turned to monochrome works on shaped canvases, which implicitly comment
on circuits of production and exchange. A show at Leo Koenig Gallery, New
York, in 2011, brought together forty identically sized black paintings arranged
in a grid. Coated with a rubberized polymer commonly used for truck-bed
linings, the canvases absorbed and reflected light, depending on the place
of viewing. More to the point, Mosset related these works to the black hole
of the art market, which sucks in everything around it.

Damien Hirst (b.1965, Bristol, UK), on the other hand, embraces the market
and affirms its potential as a medium in itself. He has remained at the
pinnacle of Brit-art notoriety since the debut of *The Physical Impossibility
of Death in the Mind of Someone Living* (1991), a tiger shark embalmed in a
minimalist cube of formaldehyde. The work was widely parodied at the time
by the Stuckists, an international group founded to promote figurative art
(they called fraud on the shark, noting that Eddie Saunders exhibited a
preserved shark on a wall in his J. D. Electrical Supplies shop in London in
1989), and still provokes hostility, such as that expressed by the keen social
observer I. Nyoman Masriadi (b.1973, Gianyar, Bali). Known for painting
black-skinned figures with savage acuity, Masriadi portrayed Hirst's shark
emerging from a digital file, as an object of scorn.

As a way of reclaiming opposition to his work, Hirst created an extravagantly
priced, diamond-encrusted human skull, *For the Love of God* (2007), which
became an instant icon of the artist's hubris as well as a sign of the times.
In September 2008, in an event entitled "Beautiful Inside My Head Forever"
held at Sotheby's, London, Hirst auctioned off 223 works finished within
the previous two years, for an astonishing two hundred million dollars. The
artist's staging of the sale was a watershed, made even more remarkable by
unforeseen circumstances—by chance, the event coincided with the collapse
of world financial markets—and was also notable for its management: sending
collection highlights to outposts such as the Hamptons and New Delhi, and
posting videos on YouTube, in a bid to bypass dealers and bring the work
directly to the sales floor.

3.4 Despite the fact that Hirst had long outsourced the assembly of his work and had been frank about his procedures (even commending his most skilled employees), his brazen profiteering provoked fresh opprobrium. This inevitably affected the 2012 installation of his "Spot Paintings" at Gagosian Gallery venues in New York, London, Paris, Athens, Hong Kong, Beverly Hills, Rome, and Geneva, which remain a conspicuous illustration of Hirst works manufactured in his absence (he has since left the gallery). Moreover, the event seemed to confirm that a 2009 exhibition of still lifes and landscapes that he painted entirely himself, mounted first at the Pinchuk Art Foundation in Kiev, and then the Wallace Collection, London, was a bid for atonement. Soon after, plans emerged detailing the contents of Hirst's massive new atelier in Dudbridge, Gloucestershire: a pickling plant for the animals destined for his sculptures and an on-site gallery to show his wares to prospective buyers. Hirst also redesigned his website in 2012, to include live footage of his team making new art during business hours.

3.5 Though extreme, Hirst is representative of much contemporary practice in his use of assistants to produce his paintings. Few artists manufacture their own work from start to finish, and many employ others—commonly, other artists who need day jobs—to stretch, prepare, or even execute canvases according to the artist's directions, and to manage their studios. However, even in this context, the example of Takashi Murakami (b.1962, Tokyo, Japan), who has created an entire corporation with a global phalanx of assistants to maintain his brand identity—a hyper-stylized mix of traditional *nihonga* painting, modern pop, contemporary *anime* (animation), and *manga* (comic books)—is noteworthy. As Murakami narrated:

> At the time [after founding Hiropon Factory in 1996], the "factory" was nothing more than a small workshop-like group of people assisting me with my sculptures and paintings.... As I took on new projects, the scale of my production grew, and by 2001, when I had a solo show at the Museum of Contemporary Art, Tokyo, the Hiropon Factory had grown into a professional art production and management organization. That same year I registered the company officially as "Kaikai Kiki Co., Ltd." To this day it has developed into an internationally recognized, large-scale art production and artist management corporation, employing over 100 people in its offices, studios, and gallery spaces in Tokyo, Saitama, and Long Island City, New York, as well as an animation studio in Hokkaido and an upcoming gallery space in Taipei, Taiwan.

3.6 Through Kaikai Kiki, Murakami also manages the careers of younger artists (like Aya Takano [b.1976, Saitama, Japan], who re-imagines 1970s *shōjo manga*

[girls' comics] and their fantasies of release from social burdens in the context of the contemporary city), curates exhibitions promoting Japanese art, and mounts an art fair in Tokyo named GEISAI. One lavish installment of GEISAI, in 2008, occurred the very day before the Hirst sale took place and the bubble burst; subsequent iterations have been constrained by more modest budgets.

Murakami's 2007–8 retrospective "©MURAKAMI," at the Los Angeles Museum of Contemporary Art, and the Brooklyn Museum, New York, housed within the exhibition space a functional Louis Vuitton boutique selling handbags and merchandise emblazoned with logos, which the artist redesigned for the luxury-goods company: jellyfish eyes, red cherry clusters, or cherry blossoms alternated with the requisite "LV" in limited-edition patterns commissioned by the fashion designer Marc Jacobs appeared on accessories and wall panels, stretched like paintings. Lower-ticket items, such as cheerful flower-head plush toys, pillows, and eraser heads were available in the gift shop, while figurines and diminutive Kaikai Kiki goods in display cases were included in the curatorial content. This blurring of art and commerce led critics to damn the concept for apparently mocking high culture, or, more favorably, to compare Murakami's wide range of goods to the painted screens, ceramics, and lacquer boxes that Japanese artists historically held in high esteem and often turned out alongside their art.

Murakami is hardly alone in targeting a wide range of consumers through products of different prices, or in embracing fashion as such. His merchandise could be seen as an extension of the Bauhaus philosophy, though he has gone further in expanding the definition of design. Moreover, his collaboration with Louis Vuitton is not unique (the company's runway show of spring 2008 featured supermodels dressed as nurses from Richard Prince paintings, while sporting purses emblazoned with the paint streaks and cartoon vignettes that feature in the American artist's joke works). Yet, like Hirst, Murakami's engagement with commercial enterprise is so vast and self-reflexive that it also conveys the more ubiquitous practice, undertaken by many artists, of issuing editions and maquettes, and of selling small panels and preparatory drawings to collectors newly entering the market.

3.7

Recognizing the role of his work within these broader economies, Kehinde Wiley (b.1977, Los Angeles, CA) lent a painting to Art Production Fund's 2011 collaboration with New York City taxicabs, for use as advertising on their vehicles. In the vein of Murakami, Wiley keeps studios around the world—the US, China, and Senegal—and has produced his signature three-quarter-length

3.8

portraits of young men for corporate clients. As an illustration of the workings of the global network, Wiley, who began by depicting track-suit-wearing African-American men he encountered on the street in poses adopted from European paintings, has embarked on an ongoing series, *The World Stage*, which incorporates youth from Nigeria, Senegal, Brazil, China, India, Sri Lanka, and Israel. This move, from using his primary surroundings as his source of subject matter and site of production to using sitters from different continents and making paintings in multiple locations, is telling. Although Wiley attends to skin color and local details of costume and background (for example, his China paintings reference propaganda posters from the Cultural Revolution, and his Israeli subjects—Ethiopian and native-born Jews and Arab Israelis—are encircled by intricate patterns inspired by folk paper-cuts and ceremonial art), the result of his systematic approach across subject matter is one of sameness rather than difference.

3.9 Acknowledging the global purview of his work and the exhibition sites where his lavishly scaled creations are installed, Subodh Gupta (b.1964, Khagaul, India) has remarked: "Art language is the same all over the world. Which allows me to be anywhere." His work supports this truism, despite the fact that his imagery explores economic transformations taking place specifically in India. Using vernacular materials—steel tiffin lunchboxes, bicycles, and milk pails—to erect massive sculptures such as *Line of Control* (2008), a mushroom cloud assembled out of kitchen silverware, Gupta insists upon the specific markers of place and custom while simultaneously promoting them in the wider sphere. His early paintings explored ideas of migration and return through imagery of luggage, jerry-rigged parcels, and travelers mid-transport; more recent paintings show a culture in thrall to consumerism, as in his fetishistic photorealistic paintings of kitchen utensils, which depict it as both mundane and aspirational.

3.10 If, like Wiley, Gupta registers globalization symptomatically, he also exploits it, pointing to the nexus of interests epitomized by the Dafancun Oil Painting Village, a Chinese town in Guangdong, lying just outside the Shenzheng Special Economic Zone. In the space of a few blocks, hundreds of galleries sell paintings produced by artists in the region, some of whom have trained in academies. Representing all manner of genres and subjects, the paintings are hung salon-style, cheek-by-jowl, in a retail environment that also employs artists to supply bulk orders for hotels, cruise ships, and offices. Although local expertise in copying Western and Chinese styles has contributed to tourism, the artists also produce paintings to order, commonly from Jpeg images, which are then shipped across the world as oil on canvas.

3.5

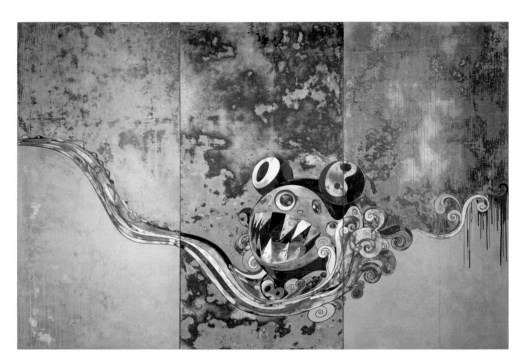

Takashi Murakami
727–727, 2006
Acrylic on canvas
mounted on board, three
panels: overall dimensions
300 × 450 × 7 cm
(118⅛ × 177³⁄₁₆ × 2¾ in.)

3.6

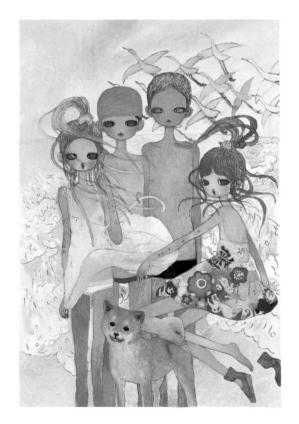

Aya Takano
All Was Light, 2012
Oil on canvas, 194 × 130 cm
(76⅜ × 51 in.)

3.7

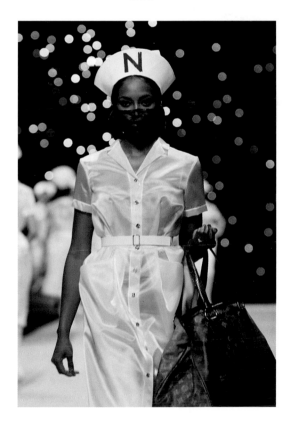

Richard Prince and Louis Vuitton
Photograph from the runway show
"Nurses," 2008

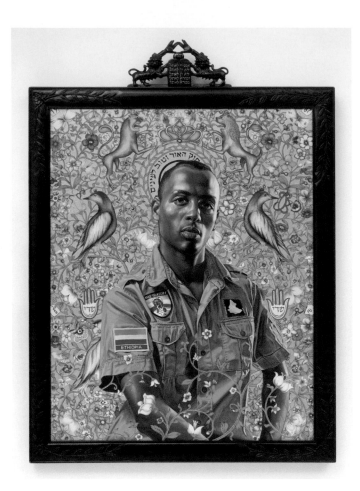

3.8

Kehinde Wiley
Kalkidan Mashasha, 2011
Oil and gold enamel on canvas
114.3 × 91.4 cm (45 × 36 in.)

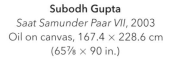

3.9

Subodh Gupta
Saat Samunder Paar VII, 2003
Oil on canvas, 167.4 × 228.6 cm
(65⅞ × 90 in.)

Dafancun has prompted commentary in the form of other projects that take the place, its organization, and its labor practices, as their subject. For example, for the Second Guangzhou Triennial in 2005, Liu Ding (b.1976, Changzhou, China) raised the question of exploitation in the Pearl River Delta, the event's regional focus. Liu hired thirteen painters from Dafancun to copy a factory sample of a landscape with a rose sky, waterfall, and pair of cranes, during a four-hour performance. With easels and folding chairs arranged in rows on a tiered platform before a live audience, the artists painted for a standard factory wage, setting out to make as many copies as possible in the allotted time. Liu later showed the paintings (which remained in various states of finish), set in uniform gold frames, in a mock nineteenth-century European interior at L.A. Galerie, Frankfurt. In repeating the same banal image, the artists promulgated stereotypes of workers toiling in post-Mao China, while hinting at the opportunity for social advancement their display of aesthetic refinement offered them. The project underscores the lingering exoticism that still colors mutual perceptions of China and the West, and highlights the mutability of the images' value, especially when transposed to a German gallery replete with upholstered furniture to assist contemplation.

3.11
3.12

Liu's *Store*, started in 2008, takes this approach further, asking what the role of the artist is in the new global economy. An ongoing project that explores systems of valuation under advanced capitalism, *Store* is both an online outlet for selling work sorted according to product lines and a platform for organizing events. "Take Home and Make Real the Priceless in Your Heart" consists of a series of landscape paintings custom-made in a factory, but signed by the artist to ensure their symbolic, if not actual, value. By contrast, everything in "The Utopian Future of Art, Our Reality"—a group of thematically linked objects, products, and works of art—levels the differences between its members, with items priced equally within a given theme.

China Painters (2007/2008), by Christian Jankowski (b.1968, Göttingen, Germany), began in the province before traveling to New York, Vienna, Stuttgart, and lastly Guangzhou for the eponymous Triennial. Jankowski asked Dafancun painters which works they would most like to see in the nearby state-run museum, a modernist shell then under construction by architects who were unaware of what kind of art the building would later house. Their paintings of the museum interior, with "fantasy" art works gracing the as-yet unfinished walls, extended from seventeenth-century Dutch still lifes of flower arrangements to history paintings, including Delacroix's *Liberty Leading the People* (1830), in addition to family portraits and nudes. Although Jankowski includes the artists' signatures on the backs of the canvases—an important

3.13

aspect given the painters' designation as artisans—his authoring of the project is paramount, which, as with Liu, depends on appropriation of the Chinese painters working on the project, despite the authorial role they inhabit within it. For his ensuing project, for the 2011 Frieze Art Fair in London, Jankowski presented *The Finest Art on Water*, a collaboration with a luxury yacht company in which he offered for sale two full-size, functional boats, described as "Jankowski" originals—objects transformed into art at the moment of purchase, provided the buyer opted to buy it as an artwork (and at a higher price) rather than as a vessel.

These instances also point to the ways in which large-scale exhibitions encourage through commissions event-like, multimedia, and collaborative projects and solicit site-specific interventions that take not only the architecture, but also the cultural, geopolitical, and commercial contexts surrounding specific objects and installations into account. Ragnar

3.14 Kjartansson (b.1976, Reykjavik, Iceland) is noteworthy for his understanding of the biennial as a vehicle. Like Liu, he proposed a project in which paintings would be made before an audience, but, unlike Liu, the project encompassed the duration of the show, therefore effectively marking the passage of time through the paintings. For *The End*, performed during the 53rd Venice Biennale in 2009, Kjartansson spent six months inside the fourteenth-century Palazzo Michiel dal Brusa on the Grand Canal, making easel paintings of the artist Páll Haukur Björnsson in a Speedo swimsuit, drinking beer and smoking cigarettes. Kjartansson paired this tableau vivant with a video projection inspired by a Caspar David Friedrich painting, depicting two men gazing in rapture at the moon—a paean to friendship and the sublime possibilities of representation. Unlike the Romantic vision proposed by Friedrich, however, *The End* resulted in a space littered by studio debris, including the paintings, which Kjartansson conceived of not as autonomous panels, but props (a strategy further discussed below, pp.175–77).

3.15 When the measure is time and the goal is to accumulate pictures, quantity rather than quality rules. The American artist Josh Smith (b.1976, Knoxville, TE) exploits the possibility of exhaustion through excess, churning out prodigious numbers of artworks based on his name used as an abstract, formal trope, and, more recently, figurative elements including fish, insects, skeletons, and leaves. Smith has admitted to completing the work for a show in a week, but, more generally, his output exposes the profligacy and unhampered possibilities of contemporary production.

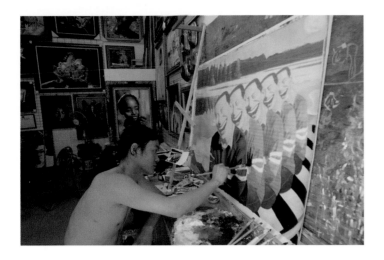

A painter at work in
Dafancun Oil Painting Village

3.10

3.11

Liu Ding
*Samples from the Transition–
Products*, Part 1, 2005–6
Oil on canvas, forty paintings,
each 60 × 90 cm (23⅝ × 35⁷⁄₁₆ in.),
painted by thirteen painters from
Dafancun Village/Shenzheng/China
at the 2nd Guangzhou Triennial,
Guangdong Museum of Art,
18 November 2005, 3pm to 7pm

3.12

Liu Ding
*Samples from the Transition–
Products*, Part 2, 2005–6
Traditional living-room furniture
and forty paintings in gilded frames,
each 69 × 99.5 cm (27³⁄₁₆ × 39³⁄₁₆ in.)

3.13

Christian Jankowski
China Painters (Still Life), 2008
Oil on canvas, 224.4 × 315 cm
(88⅜ × 124 in.)

3.14

Ragnar Kjartansson
The End–Venice, 2009
Six-month performance during the
2009 Venice Biennale, during which
144 paintings were made

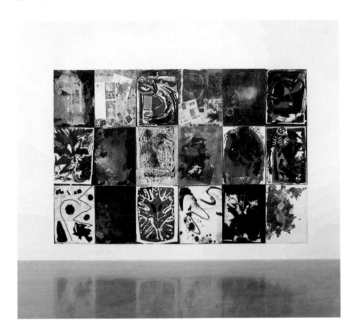

Josh Smith
Installation view of *Large Collage
(New Museum)* (2009) at the
New Museum, New York, 2009
18 mixed-media collages on panel,
each 152.4 × 121.9 cm (60 × 48 in.)

Josef Strau
What Should One Do, 2011
Floor lamp and painting
with metal chains and rings, canvas
76.2 × 101.6 cm (30 × 40 in.),
lamp height 152.4 cm (60 in.)

Aaron Young
Performance at the Park Avenue Armory,
New York, 2007, for *Greeting Card (Armory,
quadriptych)*, dimensions variable

3.17

3.19 **Kerstin Brätsch and Adele Röder**
Installation view of *DAS INSTITUT–D I
WHY?*, Swiss Institute, New York, 2009

3.18

Seth Price
Untitled, 2008–9, from
the *Vintage Bomber* series
Autobody enamel on vacuum-formed
high impact polystyrene
243.8 × 121.9 cm (96 × 48 in.)

Michel Majerus
Installation view of *if we are dead, so it is*
(2000) at Kunstmuseum Stuttgart, 2011
Digital print, multiplex, acrylic paint,
lacquer, and wood, 300 × 992 × 4200 cm
(118⅛ × 390⁹⁄₁₆ × 1653⁹⁄₁₆ in.)

3.20

Smith's project imitates its context, commonly the commercial gallery and its seasonal sales cycles. For his first solo exhibition in New York, "Abstraction," at Luhring Augustine in 2007, Smith hung paintings in standard sizes that determined pricing: large gestural compositions featuring the repetition of letters, and smaller palette paintings of the color fields left behind after using the board for completing other paintings. He also switched paintings and reconfigured the installation with new works, some painted midway through the show. This challenged the viewer to remember differences between similar canvases and ask why they should matter. For, despite repetition of certain features, the works contained variations that reflected Smith's background as a printmaker. His collages of printed images of previous works, sometimes downloaded from his own website, interrogate art as an iterative process, hypothetically without end.

Subverting the idea that production of cultural goods is automatically uncritical, Josef Strau (b.1957, Vienna, Austria), an artist, curator, gallerist, and writer now based in Berlin, has questioned what he names the "non-productive" attitude. His catalog essay for the 2006 exhibition at the Institute of Contemporary Art, University of Pennsylvania, "Make Your Own Life: Artists In and Out of Cologne," challenged the Cologne scene of the 1980s and 90s examined earlier (pp.70–75), within which interruptions in production were understood as institutional critique and a refusal to undergo commercial validation. For Strau, turning to sociality and away from object-oriented practice resulted in a "narcissistic cultivation of insignificance and meaningless," which was ultimately recuperated as style. **3.16**

Since closing Galerie Meerrettich, a small space he ran out of a former box office in a Berlin theater from 2002 to 2006, Strau has focused on his writing, found-object sculptures, and paintings, many of which consist of a monochrome ground washed with a dirty white paint that serves as the base for texts penned by himself and others. In this way, his work moves from projects similar to the ones he examines—conversations, performances, ephemeral comings together—to those that assume the form of room-bound objects. He writes:

> I have explained works in economic terms, like I make texts, but I organize a trade system for it, which maintains the practice and writing financially, like transforming flea-market lamps into a system of meaning and narratives and producing financial value through this.

Otherwise conceived, if equally reliant upon the art system, Aaron Young (b.1972, San Francisco, CA) transforms production into spectacle. For the **3.17**

inaugural contemporary art exhibit at the Park Avenue Armory in New York in 2007, Young staged *Greeting Card* with the help of the Art Production Fund. Taking its title from a 1944 Jackson Pollock painting of the same name, Young enlisted a gang of motorcycle riders to act out the gestures of Pollock's action painting. In the enormous, Coliseum-like space of the Armory, hundreds of invited guests, donning gas-masks, looked down on the performance in the central arena: for seven deafening and toxic minutes, the bikes criss-crossed a 72-by-128-foot plywood stage, their lights cutting through the exhaust and darkness. The wheels burned arabesques that revealed layers of fluorescent yellow, pink, orange, and red paint beneath the black surface. In the aftermath, the floor remained intact as an installation before being dismantled and sold as single or multiple tiles, thus following the trajectory of Pollock's paintings from horizontal, floor-bound panels to completed paintings tacked to walls.

Similarly interested in issues of dissemination, New York-based Rudolf Stingel (b.1956, Merano, Italy) (p.59) has employed a variety of strategies to make and circulate his work, such as having viewers trespass on floors which are then cut up and sold as discrete paintings. A longtime painter of commissioned portraits, in his work begun in the 1980s Stingel questioned the fundaments of painting as both a medium and a set of conventions. For example, in 1989 he published an instruction manual for creating an abstract painting. The silkscreen print *Instructions* treats this "how to" process as a composition, showing paint being squeezed from a tube and applied to a support. For his first show in New York in 1991, at Daniel Newburg's SoHo gallery, Stingel covered the entire floor with plush orange carpet, which, in an optical contrast, tinged the walls pink, thereby turning the whole room into a painting. Successive projects have pursued similar aims: formally, with carpets (pink and blue floral motifs appeared at the Walker Art Center in Minneapolis, and even in Vanderbilt Hall in Grand Central Terminal in New York City, while other monochromes that found their way onto the walls began as studio drop-cloths), and theoretically, through viewer involvement (later works comprise wall-mounted silver Celotex insulation boards on which people can leave graffiti-like marks, and Styrofoam "footprint" paintings that register the marks of bodies).

Like other artists already discussed, Stingel maintains his works' materiality, even while asking how a painting, as both image and object, moves through institutional and commercial spaces. This passage also involves conversion by other media, notably the compression of electronic files—the digital products spread through media-sharing and social networking sites. In *Dispersion*,

Hong Seung-Hye
Installation view of
"Organic Geometry," 2000

3.21

3.22

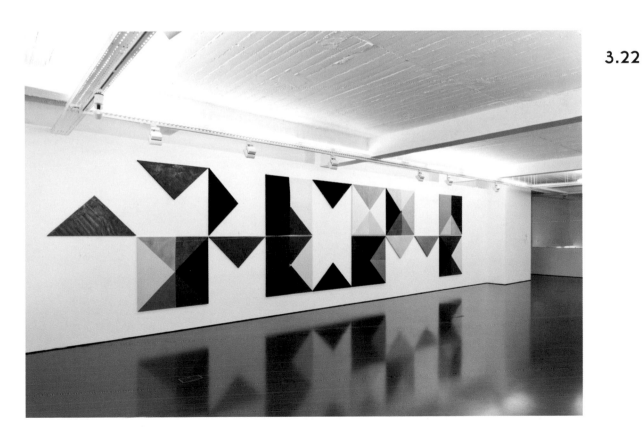

Ana Cardoso
Installation view of
"Program vs. Program," 2012

3.23

Eberhard Havekost
Flatscreen 4, 2010
Oil on canvas, 90 × 60 cm
(35⁷⁄₁₆ × 23⁵⁄₈ in.)

3.24

Tom Moody
sketch_i7a, 2012
Digital painting,
dimensions variable

3.25

Corinne Wasmuht
Brueckenstr., 2008
Oil on wood, 227 × 519 cm
(89³⁄₈ × 204³⁄₈ in.)

an influential manifesto drafted in 2001–2 for the catalog of the Ljubljana Biennial of Graphic Art, later published as an artist's book illustrated with clip-art and posted online as a free download, Seth Price (b.1973, East Jerusalem) discusses the circulation of art by mass-media technologies, which have had an incalculable impact on painting. As Price writes:

> With more and more media readily available through this unruly archive, the task becomes one of packaging, producing, reframing, and distributing; a mode of production analogous not to the creation of material goods, but to the production of social contexts, using existing material.

In this respect, the collaborative performances Price has staged with the art and publishing collective Continuous Project, formed in 2003 with Bettina Funcke, Wade Guyton (pp.47–9, 175), and Joseph Logan, are significant for asserting the indivisible nature of consumption and production. That year they made and distributed photocopied facsimiles of the first issues of the art magazine *Avalanche* (Fall 1970), for *Continuous Project 1, Eau de Cologne* (1985), and *Continuous Project 4*. The collective also stages multi-hour readings of interviews and panel discussions between artists, curators, critics, and dealers, inviting the audience's participation. As much historical re-enactment as an examination of contemporary social space, *Continuous Project* draws attention to the ways in which the content of such events is inseparable from their design.

Price's own appropriated work, which often redistributes pirated music and texts in addition to archival footage and data from the Internet, disrupts the functioning of commodity culture and the information systems on which it depends. While much of Price's work, therefore, avoids any suggestion of permanence, his *Vintage Bomber* pieces—wall-hung polystyrene panels that bear the outline of their namesake bomber jackets—take the idea of ossification literally: garments frozen in form by consumer packaging. Yet his point is that even these works remain mobile, circulated through a constant network of objects, images, and ideas, as well as through their relationship to the legacies of painting, to which they refer most obviously in their wall-bound orientation.

German artists Kerstin Brätsch (b.1969, Hamburg, Germany) and Adele Röder (b.1980, Dresden, Germany) have worked together since 2007 as an import/ export agency known as DAS INSTITUT, and collaborated with groups such as the UNITED BROTHERS (Ei Arakawa and his brother Tomoo Arakawa) for a project at the Kunsthalle Zurich (p.166). While maintaining their own

practices, Brätsch and Röder funnel work back and forth via DAS INSTITUT, importing and exporting files, while also playing with the tools of these systems. Röder's abstract digital motifs, "Starline-Necessary Couture" and "COMCORRÖDER," made with the digital codes of programs like Adobe and Photoshop, serve as patterns for a host of applications, including wearable and non-usable textiles, a digital knitwear collection, dinner napkins, DAS INSTITUT advertisements, books, and Brätsch's paintings on Mylar, which invert and manipulate their sources in the service of the final composition. Further, Röder often uses these alterations in her digital prints. While interrogating presentational conventions across media, the artists also exploit the desire for uniqueness through customized products, including paintings. In an artist statement, Röder exclaims, "MY FORMS BECOME A MANIFESTATION OF YOUR DESIRE." Flexibility becomes an expression of economic and creative boundlessness.

As DAS INSTITUT proposes, transitivity enables activities that are inspired by—and in some cases generated through—software employed as both an instrument and a metaphor. The all-encompassing nature of their work, and the possibility of it becoming a *Gesamtkunstwerk* (a total work of art embracing all others), thus transforms the Internet into a material process. Even before

3.20 this, Michel Majerus (1967–2002) had combined painting and digital media, seeing the manipulability of the latter as a way to reconfigure the former. He also extended the space of his large-scale paintings into the room, making a virtual space tangible, and in 2000 made a functional painting in the form of a skateboard ramp at the Kölnischer Kunstverein. His last project, before his untimely death, involved covering Berlin's Brandenburg Gate with a digital rendering of the Schöneberg Sozialpalast, a 1970s Berlin housing block now marred with graffiti. If the Web offers swift and continual feedback, graffiti similarly tests mechanisms of call and response, and could be considered a forerunner of the digital forum.

3.21 Staying closer to the walls, Hong Seung-Hye (b.1959, Seoul, Korea) uses her computer to design paintings suited to industrial fabrication, such as silk-screened tiles or automotive paint-covered aluminum panels that organize space in their repetitions of pattern. For "Program vs. Program" at Pedro Cera

3.22 Gallery, Lisbon, Ana Cardoso (b.1978, Lisbon, Portugal) installed *Modules HD* (2012), a painting project based on pre-programmed modular elements that suggest the possibility for infinite modification.

As these artists propose, the legacy of post-studio practice intersects with new technologies—alongside media theory, information science, and philosophy

that theorizes them—as the basis for rethinking painting digitally, and generates an expansive field of operations. That said, for many artists, these same conditions aid a return to more traditional forms of painting by means of new technology. Interested in perception and the phenomenology of what one is seeing, Eberhard Havekost (b.1967, Dresden, Germany) calls his recent paintings of gradated color, "user interfaces." Havekost works with color filters and focus effects within digital imaging programs to tamper with photographs (sometimes of flat television screens); but this mock-up stands apart from the paintings themselves, which the artist completes by removing layers of oil paint with turpentine to enhance their materiality. Underscoring that this process is a protest against dematerialization and bodily evacuation, Havekost insists that the "physical act of painting is the prerequisite for feeling one's own body again, not only for the viewer, but also for me."

3.23

The American artist and critic Tom Moody (b. [unlisted], New York, NY), adapts the animated GIFs on his blog for display, and, following a bout of turpentine poisoning and the abandonment of his previously bright, imagistic painting, since the 1990s has made cyber-art with obsolete programs and equipment, such as MSPaintbrush (the earlier version of MSPaint), photocopiers, and consumer printers. Corinne Wasmuht (b.1964, Dortmund, Germany) procures images from the Internet for manipulation via Photoshop, before using them as the basis for multi-layered paintings on wood panel, which in their back-lit intensity—an echo of the computer monitor glow—acknowledge their source. For each "portrait" in Pieter Schoolwerth's (b.1970, St Louis, MO) 2010 series, *Portraits of Paintings*, the artist takes a European painting and compresses its multiple protagonists into a dense mass against a dark ground. In preserving vestiges of the original palette, while organizing his canvases on the basis of a tagging system (where figures, land, water, etc. are amassed by type), he scrambles narratives and blends Old Master oils with contemporary rendering and processing tools.

3.24
3.25
3.26

Working before Web 2.0, Vitaly Komar (b.1943, Moscow, USSR) and Alexander Melamid (b.1945, Moscow, USSR) commissioned polls in eleven countries—Russia, China, France, the US, and Kenya, among them—to determine the most and least wanted paintings for each national constituency. The project is provocative in its exploration of certain forms of populism, and for using an open-source culture ahead of its time, and gains in relevance as artists find ways to exploit the Internet. Harm van den Dorpel (b.1981, Zaandam, The Netherlands), based in Berlin, makes works involving image interference, as well as commissioned images that look painterly online but are printed out, though he is best known for running an online gallery in 2008-9, "Club

3.27

Internet," which offered a stage for emerging artists to share their work. Outmoded by other social media sites, the project nonetheless emphasizes artists' relations to one another. More recently, he has created an online platform for viewing his works, and the means by which he finds and aggregates images as sources for his layered compositions. Posing the question of how an artist might present his work to a public, the New Museum, New York, which hosts van den Dorpel's "Dissociations," an online-only exhibition, further notes that:

> Possibilities run the gamut from the "white cube" aesthetic donned by gallery websites to the more free-form, anarchic expressions of a Tumblr page, or a simple, home-brewed interface. Through such projects, we can generally see the work in some form (whether sculpture, video, or a Firefox plug-in) as well as what an artist persona looks like online (as opposed to, say, that of a corporation). We can even approximate what an artist's brand might be amid the digital swell of marketing and self-presentation (for instance, evasive user interfaces instead of clean, user-friendly ones). In more experimental modes—think collectively built archives or an artist's blog that doubles as a public sketchbook—artist websites flout individual authorship and singular finished products that are closed to the public. And yet the question remains of whether it is possible to evince more than the artwork itself, to reveal the whole practice: the research, the influence, and what it's like to make work over time.

Like the large-scale exhibition system, the Internet acts as a platform to show works, events, or documentation, while acting as a secondary system of distribution, which in cases like Cory Arcangel (b.1978, Buffalo, NY), a digital media artist who hacks video games and appropriates technologies in the service of new works that exploit programming to aesthetic ends, creates an alternative audience that may have nothing to do with the art world narrowly conceived.

Rather than negating human agency, these changes in information access, retrieval, and transference position the subject at the center of far-flung worlds, which the artist must not only make sense of but put to use. Pulling back from the technologically possible limits of optical verisimilitude allowed by high-definition screens, Dan Hays (b.1966, London, UK) uses low-resolution images taken from the Internet—from websites for camping and caravan parks, as well as photos posted by another Dan Hays, whom the artist discovered in an online search in 1999—and further decomposes them to

3.28

3.26

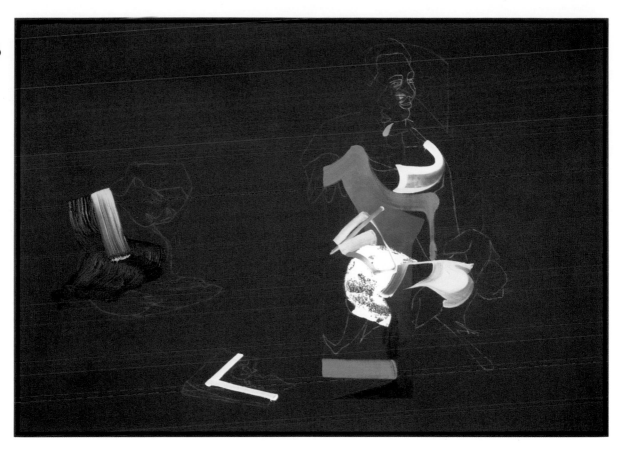

Pieter Schoolwerth
Portrait of "The Sitting"
(after Traversi), 2010
Oil on canvas, 169.2 × 240.3 cm
(66⅝ × 94⅝ in.)

3.27

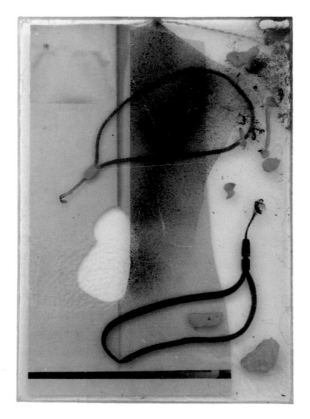

Harm van den Dorpel
On Usability, 2011
Mixed media, 24.1 × 18.6 × 2 cm
(9½ × 7⁵⁄₁₆ × ¹³⁄₁₆ in.)

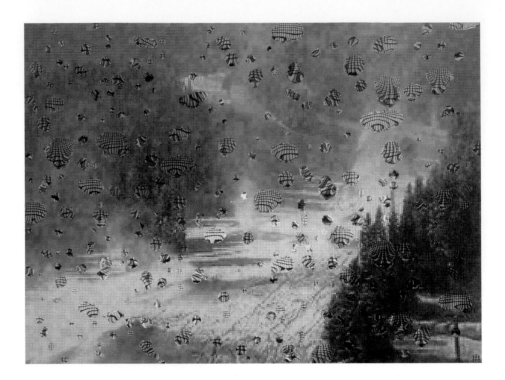

Dan Hays
Colorado Snow Effect 9, 2010
Oil on canvas, 107 × 142 cm
(42 × 56 in.)

3.28

3.29

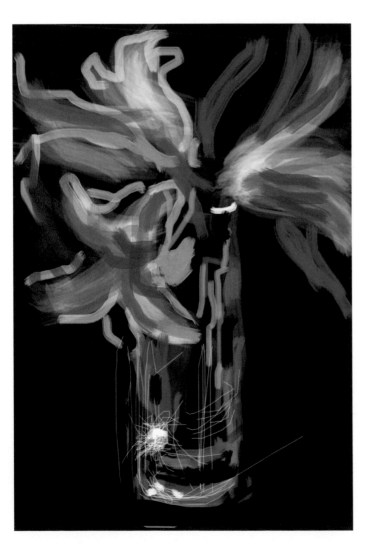

David Hockney
Untitled, 29 June 2009, 2009
iPhone drawing, dimensions variable

116

highlight their intercession. Some paintings that result verge on the abstract, while others retain pockets of legible content. The works Hays has completed based on the other Hays, who lives in Colorado (where the artist has never visited), make ample use of his namesake's blurry snapshots of the Rocky Mountain landscape surrounding his home, as well as his live webcam. Hays received permission to use the images, and even to "consider them yours and original if you wish," in a rare instance of voluntary appropriation. After working on the images with various digital mechanisms (such as modulation and inversion, restricted palettes, and simulated texture), Hays preserves the mistakes in their final passage into oil.

David Hockney (b.1937, Bradford, UK), the great chronicler of domestic **3.29** intimacies and the California leisure class, returned to the East Yorkshire of his youth in 2005 to paint landscapes *en plein air*, which he then worked up on the computer in the studio. He also began a corpus of iPhone paintings in 2009, made with the Brushes application on his handheld device. Dragging his finger across the screen, he composed diminutive scenes—self-portraits, portraits, flowers, sunrises—which he modified by hue and the application of details; he then archived the images and passed them on to friends. He has also made paintings without paint using a stylus on his iPad, created large prints with a digital inkjet printer and, applying the playback feature in the Brushes app, produced videos that reveal their underlying process. While these last works have moved into physical space, the iPhone paintings remain wholly digital in their generation and presentation, especially as the luminosity of the images is achieved solely by means of the screen. In their route from device to device—which is also a pathway from maker to beholder, or beholder to beholder—Hockney's works evidence the maintenance of personal connections, or at least that possibility, through art that is entirely dependent on the machine.

4

The Body

In 2009, Antony Gormley (b.1950, London, UK) staged *One & Other* (2009). Over the project's 100 consecutive days, 2,400 members of the public each occupied the Fourth Plinth in London's Trafalgar Square for one hour. As Gormley proposed:

> Through putting a person onto the plinth, the body becomes a metaphor, a symbol. In the context of Trafalgar Square, with its military, valedictory and male historical statues, this elevation of everyday life to the position formerly occupied by monumental art allows us to reflect on the diversity, vulnerability and particularity of the individual in contemporary society.

The artist, who has long made sculpture from his own body, absented himself from the scene, giving over the platform to strangers. Although some critics argued that *One & Other* actualized a living portrait, plenty maintained the opposite: that these individual acts made an overarching interpretation logically impossible.

4.1

Michaël Borremans
Six Crosses, 2006
Pencil, watercolor, and acrylic paint
on paper, 23.4 × 21 cm
(9³⁄₁₆ × 8¼ in.)

Neo Rauch
Die Lage, 2006
Oil on canvas, 300 × 420 cm
(118⅛ × 165⅜ in.)

4.2

4.3

Christoph Ruckhäberle
Nacht 32, 2004
Oil on canvas, 190 × 280 cm
(74¹³⁄₁₆ × 110¼ in.)

4.4

Tim Eitel
Tür, 2006
Oil on linen, 20.3 × 27.9 cm
(8 × 11 in.)

4.5

Matthias Weischer
Kleine Sitzgruppe, 2004
Oil on canvas, 64 × 90 cm
(25 × 35½ in.)

Zhang Xiaogang
(Lovers), 2007, from the
series *Bloodline*
Oil on canvas, 200 × 260 cm
(78¾ × 102⅜ in.)

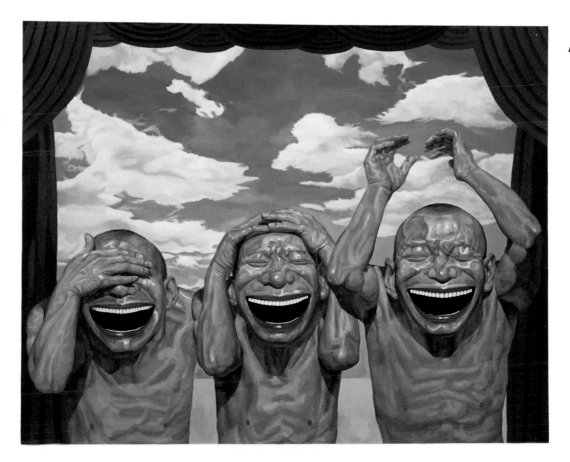

Yue Minjun
Inside and Outside the Stage, 2009
Oil on canvas, 267 × 336 cm
(105⅛ × 132⁵⁄₁₆ in.)

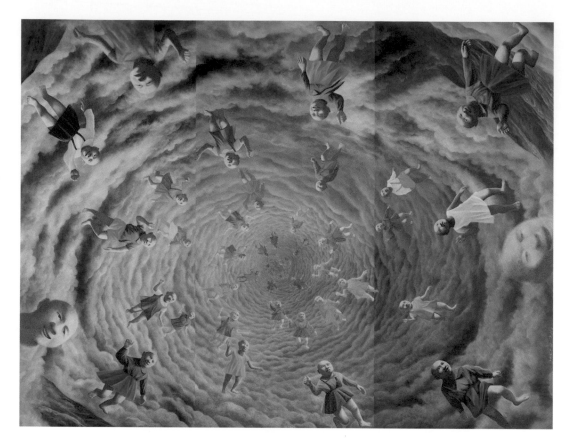

4.8

Fang Lijun
30th Mary, 2006
Oil on canvas, 400 × 528 cm
(157½ × 207⅞ in.)

4.9

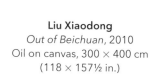

Liu Xiaodong
Out of Beichuan, 2010
Oil on canvas, 300 × 400 cm
(118 × 157½ in.)

This is but one indication of the body—as the site where the iconic, the personal, the political, the private, the state, and its economies, register most acutely—being made visible in recent years through participatory practice. Although the example described above remains outside painting, I consider below the body as both an individual and a collective medium, and the figure as its counterpoint. Michaël Borremans (b.1963, Geraardsbergen, Belgium) distinguishes his figures from the concept of people, painting enigmatic scenes in which bodies—often occluded or turned away, and sometimes lifeless, perhaps dead—are subjected to external and seemingly malevolent systems, through which they retain little sovereignty.

4.1

Questions of agency have dominated much recent representational painting, and paralleled the rise of participatory art in the 1990s and 2000s; the latter is conditioned by the same extra-pictorial concerns, whether or not these are recovered as content. Moreover, social developments might well have prepared for the re-embrace of figuration in the global marketplace, despite the factors stacked against it. Even—or perhaps especially—in the former German Democratic Republic and China, among other places, historical biases against representational practices have lost their hold. If anything, contaminations, such as Socialist Realism and other forms of figurative propaganda in East Germany, have been turned against themselves, whether as bad painting (pp.79–81) or as earnest recuperations of outmoded styles applied to new ends.

Championed for their preservation of academic figurative traditions to represent the reunified Germany, artists in Leipzig, in particular, were touted in the mid-2000s. At the time, many equated their arrival on the international scene with the Expressionism flooding galleries in the 1980s: similar instances of a return to order in the face of pluralism and globalism. Irrespective of this, collectors aggressively promoted artists such as Neo Rauch (b.1960, Leipzig, Germany), David Schnell (b.1971, Bergisch Gladbach, Germany), Martin Eder (b.1968, Augsburg, Germany), Christoph Ruckhäberle (b.1972, Pfaffenhofen an der Ilm, Germany), Tim Eitel (b.1971, Leonberg, Germany), and Matthias Weischer (b.1973, Elte, Germany) under the banner of the New Leipzig School, on account of their having studied painting at the esteemed Hochschule für Grafik und Buchkunst and having remained in the city thereafter.

4.2

4.3

4.4

4.5

Despite the differences in their work, the Leipzig artists are affiliated in education, age, and orientation, and had themselves formed a league in 2000 and a gallery of the same name, Liga, in Berlin in 2002. Rauch has been singled out for his nostalgic paintings which juxtapose political posters,

forsaken monuments, and consumer products in surreal landscapes populated by enigmatic figures who appear psychologically estranged from one another, despite their physical proximity. Meanwhile, Schnell paints landscapes fractured by perspective, teetering on the edge of decomposition; Eder paints darkly symbolic and often perverse pictures of naked women and fluffy house pets; Ruckhäberle has developed a folksy faux-primitivism suited to his single- and multi-figure compositions, in which subjects enact inscrutable scenarios, alone or en masse; Eitel places spectators in museums, absorbed in acts of hushed reverie; and Weischer empties rooms out, the better to focus on their uncanny illusionism and anticipatory function as stage sets awaiting human presence.

4.6 A similar infatuation with figurative work has evolved in China. Although many artists are working in this vein, Zhang Xiaogang (b.1958, Kunming, China) has become synonymous with it. A member of the Southwest Artist Group, active in the 1980s, he became interested in representing national character. Beginning in the early 1990s, he completed fictional portraits of Chinese citizens—bespectacled girls in braids and fathers in party attire, all with porcelain-smooth complexions and hauntingly glistening eyes— inspired by the sort of quasi-patriotic studio portraits that were popular in the 1950s and 60s and largely lost during the Cultural Revolution. Each discrete work in his *Bloodline* series is connected to the others by a thin, meandering red line of paint that roams across the sitters' faces and torsos in ironic solidarity (a testament to Mao Zedong's "revolutionary family" of the state), with some also bearing blotches of the same red, or patches of shaded imperial yellow.

4.7 Yue Minjun (b.1962, Daqing, China) and Fang Lijun (b.1963, Handan, China) have also made portraiture central to their practices. Yue uses his own appearance as the template for repetitive paintings of grinning men, with faces contorted into toothy, frozen masks that recall the Laughing Buddha. These pink-fleshed caricatures trade the icon worship associated with Mao for the elevation of the artist as both hero and logo, the latter instantly recognizable on the surface of related merchandise. Under these circumstances, the political implications of the forced smiles—so maniacal in their zealotry—remain allusive, but gain in significance due to the explicit charge of his *The Execution* (1995), Yue's post-civil protest updating of Manet's painting of the death of Maximilian, Emperor of Mexico, and his generals.

4.8 Like Yue, Fang was associated with what became known as Cynical Realism, before producing his own emblem: a bald man engulfed in water or buoyed by clouds. These works, along with others populated by babies endowed

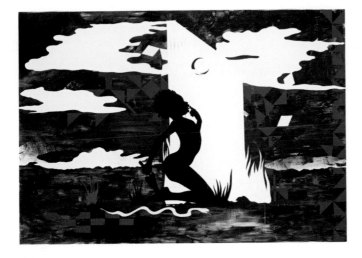

4.10

Kara Walker
Mississippi Mud, 2007
Mixed media, cut paper, and casein on gessoed panel, 152.4 × 213.4 × 5.1 cm
(60 × 84 × 2 in.)

4.11

Wayne Gonzales
Waiting Crowd, 2008–11
Acrylic on canvas, triptych,
each panel 152.4 × 152.4 cm (60 × 60 in.),
overall dimensions 152.4 × 518.2 cm
(60 × 204 in.)

4.12

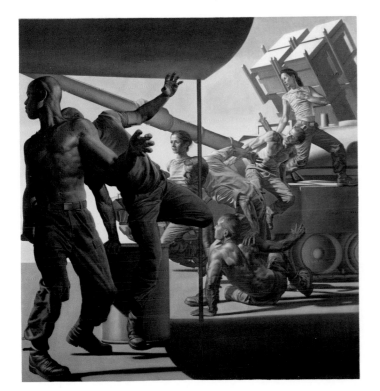

Nicola Verlato
Enduring Freedom, 2003
Oil on linen, 250 × 270 cm
(98^{7}/$_{16}$ × 106^{5}/$_{16}$ in.)

4.13

Chéri Samba
Après le 11 Sep 2001, 2002
Acrylic and glitter on canvas
200 × 350 × 5 cm (78¾ × 137⅞ × 2 in.)

4.14

Carla Busuttil
No Country for Poor People, 2013
Oil on canvas, 100 × 80 cm
(39⅜ × 31½ in.)

4.15 **Vasan Sitthiket**
I Love Democracy Ha Ha, 2012
Oil and acrylic on canvas, 120 × 120 cm
(47¼ × 47¼ in.)

with his face, play an elaborate game of hide and seek, opposition and conciliation.

Liu Xiaodong (b.1963, Liaoning, China) occupies a radically different position, whereby social and material changes—and their effects on human lives—are addressed head-on. Trading parodic appropriation of Socialist Realism for a realism of experience, Liu embraces the particularity of his subjects, whom he travels to meet and paints on site, in "a social experiment." After setting up camp, he records the sessions through other means of documentation (photographs and video) and archives them online alongside the completed works. Among the subjects of his paintings are a blue-green algae infestation of a lake caused by industrial pollution, and group portraits alluding to the aftermath of the massive 2008 earthquake in Sichuan province. One trip to Hotan, a town in the Xinjiang region of China, resulted in a series of portraits of Uyghur jade miners in a landscape transformed by centuries' worth of excavation for emperors and the wealthy.

4.9

As these few instances attest—from the fall of the Berlin Wall and civil protests in China to terrorist attacks in New York and Madrid, the wars in Afghanistan and Iraq, the Arab Spring, and many other catastrophic events—extra-aesthetic affairs have precipitated a return to the body politic. Known for her cut-paper silhouettes, gouache and watercolor paintings, light projections, and text-projects that expose the surprisingly long half-life of the American antebellum South, Kara Walker (b.1969, Stockton, CA) has noted of the media images circulated in the aftermath of Hurricane Katrina in 2005:

4.10

> I was seeing images that were all too familiar. It was black people in a state of life-or-death desperation, and everything corporeal was coming to the surface: water, excrement, sewage. It was a re-inscription of all the stereotypes about the black body.

Reflected in her work made in its wake, this argument was perhaps most forcefully communicated through an exhibition, "After the Deluge," which Walker curated at the Metropolitan Museum of Art, New York, in 2006. The show connected centuries of art that takes as its theme poverty and race and their deep-seated, seemingly intractable connections, predating and even anticipating the inequities exposed by the hurricane.

As a comparison, Wayne Gonzales (b.1957, New Orleans, LA) followed a series on Lee Harvey Oswald, the assassin of President Kennedy, with paintings of

4.11

the White House and the Pentagon in Washington, D.C., as well as the casualties of Hurricane Katrina, captured in appropriated images that reveal gross government neglect. These are striking for their incorporation of the police, since most of his crowd pictures remain anonymous and ominous, suggestive of a society under mass surveillance, and yet unidentifiable in terms of time, place, or circumstance. A Louisiana native like Gonzales, Jacqueline Humphries (b.1960, New Orleans, LA) (pp.145–46) participated in the international exhibition, "Prospect. 1", in New Orleans, in 2009, during which she exhibited three-dimensional silver paintings next to others spray-painted directly onto the brick walls of an abandoned garage. These ghostly wall paintings hinted at their future vanishing, as graffiti-like traces left behind.

Hurricane Katrina is just one natural disaster, and as such remains significant less as a category of event than for the committed responses it provoked. Something similar might be said for Hurricane Sandy, which hit New York City and the Atlantic seaboard in 2012. Damage was rampant along the coast, and many lives were lost. Media coverage of the human toll alongside the economic implications of the Chelsea arts district sinking under water (resulting in thousands of artworks shipped off to conservators or spoiled by the Hudson River water that also rotted gallery infrastructure) laid the ground for exhibitions including "EXPO 1" at Long Island City's PS1, the Museum of Modern Art, New York, and a constructed dome in the Rockaways, all of which centered on issues of ecology amid economic and political instability relative to local populations. "Surviving Sandy" in Sunset Park, Brooklyn, coinciding with the one-year anniversary of the storm, brought together artists directly impacted by the violent weather with others who made use of it as a theme, and still others participating in the spirit of solidarity for those more directly impacted.

While these shows focused on the present, or the uncertain future it portends, for many, recuperation of the body happens in the guise of history painting. As if to compensate for previous regressive tendencies, contemporary imagery is often critical, neither inspiring patriotism nor exalting heroism, but instead focusing on the unsavory consequences of inept leadership, misbegotten nationalism and sectarian violence, or of exacerbating ideological conflict. Not all works aim to replicate the scale of their historical counterparts, nor are they equally stylistically "radical," in the language of an older avant-garde.

4.12 Nicola Verlato (b.1965, Verona, Italy) retains a kind of classicism that has traditionally implied conservatism, upholding a neorealist style evocative of

Old Master painting, which he puts to use in near-apocalyptic, largely allegorical scenes of soldiers and bodies leaping from crashing vehicles. Verlato appropriates the campy, exaggerated violence common to the High Baroque and contemporary video games to comment on the clash of civilizations played out between polytheism and monotheism, and to underline its consequences for representation: cults of idols (figuration) versus prohibitions on graven images (abstraction). This is an important reminder of the different histories of form and the ideologies that underpin them, whose use depends on local context and other factors (as discussed in Chapter 2).

A one-time sign painter, Chéri Samba (b.1956, Kinto M'Vuila, DRC) uses traditional artistic forms and popular materials like sackcloth, which he incorporates into his paintings alongside fantastic images, word bubbles, and his own face as "conscience." A founding member, with Pierre Bodo, of the School of Popular Painting in Kinshasa, Democratic Republic of the Congo, he has long been committed to exposing the inequities of daily life, political corruption (in his country and elsewhere), and the ravages of AIDS. Differently committed to the histories of her people, Swarna Chitrakar (b.1974, Banpura, India) is a narrative painter and singer, who has taken traditional West Bengali scroll painting (*pat*), using customary materials (yellow comes from saffron, rice and clay create white, while cow dung makes brown), and made it relevant to contemporary events. Her work—the scrolls and her songs composed about them—encompasses religious themes, but also shows the atrocities that followed in the wake of 9/11 and the 2004 tsunami, the wreckage wrought by deforestation, and the neglect of female children in rural India.

Pablo Baen Santos (b.1943, Philippines) is known for a mode of social realism that he developed in the 1970s as protest against the Marcos regime. In 1975 he founded KAISAHAN together with other Filipino painters embroiled in effecting social change through their art during a period of martial law. While his critique has been directed at the government in his native Philippines, it also indicts society's injustices, especially where conditions of labor are concerned. Although Carla Busuttil (b.1982, Johannesburg, South Africa) has claimed that the content of her work is secondary to its formal aspects, which she evidently relishes, she uses found images of conflict to enact political parody that lampoons charismatic leaders in pointed condemnations. To her 2013 show at Goodman Gallery, Cape Town, titled "Post-National Bliss," she appended the following statement: "This world is flat, and its inhabitants are a generation lost: unhinged aristocrats, powerless

4.13

4.14

lawmen, scoundrel children, otherworldly victims—all lurching towards some unrecorded fate. It is a time after history."

4.15 Even more confrontational, Vasan Sitthiket (b.1957, Nakhon Sawan, Thailand) denounces Thai politics and problems in Asia after the economic crash, as well as American foreign policy, through especially violent and scatological imagery modeled in hamfisted, brightly colored canvases. One installation, *Thai Nukes* (2012), comprises 108 phallic carvings fashioned from wood recovered from the 2011 floods, while paintings like *I Love Democracy Ha Ha* (2012) equate the phallus with missiles and bombs, often wielded by the US president. Earlier works depicted George W. Bush—himself now recognized as an "outsider artist," who, inspired by Winston Churchill's inspirational pamphlet *Painting as Pastime* (1948), began painting portraits of dogs—but Sitthiket also indicts Barack Obama for his perceived greed and alliance with Israel.

4.16 Refusing the consolation of moralism, the Dutch artist Ronald Ophuis (b.1968, Hengelo, The Netherlands) paints horrific scenes of brutality, often presented from the perspective of the perpetrator. *Sweet Violence* (1996) was one of a group of canvases he exhibited at the Stedelijk Museum Bureau Amsterdam in 1999, under the title "Five Paintings about Violence": deemed pornographic for its depiction of a child rape scene and removed from the exhibition, the painting was reinstalled following a petition by the artist. Though less immediately subject to censorship, other projects have been equally challenging, especially given Ophuis's tendency to locate gruesome acts of sodomy and torture in contemporary surroundings (early paintings followed the model of nineteenth-century history painting, with subjects donning antique clothing in some indeterminate past). Travel to Srebrenica in 2003 yielded the *Srebrenica* series (2004–8), which memorialized the genocide there, while a 2010 trip to Sierra Leone resulted in portraits of child soldiers.

4.17 Pablo Alonso (b.1969, Gijón, Spain) has used the technique of frottage to transfer the surfaces of public monuments to other supports. This recuperation of public sculptural and architectural markers characterizes *Illegal Settlement* (2004)—a reconstruction of the Arch of Titus in the Roman Forum, erected to mark the conquest of Jerusalem and the Jewish diaspora that resulted—and other works that question the relationship between power and representation. Although these imply the presence of the body, through the actions involved in rubbing the surface, or the viewer being forced to crouch under the arch's diminutive bow to view it, other works, such as the series *You've Never Had it So Good* (2003), use cut-out, skewed, or decapitated

4.16

Ronald Ophuis
*The Death of Edin,
Srebrenica July 1995*, 2007
Oil on linen, 345 × 480 cm
(135¹³⁄₁₆ × 189 in.)

4.18

Pablo Alonso
You've Never Had it So Good 1, 2003
Acrylic paint and marker on unprimed
cotton canvas, 280 × 400 cm
(110¼ × 157½ in.)

4.17

Miguel Aguirre
Ana Martín Fernández, 2008,
from the series *In Memoriam*
Oil on paper, 50 × 35 cm
(19¹¹⁄₁₆ × 13¾ in.)

Bogdan Vlăduță
Black 03, 2011
Oil on canvas, 205 × 289 cm
(81 × 113 in.)

4.19

4.20

Serban Savu
Blue Shadow, 2010
Oil on canvas, 137 × 106.5 cm
(54 × 42 in.)

images of the body as a way of undermining the realism of their source materials (these paintings originate in newspaper excerpts from the German press—*FAZ*, *Der Spiegel*, *Süddeutsche Zeitung*), which Alonso photographed, projected onto canvas, and then painted. While the content of the clippings matters, they also raise questions of piracy and manipulation; some instances of this can be more obvious than others, given Alonso's proclivity to force multiple elements into a single frame.

Like Alonso, Miguel Aguirre (b.1973, Lima, Peru) builds paintings around found images. Following the important example of Gerhard Richter (b.1932, Dresden, Germany), and specifically his *Atlas* series (1962–present)—an encyclopedic collection of over 4,000 photographs, drawings, and diagrams that spans German history in the post-war era and provides the sources for so many of Richter's photo-based canvases—Aguirre has amassed a personal repository of images obtained from CCTV, home videos, and the printed press, for reproduction as paintings. The resulting series *DD/MM* (2007–10) brings together diverse acts of violence, from children being kidnapped to public slaughter, as circulated through these channels. Bearing down on a single event, *In Memoriam* (2008) is a series of twenty-two paintings of the victims of the 2004 Madrid commuter train bombings. Aguirre culled snapshots revealing their private lives published in the Spanish newspapers *La Vanguardia* and *El País*. In maintaining the newspapers' formatting while deleting the texts, Aguirre carefully preserves each image's sanctity but presents it out of context. He thus proposes that an image's legibility does not equate with clarity of meaning.

4.18

Since the late 1970s, Luc Tuymans (b.1958, Mortsel, Belgium) has used comparable sources for his pale, thinly layered paintings which suggest faded, color-leached photographs and film stills, and often register a body in its absence. An upshot of the artist's rule of completing each painting within the course of a single day, Tuymans's works look unfinished, though this characteristic is a trope that lends them a banality all the more discomfiting for his grave subject matter. If history painting once prompted compassion through presenting a narrative condensed into a decisive moment, Tuymans alights on seemingly insignificant, even innocuous details that are anything but: a swatch of floral embroidery comes from a chair on which a man was murdered; an empty room reveals itself as a gas chamber traced with feces and blood; a hazy gray field swallowing up a lamppost is the concrete-become-ash of the World Trade Center. Even when the reference is clear, as in *The Secretary of State* (2005), a cropped headshot of Condoleezza Rice wearing an intense expression, Tuymans's position is not.

Richter is a noteworthy precedent here, too, for Tuymans and so many others. Richter's *October 18, 1977* (1988), a series of fifteen grisaille and deliberately blurred paintings based on black-and-white press and police photos of the Red Army Faction, taken while its members were imprisoned for terrorist acts in a West German jail, presents the terrorists (Gudrun Ensslin, Andreas Baader, and Jan-Carl Raspe) found dead in their cells. Without making these projects equivalent to one another, it is still worth noting the extent to which the use of photography to achieve a painting stylistically similar to its source, while also reflecting on this mediation, is practiced among European artists,

4.19 particularly those from the former Eastern Bloc. Bogdan Vlăduță's (b.1971, Bucharest, Romania) subjects include portraits, bombed-out blocks in Bucharest, and cemeteries evoked in a somber range of grays, browns, and

4.20 blacks, which evoke death and sometimes image it directly; Serban Savu (b.1978, Sighișoara, Romania) paints scenes of daily routines, lives lived in public plazas and derelict spaces similarly begun as photographs, which he manipulates in Photoshop, where he moves figures or otherwise alters the

4.21 composition before painting it. Alexander Tinei (b.1967, Căușeni, Moldova) depicts figures often tangled in awkward embraces, which highlight the blue paint running across their limbs and elsewhere, like viscous tattoos. Tinei equates bodily graffiti with degraded environments, and allies subjects with their surroundings, or portraiture with landscape.

While the works discussed so far suggest a broad commitment to political themes on the part of many artists engaged in figurative work, the body also

4.22 has other functions. In the case of Nader Ahriman (b.1964, Shiraz, Iran), who places characters in unreal landscapes, it is used as an allegory for abstract philosophical concepts, as in an exhibition of nearly twenty paintings and twice as many drawings based on *Thus Spoke Zarathustra* (1883–85) by Friedrich Nietzsche. Other artists have begun to explore the implications of contemporary philosophy that argues against anthropocentrism. Driven

4.23 by an interest in the post-human, Pamela Rosenkranz (b.1979, Sils-Maria, Switzerland) explores a condition in which agency is ceded to bodily surrogates. For a 2009 show, "Our Sun," at the Istituto Svizzero di Roma in Venice, she treated emergency blankets—one side metallic silver to cool the body and the other gold for heating it—as canvases or floor-pieces. A 2010 series featured body-prints on Spandex grounds, using the synthetic fabric to conjure an otherwise nonexistent form, and to recast figurative painting as flesh-toned residue.

In this, Rosenkranz moves far from traditional genres such as portraiture and the nude, though having been abandoned so purposefully these

Alexander Tinei
Uncle J, 2006
Oil on canvas, 100 × 80 cm
(39⅜ × 31½ in.)

4.22

Nader Ahriman
*Now the First Form Crashes
from a Shelf into the Depths*, 2006
Acrylic on canvas and collage
170 × 120 cm (67 × 47¼ in.)

4.23

Pamela Rosenkranz
Installation view of "Our Sun,"
Istituto Svizzero di Roma,
Venice, 2009

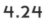

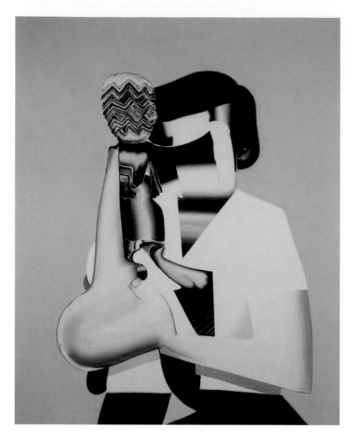

Tomoo Gokita
Mother and Child, 2013
Acrylic gouache, charcoal, and gesso
on linen, 229 × 183 cm (90 × 72 in.)

4.25

Benjamín Domínguez
El Sueño II, 2013
Oil on linen, 99.1 × 109.2 cm
(39 × 43 in.)

4.26

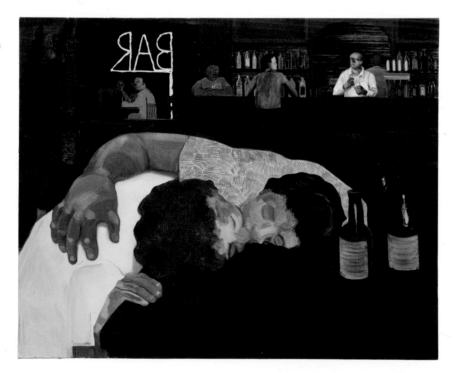

Nicole Eisenman
Sloppy Bar Room Kiss, 2011
Oil on canvas, 99.1 × 121.9 cm
(39 × 48 in.)

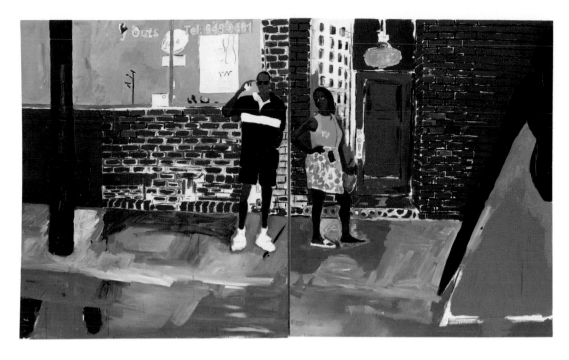

4.27

Henry Taylor
Split, 2013
Acrylic and charcoal on canvas,
two parts, each 182.9 × 152.4 × 6.4 cm
(72 × 60 × 2½ in.), overall dimensions
182.9 × 308.6 × 6.4 cm
(72 × 121½ × 2½ in.)

4.29

4.28

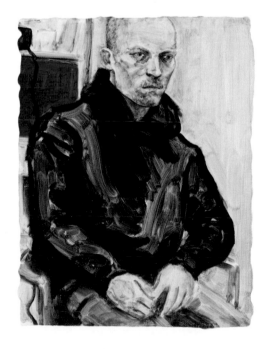

Elizabeth Peyton
Matthew, 2008
Oil on board, 31.8 × 22.9 cm
(12½ × 9 in.)

Chuck Close
Self-Portrait, 2005
Oil on canvas, 276.2 × 213.4 cm
(108¾ × 84 in.)

4.30

Gideon Rubin
Three Girls, 2012
Oil on linen, 148 × 198 cm
(58¼ × 77¹⁵⁄₁₆ in.)

4.31

Hannah van Bart
Seated Young Man, 2013
Oil on linen, 140 × 85 cm
(55¼ × 33½ in.)

genres continue to resonate elsewhere. Using black and white and the grays in between, Tomoo Gokita (b.1969, Tokyo, Japan) exploits this gradient to create surrealistic portraits of archetypes from art history (such as the Madonna and child), as well as geishas and Hollywood ingénues. Beyond this, artists like Benjamín Domínguez (b.1942, Ciudad Jiménez, Mexico), who has spent a long and noteworthy career using Renaissance painting techniques to depict the contemporary human body, or Jenny Saville (b.1970, Cambridge, UK), whose fleshy figures are based on live models posing in her studio, have maintained the bearing of traditional modes of figure painting and the means of achieving them.

4.24

4.25

Paradoxically, perhaps, given Facebook's exemplification of intimacy at a distance, the Internet has aided the organization of life-painting groups and hiring of models: life-drawing classes are posted on YouTube, and online galleries for this kind of work abound. The American artist Nicole Eisenman (b.1965, Verdun, France) flagged this method of working when she organized a figure-drawing atelier for the 2012 Whitney Biennial, with workshop exercises for sketching shadow, contour, shape, and finding the essence of forms; and, in 2014, Andrea Bowers (b.1965, Wilmington, OH) spent a week at The Drawing Center, New York, teaching Suzanne Lacy (b.1945, Wasco, CA) to draw. As with Eisenman's important interventions into queer aesthetics (since 2005 she has worked with A.L. Steiner [b.1967, Miami, FL] on the curatorial initiative Ridykeulous, staging conversations as well as organizing projects involving exhibitions, performances, and publications), her inventive and often mordantly funny paintings contain historical references, while addressing themselves to current concerns, chief among them the representation of women as "butch" or "femme" and the trials of motherhood. Public sites of sociability—beer gardens and barrooms—additionally offer moments of intimacy, here a lip-locked couple, slumped on a wooden table.

4.26

Likewise, Henry Taylor (b.1958, Oxnard, CA) works in the tradition of artists like Jacob Lawrence and Romare Bearden, who crossed folk art with elements from modern black life to portray an American landscape of mass migration and lingering oppression. Taylor counts friends, relatives, acquaintances from the art world, strangers off the street, sports stars, and politicians among the subjects of his large and unremittingly personal canvases. At times sentimental, and at others rough, his depictions of vernacular life, painted in a single sitting on canvas or on cigarette packs, cereal boxes, or suitcases, often exist together with his

4.27

sculptural groupings, composed of materials found in dumpsters and on the street.

4.28 Elizabeth Peyton's (b.1965, Danbury, CT) thinly washed, color-saturated, small-scale paintings, drawings, watercolors, and prints of objects of self-conscious, fan-like devotion—androgynous friends, celebrities and historical characters (eclectically ranging from Marie Antoinette and Abraham Lincoln to Rirkrit Tiravanija, Sid Vicious, Susan Sontag, Andy Warhol and Franz Ackermann)—are often sourced from photographs. Through a diaristic approach reminiscent of David Hockney (p.117), Peyton intimately chronicles moments of pleasure and vulnerability, paying rapt attention to certain details: popsicle-stained lips, webs of tattoos, and halos of perfectly tussled hair. Whereas her earlier works took as their material publicity stills and record covers, and trained their gaze on the idle young, in recent works Peyton has turned to studies from life. A picture of a stony, steel-jawed Matthew Barney, *Matthew* (2008), reveals deep circles under his eyes, suggesting a nascent interest in psychic intensity, or at least in its superficial clues. The portrait reappeared as an icon in a collaboration between Barney (b.1967, San Francisco, CA) and Peyton, *Blood of Two* (2009), a performance involving a vitrine containing a selection of her pencil drawings which was submerged in the sea off the Greek island of Hydra, before being exhumed and transported to a former slaughterhouse in a procession modeled on local Easter rites.

4.29 If Peyton signals a more topical recovery of portraiture—indeed, she was instrumental in its popularization in the last decade—for Chuck Close (b.1940, Monroe, WA), the genre has been a mainstay. Photorealist in style, Close's portraits are usually based on gridded photographs which he translates and aggregates into massive panels, but, on account of the artist's face blindness, committing the image to canvas involves a willed act of
4.30 recognition. Gideon Rubin (b.1973, Tel Aviv, Israel) also uses photographic aids as the basis for his paintings, though in his case the subjects are anonymous people retrieved from the pages of vintage albums. Where Close focuses on the exact details of a face, Rubin's broad, tonal strokes occlude rather than articulate the features, and can even stand in for the faces. Working from
4.31 anonymous materials, too, Hannah van Bart (b.1963, Oud-Zuilen, The Netherlands) excises pre-existing elements to project her feelings about the people she studies—individuals who become the excuse for formal play and the expression of mood. Maya Bloch (b.1978, Be'er Sheva, Israel) paints ghostly figures based on the family portraits of strangers.

4.33

Katherine Bernhardt
Blue Eyeshadow, 2013
Acrylic on canvas, 45.7 × 61 cm
(18 × 24 in.)

4.32

Chantal Joffe
*Self-Portrait Sitting on a Striped
Chaise Longue*, 2012
Oil on board, 244.4 × 183.4 cm
(96¼ × 72¼ in.)

4.34

Sofie Bird Møller
Interferenz, 2011
Acrylic paint on page torn from
Playboy magazine, 29 × 21 cm
(10⅞ × 8⅛ in.)

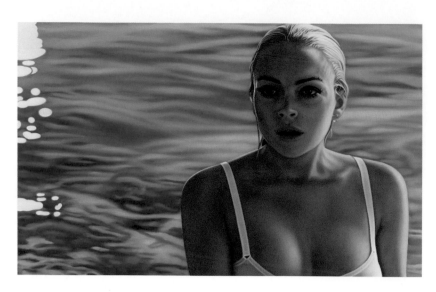

4.35

Richard Phillips
Lindsay IV, 2012
Oil on canvas, 152.4 × 241.6 cm
(60 × 95⅛ in.)

4.36

Ghada Amer
*The Woman Who Failed
To Be Shehrazade*, 2008
Acrylic, embroidery and gel medium on
canvas, 157.5 × 172.7 cm (62 × 68 in.)

4.37

Ellen Altfest
The Back, 2008–9
Oil on canvas, 40.6 × 63.5 cm
(16 × 25 in.)

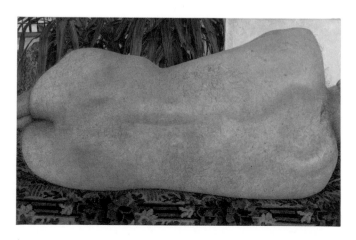

Like Close, Alex Katz (b.1927, New York, NY) is a long-established painter of portraits and figures. Katz's flatly rendered subjects, which include his wife, colleagues, and acquaintances, are composed of smooth, broad, near-monochromatic planes of color, and have changed little since the mid-1950s. Similar to that of Edward Hopper, with whom he is sometimes aligned, Katz's realism is actually a kind of abstraction spread across the surface of sensible things. Chantal Joffe (b.1969, St Albans, VT) also belongs in this cohort. Joffe culls photographs of women from various contexts—pornography, fashion magazines, and the history of art—for use in compellingly awkward portraits rendered in thick impasto. While strikingly perceptive, and sometimes even benevolent, Joffe's paintings are rarely idealized or sentimental, and, as with Rubin, her heavy brushwork materializes her subjects while denying them interiority.

<div style="text-align: right">**4.32**</div>

Katherine Bernhardt (b.1975, St Louis, MO) explores conventions of seduction through paintings of models ripped from the pages of fashion magazines: the figures' casual demeanor feels contrived, even hard-won, in the face of their disposability within the industry. While Bernhardt sometimes names her models—such as Naomi for Naomi Campbell—she is more likely to regard them as types. Sofie Bird Møller (b.1974, Copenhagen, Denmark) muddies fashion advertisements with liquid smears of paint. Richard Phillips (b.1962, Marblehead, MA), on the other hand, produces high-key celebrity portraits appropriate to the glossy contexts in which such sources thrive. He has spoken of an infatuation with wasted beauty, which found its match in Lindsay Lohan with whom he collaborates, and whose presence in a commercial-like art video and a suite of paintings serves as an endorsement for his other endeavors.

<div style="text-align: right">**4.33**</div>

<div style="text-align: right">**4.34**</div>
<div style="text-align: right">**4.35**</div>

If Phillips trades on exposure, Ghada Amer (b.1963, Cairo, Egypt) enforces a defensive barrier between viewer and viewed. Her nudes are sewn rather than painted, their tangled threads hanging in dense, colorful masses of knots and bundles that obscure the auto-erotic subject of her images (kissing, coitus, etc.). While the recuperation of craft nods to a feminist prehistory, which eschewed paint on account of its identification with maleness and mastery, these pornographic images present challenges to that lineage from within (formative works concern domestic chores of childcare, cleaning, and cooking). Equally, the prevalence of nudity, especially in the service of female pleasure, is seemingly incompatible with the artist's Arab Muslim background.

<div style="text-align: right">**4.36**</div>

However, in an earlier installation, *Encyclopedia of Pleasure* (2001), Amer forestalled such easy interpretations in creating a set of cream-colored fabric

boxes, on which the erotic tradition named in the work's title, as exemplified by medieval Islamic writing concerning the sacredness of sex, was embroidered in gold. With the text translated into English, the piece hints at concerns over censorship and intimates that taboos still resonate in Western culture and are illicit, even criminal, in other parts of the world. Indian filmmaker and painter M.F. Husain (1915–2011) spent the last years of his life in voluntary exile in Doha and London after he received death threats from religious zealots for his nude paintings of Hindu goddesses. And when Ramin Haerizadeh's (b.1975, Tehran, Iran) digital photographs of bearded men cavorting in theatrical, harem-like spaces appeared in "Unveiled: New Art from the Middle East" at the Saatchi Gallery in London in 2009, Iran's Ministry of Intelligence and National Security sought him out and raided a collector's home; Haerizadeh fled to Dubai. In another instance, Weaam El-Masry (b.1976, Cairo, Egypt) has admitted a loosening of subjects (poverty, corruption, and sexuality) prohibited under Hosni Mubarak in the wake of the Arab Spring, even as her work—superimposed figures in lustful embraces—was rebuked when an issue of *Newsweek Asia* in which she featured was deemed offensive by Malaysian censors.

More concerned with self-determination than reprimand, Cecily Brown (b.1969, London, UK) explores the point at which illusionism dissolves into pigment. It is rare to spy an intact form in her frenetic paintings, but anatomical fragments predominate, as eyes, thighs, breasts, and phalli emerge out of the smeared and slippery fields of marks that cover the surface in a sensual palette of pinks and whites. While much of Brown's early work involved imagery of sexual acts, it traded the pornographic for the evocative, focusing more on erotic analogies between oil paint and flesh. This is a convention-become-misogynistic cliché—take Renoir, who was forthright about conceiving the penis as paintbrush, or Kandinsky, who dramatized the act of painting as a rape scene—which Brown reconsiders from the other side. Thus we find in her repertoire, which is marked by numerous examples of art history, women modeled after Goya's nudes, consumed in orgasm.

4.37 Where Brown dissolves bodies into paint only to reconstitute them, Ellen Altfest (b.1970, New York, NY) upholds verisimilitude. Altfest paints from life, but attends to the minutest details—single strands of hair, individual pores, follicles, or fine veins—and frames them at close range. She lavishes equal attention on her male subjects, often presented in poses that mimic those of classic female nudes, or single body parts, as in the trompe l'oeil *Penis* (2006). Though in some ways undeniably voyeuristic, her representational comprehensiveness also yields abstract patterns. By comparison, the Indian

4.38 artist Bharti Kher (b.1969, London, UK) makes abstractions out of—and

covers sculptural forms with—a multitude of discrete bindis (the decorative forehead dots worn by women in South East Asia), as signs for the bodies to which they refer.

Pattern is also key to Mickalene Thomas's (b.1971, Camden, NJ) tactile paintings. Layers of oil, acrylic, and rhinestones achieve magpie-like overlays of modernist idioms. Initially working from photographs that Thomas takes of her muses in built environments, which recall both the fabric backdrops of West African studio photography (exemplified by Malick Sidibé and Seydou Keïta) and the patchwork décor of her past, she makes oversized portraits of accessorized and painted women. Her *Odalisque* series (2007) emblematizes the artist-model relationship, so crucial to her project, as a function of same-sex desire. Thomas's multiple versions of Gustave Courbet's infamous painting of a crotch splayed open, *L'Origine du monde* (1866), feature herself and her partner as the recumbent figure swaddled in dirty linens, while her tendency to plaster genitalia with glittery encrustations—sparkly fig leaves—simultaneously highlights and conceals such sexual markers.

4.39

In 1994, Miriam Cahn (b.1949, Basel, Switzerland) turned from the black, white, and gray of her early work—which reflected her early exposure to black-and-white television and textbook reproductions of art—to more saturated palettes, in which certain aspects of a subject's face or body are highlighted to emphasize fecundity: these include the genitals, breasts, or lips, as in *zeige!* (2010), where the figure's lips and breasts are accentuated—rimmed and dotted, respectively, a fiery rose—and her sex is both constituted and cleaved by a deep black line. Cahn has also mixed painting with performance, working around her menstrual cycle, or drawing while crawling on hands and knees, sometimes naked and blind, or both.

4.40

Though far from the performance work discussed earlier (p.118), Jacqueline Humphries's (p.128) paintings insist upon embodied making and viewing, emphasizing that while the body is most obviously represented in figurative work, it is no less essential to gestural abstraction. Moreover, while non-objective paintings may not refer to it, they often register the body's activity and, increasingly commonly, recuperate its traces, whether marks or wholly manipulated surfaces, as pictorial incident. They might also insist on the centrality of the viewer's body, in order to see paintings as physical objects above and beyond images. As paintings come off the wall, or create environments that we can walk into, the spectator's engagement becomes increasingly physical.

4.41

Beginning with her use of ultraviolet pigments in 2005, Humphries posited that light might exist separate from color. Back-lit through translucent fabric supports, synthetic fluorescents turn on and off. When on, these paintings determine the ambient space and its occupants, creating a psychedelic roomscape in which everything is incorporated: dust, lint, and fingernails all glow, along with teeth and the whites of eyes. Her silver paintings also act as agents of destabilization. Circumambulating a room in which they are installed, moving forwards and back, examining fronts dead-on or obliquely from the sides, reveals their profoundly conditional nature. Contingency is perhaps inherent to art, but Humphries radicalizes this tendency by opening her paintings' surfaces to environmental factors, thereby making mutability her nominal subject.

As a general rule, Humphries primes a canvas before using a dense, clay-like black as the ground for colors applied wet-on-wet, followed by a monochromatic spread of silver, which in turn precipitates further actions—scraping, re-painting, stripping, gouging—that compromise the integrity of the layers. An ever-reversible dance of figure and ground, painting and erasure, illustrates the artist's vigorous attempts to manage resistant materials. The brute physicality necessary to force the black paint out of the tube, and the various implements required to manipulate it, attest to the exertion of the technique.

4.42 Though Julia Dault's (b.1977, Toronto, Canada) sculptures of commercial detritus, arced and folded, and improbably tethered to the wall, contain no illustration of the individual who made them, they insist everywhere on the body's centrality, above all in the brute strength necessary to coerce unwieldy sheets of Plexiglas and Formica for each site-specific installation. First principles, including velocity, gravity, and weight, are knowable in their mechanics, if unpredictable in their results. This extends to her "drapes"— mutable paintings that hang from a nail or pin, bunched and folded in casual wall-bound arrangements. These formations belie their previous lives (stretched canvases and other things) and oblige further remaking with each hanging. Yet even in her more traditionally formatted works, Dault submits herself to restraints—industrial implements like metal rulers and door handles, and jerry-rigged utensils such as branches and manipulated brushes— that might control her gestures while still evidencing the spontaneity of her body's movements.

If Dault privileges direct physical activity, Bernard Frize's (b.1954, Saint-Mandé, France) bright geometric paintings (based on rules or systems that

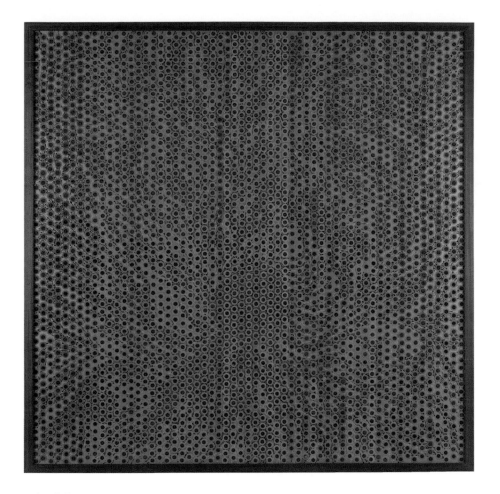

4.38

Bharti Kher
Peacock, 2009
Bindis on painted board
158 × 158 × 7 cm
(62¼ × 62¼ × 2¾ in.)

Mickalene Thomas
Origin of the Universe 1, 2012
Rhinestones, acrylic, and oil on wood panel
121.9 × 152.4 cm (48 × 60 in.)

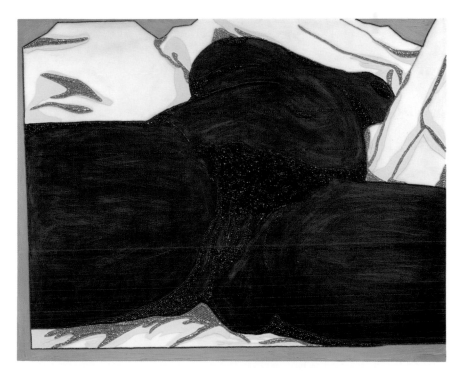

4.39

4.40

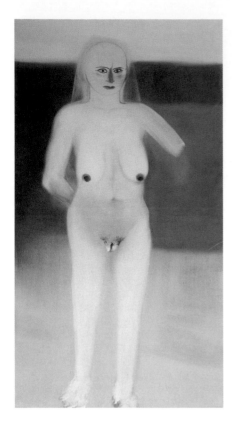

Miriam Cahn
zeige!, 21.12.2010, 2010
Oil on canvas, 185 × 100 cm
(72¹³⁄₁₆ × 39³⁄₈ in.)

4.41

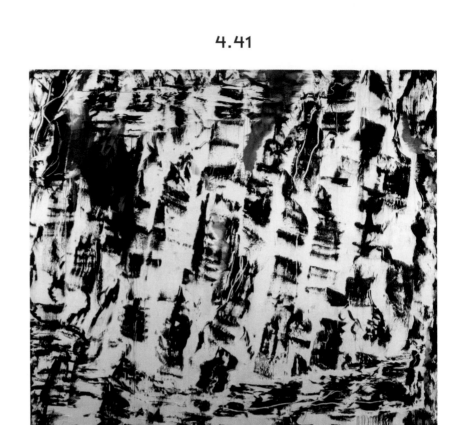

Jacqueline Humphries
Untitled, 2013
Oil and enamel on linen
254 × 279.4 cm (100 × 110 in.)

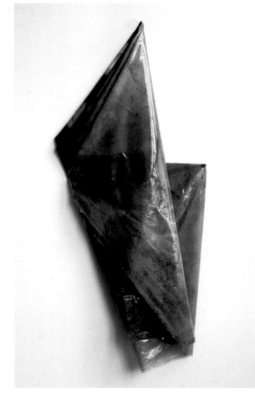

4.42

Julia Dault
Sure You Can, 2011
Oil on vinyl, dimensions variable

Frize establishes in advance, and achieved with concocted tools and techniques, like bundling brushes of different sizes together and using them to interweave colors as the tips glide across a thick, smooth layer of resin), are produced with assistants, among whom he divides the tasks necessary in an integrated choreography of divided labor. Though Frize's paintings also do not image a body, they conjure it abstractly. Moreover, his position serves as a reminder that deconstructing authorship does not preclude physical acts of labor; indeed, the former might well be determined by the latter. The spectacular quality of this practice, as it relates to contemporary painting, is the subject of the next chapter.

5

Beyond Painting

5.1

5.2

There has been a preponderance of work in recent years that moves off the stretcher to intervene physically in an installation or room. Pieter Vermeersch (b.1973, Kortrijk, Belgium) forgoes the support altogether and annexes the wall as a paint surface for murals of color gradients that seem to dissolve the wall plane even as they cling to it, while Clément Rodzielski (b.1979, Albi, France) leans his structures against it. Adrian Schiess (b.1959, Zurich, Switzerland), on the other hand, lays his "flat" paintings—large and reflective aluminum panels—on the ground. But as these projects illustrate, in moving off the wall, painting does not cease to be painting; instead, the questioning of painting's fundaments—its material history and conventions—expands what painting might be without losing sight of what it once was.

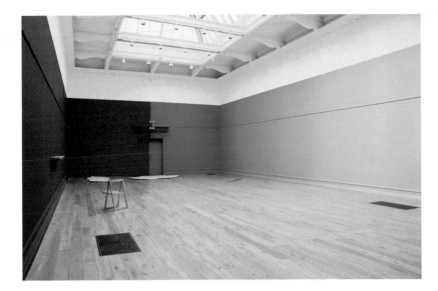

5.1

Pieter Vermeersch
Untitled, 2009
Acrylic paint on wall,
each 5 × 31 m (16½ × 101¾ ft)
Exhibition view of "Beyond These Walls,"
South London Gallery, London, 2009

5.2

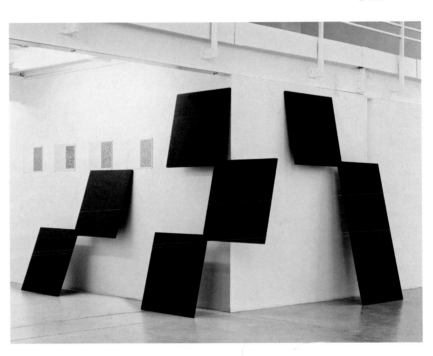

Clément Rodzielski
Installation view of *Untitled*, 2008
Five notebook sheets,
each 41 × 30 cm (16⅛ × 11¹³⁄₁₆ in.);
three wooden boards, 136 × 136 cm
(53⁹⁄₁₆ × 53⁹⁄₁₆ in.), 203 × 136 cm
(79¹⁵⁄₁₆ × 53⁹⁄₁₆ in.), and 207 × 136 cm
(81½ × 53⁹⁄₁₆ in.), dimensions
of installation variable

5.3

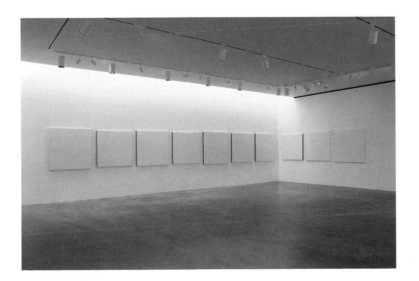

Robert Ryman
Installation view of
No Title Required 3, 2010
Enamel and acrylic on birch plywood
(panels 1–4 and 6–9) and enamel
and acrylic on board panel (panels
5 and 10), overall installation dimensions
213.4 × 1331 cm (84 × 524 in.)

5.4

Ekrem Yalçındağ
Camouflage, 2008
Oil on canvas, 180 × 160 cm
(70⅞ × 63 in.)

5.5

Odili Donald Odita
Installation view of *Equalizer*,
The Studio Museum
in Harlem, New York, 2008

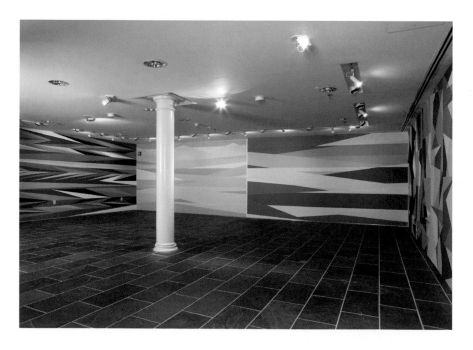

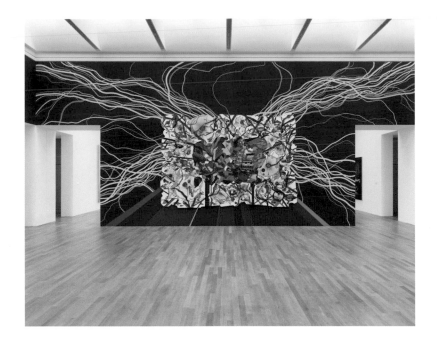

Franz Ackermann
*Große Kreuzung: Alle meine Städte
(Big Crossroad: All My Towns)*, 2012
Mixed media, paint on paper and
canvas, photographs, and wallpainting,
dimensions variable

5.6

5.7

Imran Qureshi
Installation of *They Shimmer
Still*, 2012, for the 18th
Biennale of Sydney

5.8

Ian Davenport
*Puddle Painting: Dark Grey
(after Uccello)*, 2010
Acrylic on aluminum mounted on
aluminum frame, 148 × 128 cm
(58¼ × 50⅜ in.)

5.9

Jim Lambie
Installation view of *Zobop Colour*, 1999
Vinyl tape, dimensions variable

Robert Ryman (b.1930, Nashville, TN) has long been involved with the **5.3** pragmatic testing of materials, and, among their mutually determining relationships—primer and paint, paint and support, support and edge, or edge and wall—the stretcher has proven crucial. A by-no-means exhaustive list of his chosen supports includes unstretched canvas, cotton duck, linen, jute, Bristol board, corrugated board, feather board, fiberglass, newsprint, paper, tracing paper, wax paper, wallpaper, Chemex coffee filter paper, wood, steel, and copper. But in addition to employing a wide range of materials (his spectrum of utensils and paints is equally diverse), he has painted directly onto walls, moved fasteners (tape, staples, steel, and other brackets) around to the front of canvases, and projected paintings outward from their wall planes at right angles. *No Title Required 3* (2010), a single painting composed of ten individual panels, continues this investigation of media through the physical stuff of painting. When hung in the Pace Gallery in New York, the squares, though almost imperceptible in their differences in size, were spaced at regular intervals, even traversing a corner.

Jennifer Bartlett (b.1941, Long Beach, CA) has described *Recitative* (2009–10) as an unending painting without edges. Running near to 160 feet, it covers three walls and comprises 372 enamel-coated steel plates. In dispersing a work across so many constituents, Bartlett revisits her groundbreaking *Rhapsody* (1975), which she exhibited at the Paula Cooper Gallery, New York, in 1976. Where *Rhapsody* follows abstract and figurative panels (images of houses, mountains, trees, and oceans) through varying color patterns and configurations, *Recitative* groups together abstract notations—colored dots, lines of different lengths and widths, hatch marks and brushstrokes, all of which might be infinitely recombined—before trailing off in a loopy black line.

Also interested in permutations of abstract elements, Ekrem Yalçındağ **5.4** (b.1964, Gölbasi, Turkey) extends sequences of colors over canvases and walls in non-repeating ornamental patterns that suggest mosaic or embroidery, despite being made with fine brushes and luminescent paints. Although the fractured planes and off-kilter geometries of Odili Donald Odita's (b.1966, **5.5** Enugu, Nigeria) murals seem non-objective, they often reference the textiles, clothing, and landscape of his native Nigeria. *Equalizer* (2007), a site-specific project that inaugurated the Project Space at The Studio Museum in Harlem, New York, takes the interactions of colors and shapes as the basis for what Odita names a "conceptual journey," based on the transatlantic slave trade and more recent waves of emigration from Africa to the Americas. Travel is also a leitmotif for Franz Ackermann (b.1963, Neumarkt-Sankt Veit, Germany), **5.6** as well as a precondition that enables his art. On a trip through China,

Mongolia, and Russia, Ackermann began making small watercolors, so-called mental maps, of the places he was visiting. He later reworked them in the hotel and subsequently the studio, where he makes site-specific projects on a larger scale, some of which cover vast walls with vibrant colors and decontextualized glimpses of place. Like Odita's efforts, these exercises in subjective cartography, by which a place is remembered in the remaking, are referential rather than representational.

5.7 Imran Qureshi (b.1972, Hyderabad, Pakistan) takes large public spaces—the courtyard of Beit Al Serkal for the 2011 Sharjah Biennial, a former dry dock on Cockatoo Island in Sydney Harbor for the 2012 Sydney Biennial, and the roof of the Metropolitan Museum, New York, for a 2013 installation—as ground for the application of paint in intricate thickets of form. Like Shahzia Sikander (p.82), Qureshi trained at the National College of Arts in Lahore, attending the class for miniature painting, which he too has used as a means to comment on contemporary politics in the region. Both the artist's miniature and large-scale painting projects admit the tenuousness of life there, which remains subject to conflict between various different religious and ethnic groups, particularly militant Sunnis and Shiites. Qureshi's use of paint the color of dried blood, applied in an ornamental pattern, splashed, or allowed to seep in viscous pools, might be seen as a response to the violence of everyday life, one that gains in meaning relative to the site of its display.

For Miquel Mont (b.1963, Barcelona, Spain), painting returns as subject. His walled paintings are precisely that: painted surfaces hidden between thick walls, boards or canvases, which might be shown on yet another wall, on the floor, or as an architectural expanse from which the paint—sandwiched together—oozes from the crevice. Ian Davenport (b.1966, Sidcup, UK) regards

5.8 the paint spill itself as method and iconography. He makes many works by pouring or using a syringe to squeeze household gloss paint onto a tilted surface (typically, medium density fiberboard), assuming that gravity will take care of the rest. Like Davenport, who sees these sequences as analogous to

5.9 a musical beat, and his process to rhythm and timing, Jim Lambie (b.1964, Glasgow, UK) takes musical structures as the basis for works that operate explicitly in relation to architecture. His iterative floor mural *Zobop* (1999–2003) might be described as a dance floor. For each installation, Lambie creates an undulating, disorienting Op-inflected pattern of tape laid edge to edge, as it extends out from the shape of the room or space that encloses it. His compositions, while rooted in color theory and the concept of synesthesia (an experience of sensory stimulation that leads involuntarily to another), are also keyed to the everyday. For example, Lambie's inspiration for *Plaza* (2005),

5.10

Angela de la Cruz
Deflated XVII (Yellow), 2010
Oil on canvas, 153 × 180 cm
(60¼ × 70⅞ in.)

5.11

Dan Rees
Payne's Grey and Vermillion, 2010
Acrylic on canvas and wall
142.2 × 101.6 cm (56 × 40 in.)

Kristin Baker
Kurotoplac Kurve, 2004
Acrylic on PVC and metal
support, 304.8 × 609 cm
(120 × 239¾ in.)

5.12

5.13

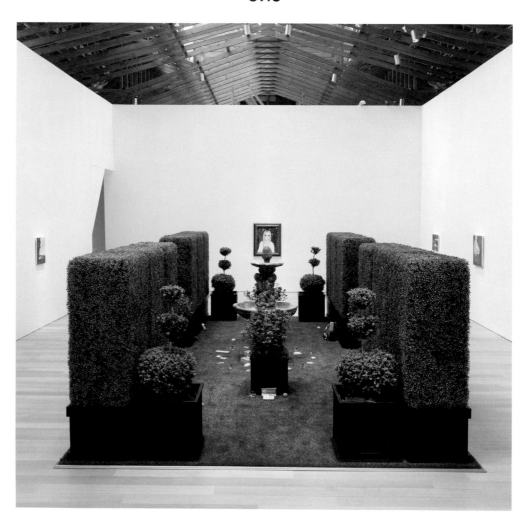

Karen Kilimnik
Installation view of *Fountain
of Youth (Cleanliness is
Next to Godliness)*, 2012

a series of seven plastic bags with paint seeping out and streaming down the wall, came from seeing a shopper unaware of leaving a trail of leaking milk.

In a somewhat different way, Steven Parrino's (1958–2005) so-called "misshaped paintings" similarly stand for a rethinking of the properties and function of the support. Known for violent-looking works that might be described as modernist monochromes ripped from the stretcher, or folded, torqued, punctured, or cleaved in sections to highlight the intervals between canvas and frame, Parrino has become increasingly important to other artists in the years following his untimely death. Not only do his entropic, sagging works open a space between painting and sculpture through their manipulation of weight and mass; they also suggest an extension into popular culture, particularly heavy industry, motorbikes, and guitars, such as his ruptured plaster panels in memory of Joey Ramone, *13 Shattered Panels for Joey Ramone* (2001). The panels' reduced palette of black, white, and silver, punctuated with orange, red, and blue, is as punk as it is minimal, a fact not unrelated to the fact that Parrino played the electric guitar in several bands, the final one being Electrophilia, a two-person group that he formed with artist Jutta Koether (p.161) as keyboardist.

Angela de la Cruz (b.1965, A Coruña, Spain) also exploits the language of assault, resulting from a studio epiphany caused by removing a stretcher and seeing the emotional impact of the collapsed painting. De la Cruz makes paintings to be destroyed: paintings that are ripped and often dangle from their frames, or are propped in corners. Abject in form, they evoke a decidedly human vulnerability. Indeed, anthropomorphism, also latent in Parrino's work, is suggested by de la Cruz's moniker, "person-objects," as well as by titles that name emotions. Although it is tempting to relate these acts to the artist's biography (she suffered a massive stroke in 2005, the details of which were obsessively recounted when de la Cruz became a finalist for the Turner Prize in 2010), she in fact worked in a similar vein well before this event. In an earlier piece, the tragicomic *Self* (1997), an oversized painting was crammed into a seat opposite another painting on a wall.

5.10

Premised on notions of communication, Dan Rees's (b.1982, Swansea, UK) Rorschach-like *Payne's Grey and Vermillion* (2010) works as a site-specific, acrylic monoprint: a canvas with two hovering colored forms provides the stamp for a mirror image hung on the adjacent wall, thus making evident the causal chain that produced it. Like de la Cruz, Rees incorporates furniture into painting (both might be said to recall John Armleder's "Furniture Sculptures," which conjoin abstract art and functional objects, treating them equally as

5.11

trifling décor). For *Shaker Peg Painting (Triptych)* (2011), he hung canvases on wooden peg rails, like disrobed clothes, to emphasize their status as objects.

The space between painting and sculpture, or, more accurately, the extension of the one into something resembling the other, is also explored by Yunhee Min (b.1964, Seoul, Korea), who uses iridescent pigments applied directly onto freestanding fluorescent tubes, which are juxtaposed with paintings. In contrast to Min, for Kristin Baker's (b.1975, Stamford, CT) painting, *Kurotoplac Kurve* (2004), the sculptural element—shaped in an arc to replicate the hairpin curve of a racetrack—serves as the support. Other works also use abstract overlapping planes (which reflect racing stock-car patterns) painted in acrylic on PVC, to organize and funnel space, but within the bounds of a flat support. More recently, Baker has jettisoned this speedway imagery, indicating that it was fundamentally a metaphor for process, since the track and its inevitable accidents supplied an abstract painterly language—of calculation and risk, mastery and potential failure—through which to image them.

5.12

5.13

Karen Kilimnik (b.1955, Philadelphia, PA) trades the composition of discrete works, however diverse in nature, for multi-part installations in which painting exists as one focal element. Best known for the "scatter" pieces she pioneered in the late 1980s, she has since developed full *mise-en-scènes*. Employing devices like fog machines, period furniture, custom wallpaper, and chandeliers, Kilimnik builds room-sized fantasies as a context for loosely executed paintings: these illustrate a lush, casual, and quasi-fictive world where august artistic references brush against icons of contemporary tabloid culture. Kilimnik staged this mixing of subjects and genres in the pavilion *The Red Room* (2007), a red brocade chamber containing fifty of the artist's paintings arranged in the style of a nineteenth-century salon display, itself set inside a nondescript, freestanding white cube. In creating a nesting, doll-like exhibition within an exhibition, the artist here makes explicit her use of the gallery as a frame, a strategy continued in the *Fountain of Youth* (2012), with its boxwood hedges, grass, and ivy.

5.14

If Kilimnik commandeers architectural space to create an atmosphere that is both appropriate to, and acts as an extension of, her paintings, Katharina Grosse (b.1961, Freiburg, Germany) creates vast works to fill it. In a process that has been compared to aestheticized street art, Grosse wields an industrial spray gun to paint directly onto walls, floors, ceilings, windows, or façades, as well as the objects contained inside them. (This follows her earlier work which discarded the canvas for supports of found objects, or the lightweight resin used for surfboards.) Although she has applied this spray technique to

existing sites, including a whole house in New Orleans left behind after Hurricane Katrina, Grosse typically creates landscapes composed of dirt, found objects, and clothes, as well as abstract, tectonic shapes made in wood, Styrofoam, or plastic as the ground for paint. Since the color—intense fluorescents and acidic synthetics—continues unabated irrespective of what it is covering, it produces a superficial continuity of forms. To achieve this effect, Grosse works very quickly, using a compressor to keep the pigment flowing. She also dons an impermeable Hazmat suit, in what might be described as a performance without an audience. For though the works are completed on site and in a dramatic manner, this happens prior to the show's opening.

Grosse's decision to keep the execution of the work unseen contrasts with artists who incorporate actions into the work, often as a way of postponing resolution. Alex Hubbard (b.1975, Toledo, OH) performs for the camera in his studio, producing short, single-channel videos, shot from above, of his manipulation of objects on a tabletop. The fixed vantage aligns the representational frame with its subject and reproduces the flat plane—a stand-in for the painted surface—as a space of destruction, which is recuperated as actual paintings representing artifacts from the video. One collage-like example flaunts a balloon from *Cinépolis* (2007), a video in which Hubbard haphazardly paints around a projection screen before using the support as a ground for a set of Mylar balloons, which he torches, tars, and feathers with the insides of a disemboweled pillow.

5.15

Jutta Koether (b.1958, Cologne, Germany) has perhaps been most influential in this change of emphasis, positing a dialectical relationship between painting and performance. In the vein of her friend Martin Kippenberger (p.70), Koether has achieved near-cult status for acting out the mentality of bad painting, with supports that might be festooned with cheap jewelry, encased with resin, or coated with washes of pigment. This is to say nothing of her installations—replete with curtains of Mylar ribbons, silver walls, shiny, oversized fitness balls, or pulsing strobe lights—still less her theoretical writing and criticism, or work for the music and pop-culture magazine *Spex*. As a performer, she has collaborated with Kim Gordon and Thurston Moore of Sonic Youth, Tom Verlaine, Tony Conrad, John Miller, Mike Kelley (p.80), and others, in alternative or underground scenes in Europe and America (she moved to New York in the 1990s). With Gordon and Rita Ackermann as the group Freetime, Koether experimented with collective paintings, and has worked in collaboration with other artists—Josef Strau (p.107) and Emily Sundblad (b.1977, Dalsjöfors, Sweden), among them—and under a variety of names, such as JXXXA, Mrs Benway, Reena Spaulings, and Grand Openings.

5.16

Though Koether exhibits her paintings as completed objects (meaning they are not subject to subsequent transformation into another physical state), she incorporates them into scenarios—of site and context, medium and its history—and allows for a multiplicity of uses, by herself and others. For example, her *Mad Garlands* (2011–12), a series of painted planks inspired by the tradition of the garland motif from ancient Roman wall paintings, has been shown as wall-bound objects at Campoli Presti in Paris, as elements of a dance contest at the Museum of Modern Art, New York, and as illustrations of a presentation at a conference on art and subjecthood at the Frankfurt Städelschule. Before these, "Lux Interior," her 2009 show at Reena Spaulings Fine Art, New York, presented just a single painting, which hung not on the gallery's walls but on a freestanding support in the center of the room. (Koether repeated this strategy in 2011, avoiding the walls of Galerie Daniel Buchholz, Berlin, as if their very use might render the work ornamental.) But it is *Hot Rod (after Poussin)* (2009), her homage to Poussin's *Landscape with Pyramus and Thisbe* (1651)—the sole item in "Lux Interior" and the basis for performances around it—that has accounted for the lion's share of her critical attention. This owes much to critic David Joselit's reading of her work as exemplifying the "behavior of objects within networks by demonstrating... their transitivity," by which he means their open-ended passage. This has proven a highly influential argument for painting's ability to escape reification through its refusal to congeal social relations, or to remain static. One might well counter that painting is never—and never has been—static, or even ask whether (and why) the static condition might be undesirable.

5.17

The co-founder of Reena Spaulings (also a fictional character of a 2004 novel published under the name of Bernadette Corporation, and the cover for a group of anonymous collaborators), Emily Sundblad occupies a range of positions, from dealer and artist to actress and singer, and asks the same of her art. For "Si me dejas te destruyo" (If you leave me I will destroy you) at House of Gaga in Mexico City in 2010, she acted in the capacity of both artist and dealer, and more, hanging paintings in a restaurant next to the empty gallery, playing music in the streets, and exhibiting Francis Picabia's painting *Woman in Blue Scarf* (1942), courtesy of Michael Werner Gallery, New York, in Mexico City, via an I-chat live feed.

For "¡Qué Bárbaro!" at New York's Algus Greenspon (2011), Sundblad worked with the gallerist Amy Greenspon and prop stylist Matt Mazucca to design the interior for the opening: gold folding chairs set up on a champagne carpet bathed in colored lights, while canvases referencing friends and influences hung on nearby walls. She kicked off the show with a cabaret performance of music

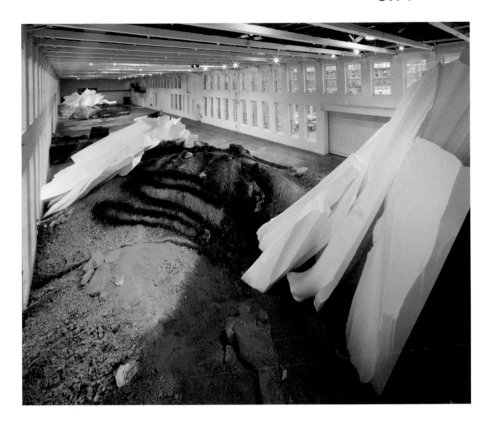

Katharina Grosse
Installation view of *One Floor Up More Highly* (2010) at Massachusetts Museum of Contemporary Art
Acrylic on wall, floor, clothing, styrofoam and glass fiber reinforced plastic,
780 × 1680 × 8260 cm
(307 × 661½ × 3252 in.)

5.14

5.15

Alex Hubbard
Still from *Cinépolis*, 2007
Color video with sound, 1:55 min.

163

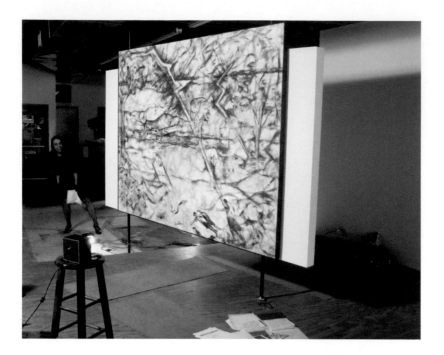

Jutta Koether
Performance documentation of
"Lux Interior," Reena Spaulings Fine Art,
New York, 2009

5.16

Emily Sundblad
Installation view of the exhibition
"¡Qué Bárbaro!", Algus Greenspon Gallery,
New York, 2011

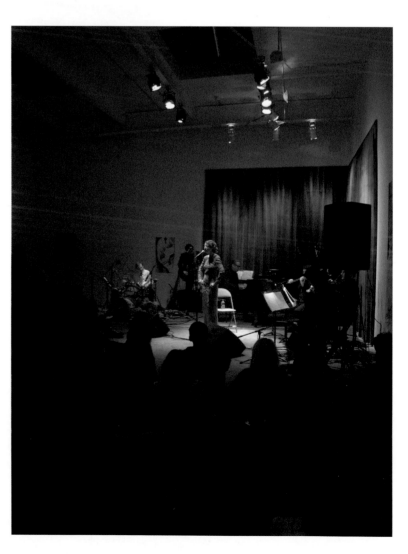

5.17

orchestrated by Pete Drungle, who played a grand piano alongside a seven-piece band, during which Sundblad sang in a gown designed by Lazaro Hernandez and Jack McCollough of the American fashion brand Proenza Schouler. After the first night, the costume came to rest on the wall, alongside newly designated paintings of flowers and clocks, abstractions and framed pages from an auction catalog, which had been released from duty as props. However, the changing status of an object as painting or prop continued, since in parallel with the gallery presence Sundblad sent a self-portrait/announcement for the show directly to Phillips de Pury, to be auctioned in its sale of contemporary art on May 13, 2011. As she wrote in the press release: "The time of the artist's emergence and their work showing up at auction is shockingly brief. With this painting I decided to cut to the chase."

Ei Arakawa (b.1977, Fukushima, Japan) also exemplifies art as social spectacle, **5.18** which is manifested through processes of reflexivity. *Mid-Yuming as Reconstruction Mood* (2004), a half-hour-long performance in which Arakawa and his collaborators built and disassembled a temporary platform, was based on the rapid construction and dismantling of the stage for the National Football League's famous Superbowl halftime show—a coordinated effort involving hundreds of people working together to complete the task within the allotted time (the length of a commercial television break). While the work doubled back on itself so as to leave nothing behind, it also related contingency and dispossession to the lives of the makers, who, like Arakawa, had been immigrants. When performed under the sign of "homelessness" at the Yokohama Triennale in 2008, Arakawa challenged the parameters of spectatorship by failing to indicate the beginning of the performance; consequently, the action looked like a work being installed by handlers, with bodies moving around a construction site and materials shuffled into and out of place. As soon as forms began to connect, whatever had been erected was undone in a deferral of finality, which was only fulfilled after the materials had been tucked away behind a false wall.

If *Mid-Yuming as Reconstruction Mood* treats making and dissolution as an allegory of visibility in the public sphere, *Towards a Standard Risk Architecture* (2006) further incorporated the public as participants, however unwittingly. The artist and his associates endlessly shifted construction materials, vacuumed, and otherwise distracted gallery-goers at Reena Spaulings Fine Art, New York, who were thereby stymied in their efforts to see the wall-bound works—the art ostensibly on view. Arakawa more explicitly invited audience interaction when, following a dance routine carried out by art students from the Hochschule für bildende Künste Hamburg, people were encouraged to

dance in the streets around the venue. This piece, the opening of "BLACKY Blocked Radiants Sunbathed" at Kunsthalle Zurich in 2011, featured Arakawa and his brother Tomoo Arakawa (under the name UNITED BROTHERS) in collaboration with DAS INSTITUT (p.111) and the fashion designer Nhu Duong.

If collaboration is a mainstay for Ei Arakawa, so is travel, a point that formed the basis of "I am an employee of UNITED, Vol.2" at Overduin and Kite, Los Angeles, in 2012 (Volume 1 took place at Galerie Neu in Berlin in 2010). As the press release stated:

> With their expanded organizational skills, they [Arakawa, Nikolas Gambaroff, and Shimon Minamikawa] manage to fly 100,000 miles (160,000 km) in a calendar year, all operated by one airline alliance. Museums and galleries covered all of the expenses. The collective is now Premier 1K™.... Since 2005, their performances have been all over: Jan: Tokyo, 14,000; Feb: Berlin, 7,000; Mar: London, 7,000; Apr: Paris, 7,000; May: Seoul, 14,000; Jun: Basel, 7,000; Aug: Milan, 7,000; Sep: Sao Paulo, 9,000; Oct: London, 7,000; Nov: Warsaw, 8,000; Dec: Hong Kong, 14,000; total: 101,000. This is typical of a performance artist today.... Inside our carry-ons, each under 14 inches × 9 inches × 22 inches (23 × 35 × 56 cm), there are objects not claimed as art. Those objects are almost like tools, yet too precious and fragile to send them over by FedEx.... The objects are scanned and explained at the security gate (officers don't really care what they are). We take care of those objects as if smugglers.

Assuming the contemporary artist as cultural service provider, Arakawa explored themes of transit and exhaustion through a performance involving painted panels inserted into wall niches and mannequins, which were left behind for the duration of the show to sit in wooden chairs and contemplate a wall painting. In treating the aftermath as nascent installation, Arakawa suggested the future convertibility of these materials and the repurposing of the infrastructure. In fact, in a kind of exquisite-corpse game, the scenario served as the basis for Nikolas Gambaroff's (b.1979, Frankfurt am Main, Germany) own excursion at the same gallery two months later.

5.19

For this show, Gambaroff reclaimed a blue rectangle emblazoned with a white United Airlines logo, which had been misspelled by Arakawa as UNTIED; he then corrected the word to UNITED, and erected a freestanding wall in front from which the anagram UNEDIT had been cut out. Both grounds functioned as backgrounds for discrete objects: mixtures of paintings and

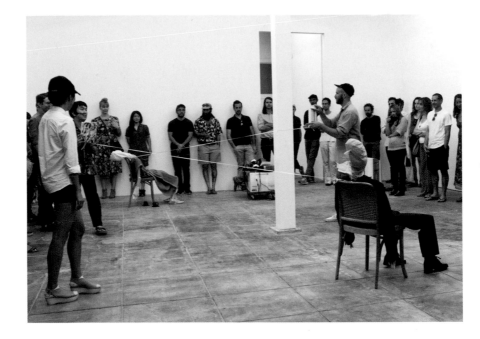

5.18

Ei Arakawa
Performance of *I am an employee of UNITED, Vol. 2*, at Overduin and Kite, Los Angeles, 2012

5.19

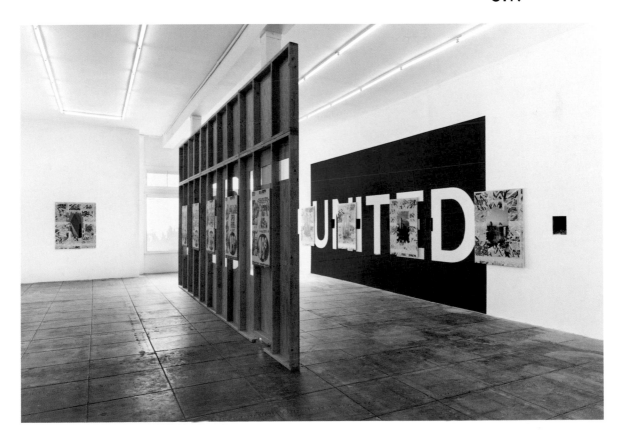

Nikolas Gambaroff
Installation view of *Tools for Living* at Overduin and Kite, Los Angeles, 2012

5.20

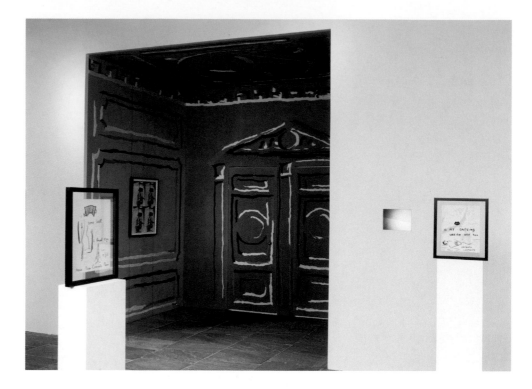

Nick Mauss
Installation view of *Concern, Crush, Desire*
at the Whitney Biennial, New York, 2012

5.21

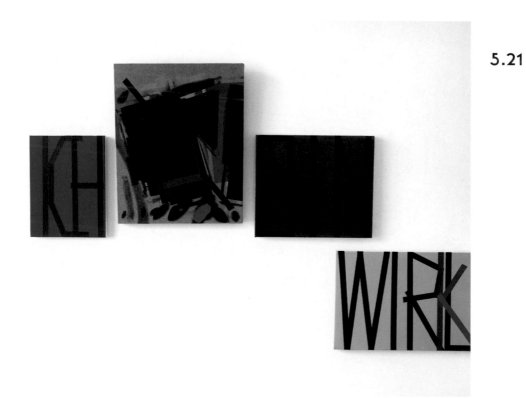

Paul Branca
Couch Crash, 2010
Oil on multiple canvases,
dimensions variable

5.22

Reto Pulfer
ZR Potzwaus, 2008
Textile, zipper, pastel on paper, thread,
and framed A4 text, 320 × 254 cm
(126 × 100 in.)

5.23

Theaster Gates
Civil Tapestry (Dirty Yellow), 2012
Decommissioned fire hose
149.9 × 203.2 × 12.7 cm
(59 × 80 × 5 in.)

5.24

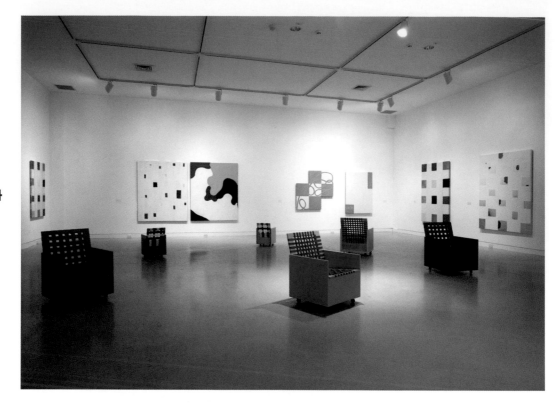

Mary Heilmann
Installation view of *To Be Someone*
at Orange County Museum of Art,
Newport Beach, California, 2007

5.25

David Adamo
Installation view of *Museum Museum
XX* at the American Wing Mezzanine,
Metropolitan Museum of Art,
as part of PERFORMA 2007.
A day-long duet between Adamo and
John Singer Sargent's *Madame X*.
Image: C-print, edition of 9 plus
2 artist's proofs, each 30.5 × 40.6 cm
(12 × 16 in.)

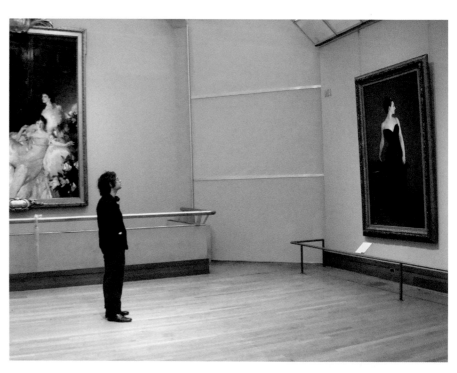

collage, incorporating newsprint, ads, and grocery posters layered in various patterns, such as a series featuring color photographs of cityscapes strung across UNITED, and another incorporating supermarket materials that crossed with UNEDIT as it bisected the room. Taken together, they proposed relationships between the shifting sightlines and disjunctions created by the excised letters in the freestanding wall, and the equally disorienting juxtapositions of form within the compositions. As in his other projects in which performance acts as a support for painting, Gambaroff simultaneously treated process as form, and form as process.

Like Gambaroff, who titled a show at Balice Hertling, Paris, "2008 8864 3362 2250 Z1 CDGRT" after the FedEx tracking number attached to the abstract oil paintings he sent to the gallery, Nick Mauss (b.1980, New York, NY) and Paul Branca (b.1974, New York, NY) expose the gallery as a social structure within which painting operates. For the 2012 Whitney biennial, Mauss built an antechamber to the cosmetics company Guerlain's first Institut de Beauté spa in Paris (dating from 1939), designed by Christian Bérard. Instead of supplying his own drawings or silver paintings, he installed objects from the Whitney's collection on the makeshift walls. A small screen embedded in one of the walls of the stage-set-like space reverse-projected slides of Mauss's studio, fragments of text, and abstractions, which set off further associative chains to be reconciled (or not) by viewers.

5.20

Somewhat differently, Branca develops explicitly relational projects. He has painted images on phone cards for use by immigrants, and more recently, in 2010, set up a "painting distribution project" at Golden Parachutes in Berlin. For this show, Branca hung nineteen monochrome paintings in the colors of the German flag, emblazoned with words or punctuation marks—the ham-fisted results of Google-translated lines about travel and displacement. The title "Couch Crash" nodded to staying with friends, and, more broadly, suggested the peripatetic condition of artists traveling from place to place, and on a low budget. Yet, like Arakawa's work, it also admitted the networks that make this possible. Branca invited his friends in Berlin to take a painting as a gift on a first-come, first-served basis: once they removed their respective paintings, the nails were left behind as markers of the accepted offerings. The only paintings for sale, and which remained on view after the others were taken home, were three works composed of materials left over from making the presents. Thus Branca proposed alternative kinds of exchange.

5.21

In holding these aspects of his work in relationship, Branca refuses the approach of so many relational projects of the preceding decade, which

proposed that gifting upends capitalism, rather than providing it with another point of entry. (While there has been sustained discussion about participatory work—from its prehistory as performance to its consolidation as genre—how painting relates to it remains unclear, as such conversations tend to discuss the participatory artwork as a medium without necessarily attending to its form.) Branca nevertheless maintains the integrity of the painting as painting: whether given or sold, it functions as a painting in the gallery and continues to exist as one after leaving it.

For many others, though, this stability is not taken for granted. Instead, they question not only the value of a painting, but where, when, and under what circumstances it might become or cease to be one. Falke Pisano's (b.1978, Amsterdam, The Netherlands) *Figures of Speech* (2005–10), for example, deftly examines the shifts of role, form, and meaning that occur, according to whether ideas circulate as objects, performances, texts, and so on; likewise,

5.22 Reto Pulfer (b.1981, Bern, Switzerland) insists on lack of finality to the point that a single object—say, *ZR Potzwaus* (2008)—can be endlessly rearranged. Often using time-based strategies, these artists present painting as a malleable form that relies heavily on external factors to activate the medium's potential.

Others use paintings as pretexts for different conversations, still decidedly social in nature, despite the critiques of participatory work like those voiced by Branca. In 2000, Özge Acıkkol (b.1976, Istanbul, Turkey), Güneş Savaş (b.1975, Istanbul, Turkey), and Secil Yersel (b.1973, Istanbul, Turkey) founded the collective Oda Projesi, or "Room Project," in Istanbul, using an apartment in Galata (one of the city's oldest neighborhoods, but gentrifying so rapidly that Oda Projesi lost their lease in 2005, initiating a comparatively mobile way of working) as the site for communal activities and a gathering place for artists, musicians, scholars, and nearby residents. Engaging directly with local children on a regular basis through, among other things, a Sunday program, Oda Projesi's members provided art supplies and instruction, and used clotheslines to display artwork and streets as sites of production and pedagogy.

5.23 More recently, Theaster Gates (b.1973, Chicago, IL) has commenced Dorchester Projects, a major urban renewal project on the South Side of Chicago, where, due to the subprime mortgage crisis, he was able to purchase a condemned building (and then others, including a former beer warehouse close to the first). These are being put to use for concerts and performances, as well as acting as repositories for art and architecture books, nineteenth- and twentieth-century glass-lantern slides, and the archive of John H. Johnson, who founded Johnson Publishing Company, famous for the

5.26

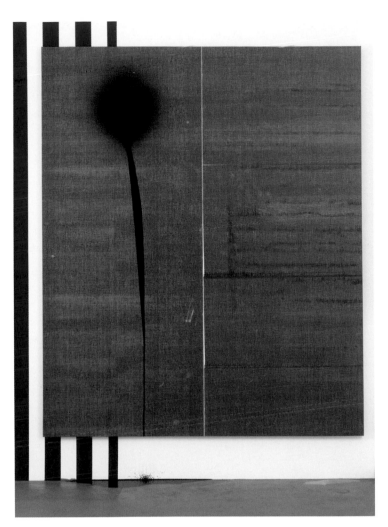

Stephen Prina
PUSH COMES TO LOVE,
Untitled, 1999–2013, 2013
The contents of a can of enamel spray
paint applied to Wade Guyton's,
Untitled, 2013, Epson UltraChrome inkjet
on linen, dimensions variable

5.27

Allan McCollum
Plaster Surrogates, 1982/84
Enamel on cast Hydrostone,
each unique, dimensions variable

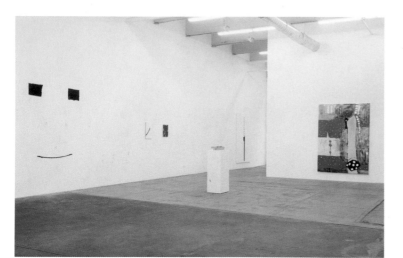

5.28

Richard Aldrich
Installation view of "Once I Was…,"
Bortolami Gallery, New York, 2011

5.29

Mika Tajima
Installation view of
The Extras, × Initiative,
New York, 2009

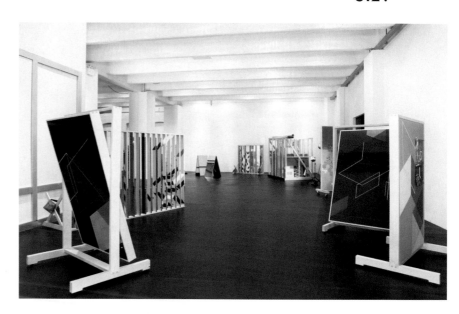

5.30

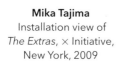

Sarah Crowner
Installation view of "Ballet Plastique," 2011
Paintings and wooden platform,
dimensions variable

magazines *Ebony* and *Jet*. These cultural activities are financed by the sale of artworks fashioned by materials—marble, wood, roofing paper—salvaged from the extant structures. The decommissioned fire hose in particular has become important to Gates for its additional reference to the hosing of peaceful civil rights demonstrators in Alabama in 1963. The project might be compared to others in the US: Edgar Arceneaux (b.1972, Los Angeles, CA) and Rick Lowe's (b.1961, Eufaula, AL) Watts House Project in Los Angeles—modeled on Project Row Houses, Houston, a previous venture by Lowe in the 1990s, which gave shelter to single mothers and set up artist residencies and exhibitions—a nonprofit that gathers artists, designers, and residents of the eponymous post-industrial neighborhood to renovate homes.

Operating within the museum, the Taiwanese artist Michael Lin (b.1964, Tokyo, Japan) makes elaborately painted, day-bed-like platforms, furniture, and cushions with which to absorb work, and in the process become it. Mary
Heilmann (b.1940, San Francisco, CA) produces furniture, the better to view her paintings. Her painted wood and polypropylene webbed Clubchairs on casters allow people to idle and roll about to form conversational groups, in a refusal to administer and determine social space. In a performance involving spectatorship, David Adamo (b.1979, Rochester, NY) stood in front of John Singer Sargent's *Madame X* (Madame Gautreau) (1883–84) at the Metropolitan Museum of Art, New York, for a whole day, interacting with other viewers. For Gaylen Gerber (b.1955, McAllen, TX), artworks can serve as the backdrops for others: his gray monochrome became the support for an intervention by Stephen Prina (b.1954, Galesburg, IL) (p.182), who deposited the contents of an entire can of spray paint onto its pristine surface. Prina has repeated this action with Wade Guyton (pp.47–8) in performances that display paintings for a single night.

5.24

5.25

5.26

In so many cases, as with Koether, Sundblad, et al., the idea of the prop is central, in that it indicates a move away from understanding painting as a discrete and complete object, even when it looks exactly that—a vital point raised by Allan McCollum (b.1944, Los Angeles, CA), who recognized the potential for critique through the production of painting-like objects. The "Surrogate Paintings" that he began in the late 1970s simulate rather than reproduce traditional paintings, even while hanging on the wall. Some are fabricated from wood and museum board, others from plaster cast from rubbed molds, and all have black centers where there could be an image. As McCollum stated in 1982: "My paintings are designed as 'signs' for paintings, or as surrogates; they are meant to function in a way similar to that of a stage prop, but in the normal world of everyday life."

5.27

5.28 In 2007, Richard Aldrich (b.1975, Hampton, VA) wrote of his mostly abstract paintings, which reflect on the process of their genesis and the conventions that determine it:

> These paintings are meant to become props in an ongoing production that aims to present a series of systems that interact with one another. They are not metaphor, nor allegory, but prop. The objects created are specific in themselves, but that specificity is not pertinent to the workings, that is the form of the interactions that can take place, of the systems. These systems are not about a balance or a thought, a final idea or an idealized end, nor a perceived direction, but rather a body in which things are happening.... What is important is that the work sets up a sort of stage in which the viewer is responsible for navigating themselves around.

Aldrich is keen to supply his paintings with a written, even narrative, passage, through manipulations of the insipid form of the press release, from which the above quotation was taken. In so doing, he registers how meaning might be extraneous to the painting, despite the materiality of the work (some of his canvases are incised to reveal the stretcher or wall, while others are decorated with objects that become interchangeable with brushstrokes).

If painting is illuminated here by textual accompaniment, elsewhere it is determined by installation. With curator and artist Howie Chen (b.1976, **5.29** Cincinnati, OH), Mika Tajima (b.1975, Los Angeles, CA) founded the New Humans in 2003, to produce sound work (using physical materials, piercing drones, static, and low bass frequencies)—among other interventions mounted with a larger cohort of collaborators—within the parameters of her own shifting multimedia practice. The elements she includes in her works are paintings, props, stage markers, and functional structures, though not simultaneously. A notable case is *The Double* (2008), presented at The Kitchen in New York, and at the Center for Opinions in Art and Music in Berlin. Tajima conceived of a room bisected by double-sided freestanding panels on wheels, which suggest painting in their planarity and sculpture in their dimensionality, while referencing Robert Propst's Action Office designs commissioned by Herman Miller to foster productivity and conviviality (in fact, they have become markers for alienated labor.)

In addition, Tajima has repurposed the modular units in many exhibition contexts. In *The Extras* (2009) she proposed wooden painting panels as human surrogates amid a scene redolent of a construction site or production set,

while for a 2011 show at Elizabeth Dee Gallery in New York she juxtaposed workspace dividers, ergonomic kneeling chairs, spray-painted wall-bound décor, and a performance by two contortionists; the last strained against these ciphers of efficiency while at the same time flaunting the results of a punishing routine. In concert with Charles Atlas (b.1958, St Louis, MO), Tajima occupied the main space of the South London Gallery for *The Pedestrians* (2011). Over a ten-day period, the exhibition area became a rehearsal venue, film set, and installation, supporting a program of performance, music, video, lecturing, painting, and sculptural tableaux—all of which were negotiated by viewers, who were guided through the space on a walkway.

Sarah Crowner's (b.1974, Philadelphia, PA) collage-like, sewn geometric paintings appropriate schemes from Victor Vasarely, Lygia Clark, and others, in their part-by-part seamed constructions, and also serve as backdrops for unscripted actions in the gallery, with some even suggesting theater curtains opening to an empty stage. "Ballet Plastique" (2011), at Galerie Catherine Bastide in Brussels, featured a raised plywood platform—clearly, a stage—on which visitors climbed to inspect the paintings. For "Acrobat," a show of the same year at Nicelle Beauchene Gallery in New York, Crowner exhibited small wooden sculptures, envisioned as theater models, or, less specifically, proposals for subsequent incarnations. Indeed, this permissiveness was borne out in her painted backdrop for a Robert Ashley opera at the Serpentine Gallery, London, in 2012.

5.30

Given these destabilizing relations, one might assume that painting has lost any sense of boundaries or coherence. Yet the flip side of these negotiations of borders is that they are being redrawn, for it is a stable—or at least stable enough—definition of "painting" that allows for and even makes meaning of such deconstruction. To act on painting, as opposed to using it to transmit content, represent narrative, and so on, is to endow it with a self-reflexivity capable of producing painting about painting, as the final chapter will describe.

6

About Painting

Writing in *Art News* in 1958, Allan Kaprow eulogized Jackson Pollock, arguing that his "near destruction" of conventional painting obliged its revaluation, less as a medium than as a context for conveying multiple sensory experiences. In a rightly famous passage near the text's conclusion, Kaprow insisted that:

> [Pollock] left us at the point where we must become preoccupied with and even dazzled by the space and objects of our everyday life.... Not satisfied with the suggestion through paint of our other senses, we shall utilize the specific substances of sight, sound, movements, people, odors, touch.

While this charge led away from painting into, say, Kaprow's own Happenings, painting now, as the previous chapter has shown, readily incorporates the "beyond." This might happen through works that move painting further from their function as images, and towards objects that act in space, intervene in sites, or mutate through a performance.

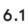

6.1

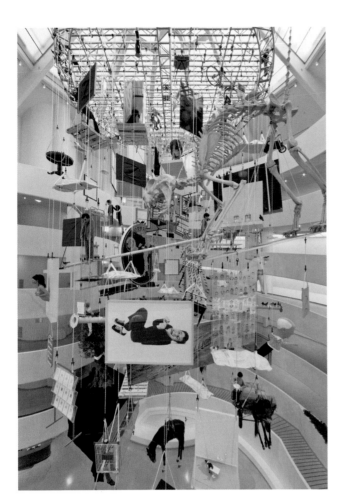

Maurizio Cattelan
Installation view of "All," 2011
128 works in mixed media,
dimensions variable

Nasrin Tabatabai and Babak Afrassiabi
Installation view of "Two Archives,"
Tensta Konsthall, Stockholm, 2013

6.2

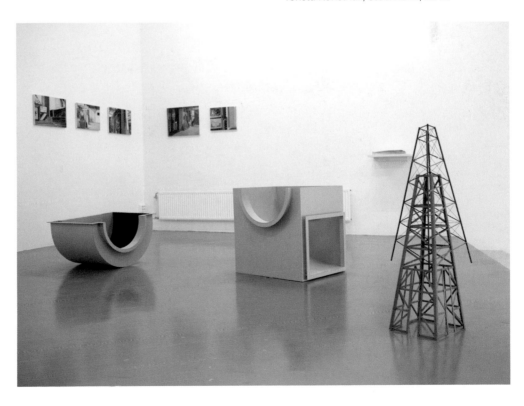

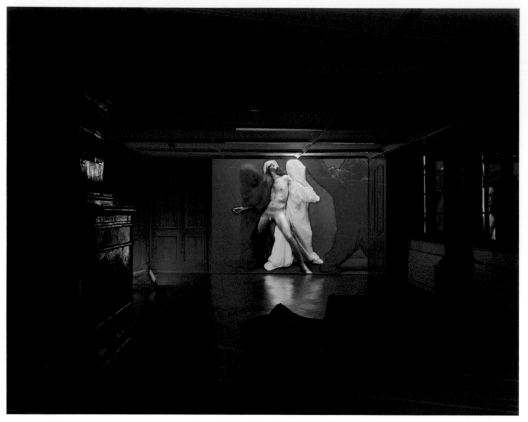

6.3

Heimo Zobernig
Installation view of "Ohne Titel (In Red),"
Kunsthalle Zurich at Museum Bärengasse,
2011

6.4

Stephen Prina
Installation view of *Exquisite Corpse: The
Complete Paintings of Manet, 135 of 556:
L'Execution de Maximilien de Mexique III
(The Execution of Maximilian of Mexico III),
1867* at Kunsthalle Mannheim, 1990.
Left panel: ink wash on rag and barrier
paper, 252 × 305 cm (99³⁄₁₆ × 120¹⁄₁₆ in.);
right panel: offset lithography on paper,
66 × 83 cm (26 × 32¹¹⁄₁₆ in.)

Maurizio Cattelan (b.1960, Padua, Italy) achieved a spectacular version of this **6.1** possibility when he installed 128 of his artworks—representing the near-entirety of his work since 1989, from preserved animals to framed photos and paintings—at the Guggenheim Museum, New York, in 2011, for his retrospective "All." The works did not hang on the walls, but rather from ropes lowered from the ceiling of the museum's Frank Lloyd Wright rotunda—an especially strange unmooring for some pieces, like *Untitled* (2009), a painting pinned to a wall by a broom, whose upright stick pokes and distorts the canvas surface. Viewers circled the ramps to view the art, which was organized without chronology or spatial order. Compared in the press to a dissection theater, the show amplified Cattelan's broader theme of death (his most famous works include a sculpture of Hitler kneeling in prayer in the former Warsaw ghetto, and another of Pope John Paul II struck down by a meteorite). Cattelan turned the condition of potential obsolescence, signaled by the mid-career retrospective, into a kind of gallows humor, announcing that he would retire from making art at the conclusion of the show.

If Cattelan represents just one position for painting as an object—and a potentially inert one at that, hanging listlessly, as if from a noose—he also suggests the ways in which artists have internalized their forebears' institutional critique. The Guggenheim's history itself affords examples of past assaults, by the likes of Hans Haacke (b.1936, Cologne, Germany) and Daniel Buren (b.1938, Paris, France): both called foul on the institution while operating within it, pointing to the burden of architecture as well as to the museum's operations. In 1971, Haacke's solo show at the Guggenheim was cancelled and the curator Edward F. Fry fired, when the artist refused to pull works such as *Shapolsky et al. Manhattan Real Estate Holdings, a Real-Time Social System, as of May 1, 1971*, which details through images and data the real-estate holdings of a New York empire built on slums. Earlier that same year, Buren's *Peinture-Sculpture*, a giant, vertically striped banner, unfurled from the skylight at the apex of the rotunda, was removed from the museum's "Sixth Guggenheim International Exhibition" after fellow exhibitors complained that Buren's installation blocked sight of their works. Though other artists wrote protesting this act of censorship, the painting was not reinstalled. The Buren episode remains a potent instance of institutional critique, as well as one registered through painting.

For Nasrin Tabatabai (b.1961, Tehran, Iran) and Babak Afrassiabi (b.1969, **6.2** Tehran, Iran) it is the political exigencies that result in paintings moved across borders, and into or out of visibility, that form the subject of their painting, installation, and video work. Since 2004 they have collaborated

under the name Pages, and published a bilingual (Farsi and English) magazine; in 2011 they began a series involving intersecting archives in the UK and Iran, one industrial and the other cultural. The British Petroleum (formerly the Anglo-Persian Oil Company, and then the Anglo-Iranian Oil Company) archive recounts the modernization that took place in the region, through documents relating to the company's operations in Iran from 1908 to 1951 (when the oil industry was nationalized). Their second case study, the collection of modern Western art by the Tehran Museum of Contemporary Art during the late 1970s, continues the former project on different terms, since it was rising oil prices that made possible the acquisition of Western works. Following the Islamic revolution in 1979, the collection was withdrawn for twenty years and put back on display only intermittently thereafter. Tabatabai and Afrassiabi's images of storage racks further estrange these works, while simultaneously exposing the situation.

6.3 In another instance of props used to transform perceptions of painting, Heimo Zobernig (b.1958, Mauthen, Austria) has installed "paravents"—grids based on canvases and supports. These refer to a related series of geometric abstract paintings and continue his earlier appropriations of modernist exploits, from monochromes keyed to International [Yves] Klein Blue to primed white canvases. Asking not only what a painting is, but literally how we see one, Zobernig collaborated with Albert Oehlen (p.69) in 1994 for a show at the Vienna Kunsthalle, where he installed red fluorescent lighting— an incandescent haze through which to see Oehlen's canvases. Zobernig reprised this strategy at the Museum Bärengasse in 2011, where, as before, the circumstances of display transformed the objects on view—in this case, Zobernig's own work—which were ostensibly independent of it. But the strategy was in part pragmatic, a deliberate amplification of the museum's lighting problems, which Zobernig made worse, effectively recuperating these institutional shortcomings as aesthetic.

6.4 Stephen Prina (p.175) has described his output as "system specific," a reflection on exhibition spaces in relation to art discourse. His long-term projects often mutate within different contexts—of association as much as architecture— in a chain of reference that leads back to previous shows and sources. *The Painter's Studio, Real Allegory, Resolving a Phase of 153 Years in My Artistic Life: A, No.1* (2001), an off-white, screen-printed canvas with the initials "SJP," suggests his longstanding affair with painting as subject and practice. More recently, he has made paintings in primary colors on commercially produced linen window blinds, merging art and architecture in a new variation on collaborating with site.

6.5

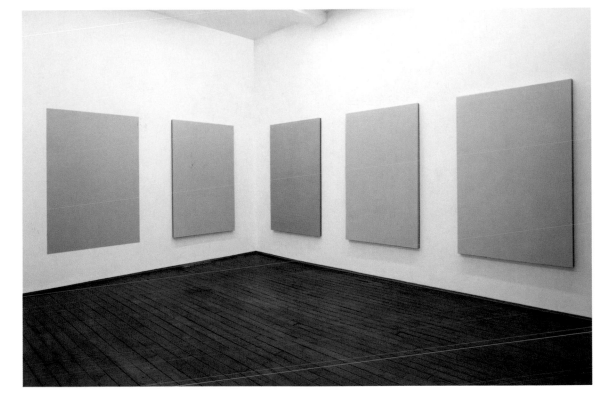

Scott Lyall
Installation view of "Nudes" (2011)
at Sutton Lane, Paris, 2011

6.6

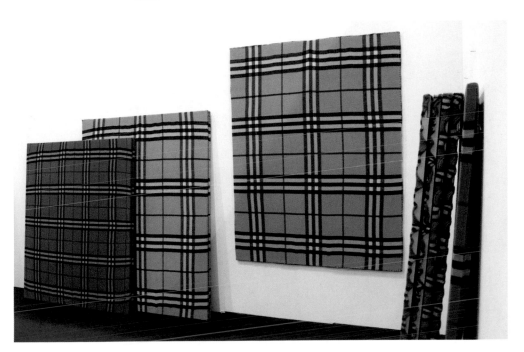

Merlin Carpenter
Reena Spaulings booth at
Frieze Art Fair, London, 2008

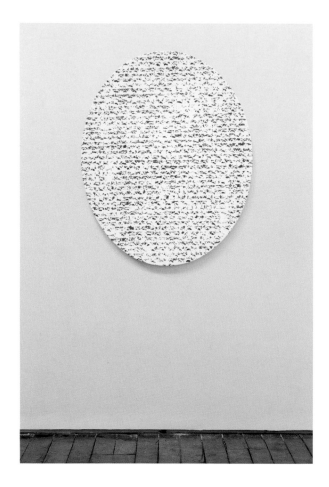

Cheyney Thompson
Chromachrome (S6/SPR) (Tondo), 2009
Oil on canvas, 76.2 × 61 cm
(30 × 24 in.)

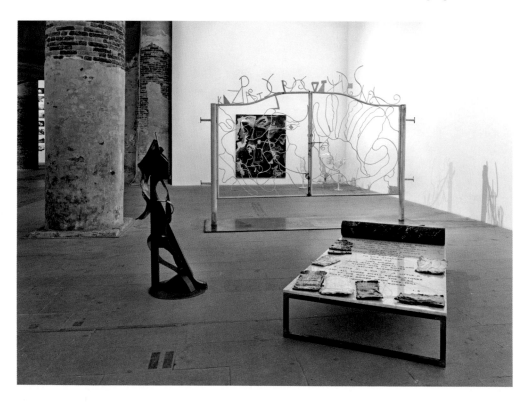

Ida Ekblad
Installation view of "ILLUMInations,"
54th Venice Biennale, 2011

6.9

Matt Connors
Table II (16 Cups), 2010
Oil and acrylic on canvas
91.4 × 66 cm (36 × 26 in.)

6.10

Robert Janitz
The Tarot Card, 2013
Oil, wax and flour on linen,
195.6 × 152.4 cm (77 × 60 in.)

6.11

David Ostrowski
F (A thing is a thing in a whole which it's not), 2013
Acrylic, lacquer, and paper on canvas
240 × 190 cm (94½ × 79⅞ in.)

6.12

Gary Hume
Yellow Window, 2002
Gloss paint on aluminum, 135 × 98.1 cm
(53⅛ × 38⅝ in.)

6.13

Guillermo Kuitca
Lontano, 2010
Oil on linen, 195 × 164 cm
(76¾ × 64½ in.)

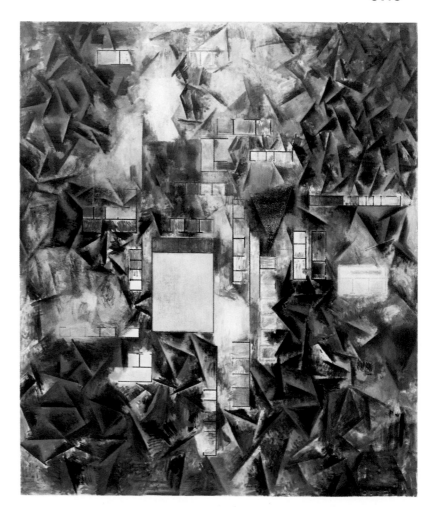

Yet Prina's best-known project is his *Exquisite Corpse: The Complete Paintings of Manet* (1988–present), an ongoing reinterpretation of each of the 556 items of Édouard Manet's oeuvre listed in a now-outdated catalogue raisonné. Rather than reproducing the extant paintings, Prina pairs a lithograph of a particular work with a tabulated overview of Manet's corpus as a whole, executed in ink wash or watercolor on rag paper. Each of the individual titles—when cited in full—refers to an original painting and its location, including the places and collections through which it has passed. Prina has admitted to choosing Manet as the subject of this exercise precisely because of the latter's erstwhile status as the first modernist artist, as well as that of the first "museum artist"—that is, an artist who assumed the museum as the eventual home for his painting—according to the philosopher Michel Foucault. This formulation shows paintings to be implicated in institutions and dispersed across fields of information, even before they are painted.

This anticipation of the gallery as the destination for painting, broached in Prina's project, has been investigated in other instances. Scott Lyall (b.1964, Toronto, Canada) introduces relations between material, the gallery space, and his areas of research. For an exhibition at Sutton Lane, Paris, in 2011, he exhibited fields of color—a digital composite of innumerable information sources—applied to canvas and vinyl. If the work is neither solicited for subsequent showing, nor purchased, Lyall retires the file on which it is based.

6.5

Merlin Carpenter (b.1967, Pembury, UK) is a former assistant of Martin Kippenberger, as well as a writer and co-founder of Poster Studio—an artist-run space in London, which he started in 1994 with Dan Mitchell, Nils Norman, and Josephine Pryde. In 2011, Carpenter gave away a gestural painting in exchange for twenty copies of it, painted by the recipient and signed with a stencil. He has exhibited paintings produced in galleries just in advance of, or even during, exhibition openings: the latter canvases bear slogans such as "BANKS ARE BAD," "Kunst = Kapital," and "DIE COLLECTOR SCUM," and have been presented in galleries in New York, Zurich, London, and Brussels, as well as in a car showroom and a fashion boutique. In 2005, he enlisted the assistants at Reena Spaulings Fine Art, New York, to make abstractions in the style of Josh Smith (p.102), using gallery materials, one Xerox per canvas, resulting in a portrait of the gallery at the time of exhibition. At the Frieze Art Fair in London in 2008, he exhibited Burberry throws, both genuine and knock-off, displayed on stretchers.

6.6

As these works illustrate, Carpenter's paintings are suited to the spaces they critique, especially, perhaps, his holistically conceived "Tate Café"

at Reena Spaulings in 2012, the upshot of gallerists contributing a work of Carpenter's to the Tate for its 2009 pop-art blockbuster, "Pop Life." The "Tate Café" was built around its namesake's recognizable furniture, counter area, comment cards, and a photomural of the venue's view of the Thames. At the same time, a bookstore stocked with books associated with the gallery provided a setting in which to peruse an interview between Carpenter and gallerists John Kelsey and Emily Sundblad (pp.161–65), which discussed the event but failed to answer the questions it prompted about the roles of artists and museums. Like a snake eating its tail, the paintings Carpenter included could well end up at the Tate.

6.7 Cheyney Thompson (b.1975, Baton Rouge, LA) similarly explores the subject of networks of invention and display, often using folding tables as organizational frames for objects. "Quelques Aspects de l'Art Bourgeois: La Non-Intervention (Certain Aspects of Bourgeois Art: Non-Intervention)," a 2006–7 show at Andrew Kreps Gallery, New York, consisted of a series of twenty-five color offset lithographs depicting the gallery's art storage bay, clustered in groups of five; four large abstract, grayscale oil paintings derived from blurred photocopies; and eight lightweight folding tables on which were displayed sixteen imageless photographic prints progressing from white to black. A viewer following the diagonal path of the tables would traverse the gallery to arrive at the storage bay pictured in the lithographs, completing the narrative circuit. However repetitive the loop, the folding tables—on the one hand, neutral presentational devices and, on the other, explicit symbols of the portable economy of the street—led back outside, further extending the reach of the objects and their relations featured indoors.

In 2009, Thompson completed two related projects, *Chromachromes* and *Chronochromes*, which addressed painting and its systems even more directly by exploring the materiality of canvas and its historical formats. For these works, Thompson scanned, enlarged, and reproduced the grid of a section of raw linen on a series of new canvases of different shapes and sizes—the circular format of one echoes a Renaissance tondo, while another consists of a wry 24 × 1-inch piece, whose dimensions are even more absurd in relation to the other shapes. Each canvas is composed of a pattern that replicates the actual weft of its material support, oriented either horizontally or diagonally. Though Thompson relies on mechanization, the paintings are, in fact, hand-painted in an array of complementary hues based on the American Albert H. Munsell's colorimetric system, which Thompson has extended through the use of specific colors on certain days (even the colors' tones are based on the hour of their painting, with noon calling for absolute black and white.)

6.14

Elise Adibi
Charcoal Drawing, 2011
Rabbit-skin glue, graphite,
and charcoal on canvas
182.9 × 182.9 cm (72 × 72 in.)

6.15

Juan Uslé
In Kayak (Silente), 2012
Vinyl, acrylic, dry pigment, and
dispersion on canvas, 46 × 31 cm
(18⅛ × 12³⁄₁₆ in.)

6.16

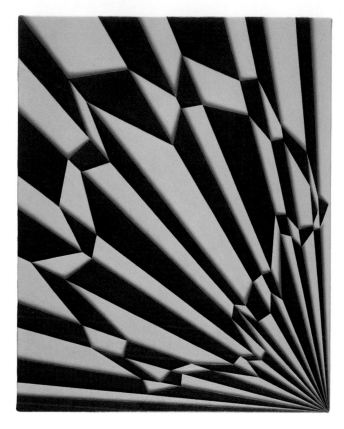

Tomma Abts
Meko, 2006
Acrylic and oil on canvas
48 × 38 cm (18⅞ × 14¹⁵⁄₁₆ in.)

6.17

Sigrid Sandström
Untitled, 2009
Acrylic on board
122 × 153 cm (48 × 60 in.)

More recently, a playful installation featured Thompson's abstract images as a kind of painting by the yard, with items of identical height but inconsistent width proportioned to the walls, as if they had materialized in response to them. Installed in a room of different dimensions, these paintings will occupy another position, reflecting their origins and history of display.

Like Thompson, Ida Ekblad's (b.1980, Oslo, Norway) works imply the world beyond the gallery. Her sculptures are often accumulations of metal and other materials salvaged from the street or scrap yard, welded together and painted in monochromatic coats of lacquer that treat fragments of cars, train tracks, or ironing boards as aesthetic objects. She also makes so-called "sculpture missions" on location—from New York's Rockaway Beach to London's Clapham Common—for presentation in these cities. In some cases, Ekblad has fashioned freestanding gates, which emphasize the portal-like nature of her gestural paintings, and lead, in this case, into the canvases. The brightly hued, roiling expanses of color folding in on itself imply a passage from shape to shape, and into entangled, contour-less form.

6.8

At the same time, Ekblad's withdrawal into the picture admits a dependence on modernism: Kandinsky and Miró, Matisse and Asger Jorn. Like so many other artists, she mines this past with an unburdened openness. In this respect, she comes close to Matt Connors (b.1973, Chicago, IL), who appropriates a host of individual precedents (many of which overlap with those visually cited by Ekblad, with the notable addition of color-field abstraction as practiced by Morris Louis and Kenneth Noland). But Connors also moves, in his own words, towards "a kind of inward progression so that materials, processes, the studio, and my own actions have all started to qualify for me as origin points in and of themselves." Using mostly raw canvases, he pours paint, which the fabric absorbs like dye, and has also imprinted one canvas with another, and with the traces of their surroundings. Connors seems to go out of his way to make clear the reasoning behind his compositional choices and methods of execution, whether cockeyed forms, over-painted designs, or rings left behind from paint cans, jars or coffee mugs (containers he was using at the time to hold paint, gesso, and brushes).

6.9

Connors also places a premium on frames. *Picture Corners* (2010), a relatively small panel, employs three devices to emphasize the frame—large black triangles fixed to the corners of the canvas, just shy of its edge, an unpainted perimeter, and, close to this, a thin blue line. Fergus Feehily (b.1968, Dublin, Ireland) also relies on the frame as a primary element, in small paintings

6.10 composed of wood, paper, fabric, and paint, sometimes to bind a stack of such materials together. Robert Janitz (b.1962, Alsfeld, Germany) moves oil and wax around on a linen support in thick strokes, which evoke the repetitive actions involved in window washing, spackling, or grouting. He also leaves corners unpainted to reveal under-painting, thus implying the picture plane is a kind of threshold, while preventing optical regression except at the periphery.

6.11 Many of David Ostrowski's (b.1981, Cologne, Germany) works incorporate frames (which might be painted a sunny yellow, black, or both in some combination), or play with finitude. Plenty of his paintings involve abstract figures placed askew, as if the picture plane has been rotated relative to its support; in some, a trail of spray paint follows the edge and reinforces where the surface stops. Ostrowski's reduction of means and his accidental formalism—which, like that of Connors, arises from chance events (such as canvases marked with dirt picked up from the studio floor)—emphasize the inevitably pictorial nature of what these borders contain: collaged sheets unevenly pasted down to create a tactile, near-sculptural, presence; the application of a piece of foil that garishly revels in the refraction of light; and gestural passages of quickly applied paint.

6.12 Gary Hume (b.1962, Tenterden, UK) has also made paintings that focus on the frame as theme. His *Door Paintings*, some fifty big, rectangular slabs, the dimensions of which mimic precisely those of their subject—the swing doors in a derelict, state-funded London hospital—were shown to great acclaim in the generation-defining "Freeze" show curated by Damien Hirst (p.95) in 1988. Although Hume got the idea for the series from an advertisement for private health care at the time of the funding cuts to the UK's National Health Service carried out by Margaret Thatcher's government, the doors also offered a template adaptable in color and design but consistent in its reference to the tradition of painting. More specifically, they also operated as a metaphorical window to another realm, which he made literal in a painting of a window composed in 2002, a decade after painting the final door. The panes of Hume's window, however, are blacked out, presenting a flat plane and annulling transparency and perspectival depth.

6.13 Though grids, plans, and evocations of geopolitical displacement (as in *Le Sacre* [1992], a suite of fifty-four child-size mattresses painted with maps of various randomly selected locales) remain of interest, Guillermo Kuitca (b.1961, Buenos Aires, Argentina) has also turned to the legacy of painting itself, in the series *Desenlace (Dénouement)* (2006–7). In these and later works, signs of modernism and abstraction, which he appropriates as pictorial effect,

become a series of modes to revisit (for example, the faceted planes key to the early Cubism of Picasso and Braque cover Kuitca's surfaces, differing in scale and brushwork).

Elise Adibi's (b.1965, Boston, MA) works involve a more direct engagement with the material of painting, exploring the role of accident in generating relationships. As well as activating the canvas itself (Adibi works with a precise shade of pistachio green that brings forth the otherwise imperceptible red in the unprimed beige fabric), in many pieces she uses the grid as a foundation for emergent patterns. Despite the priority of the canvas and its regularized matrix, the combination of multiple paint layers and human slips means that physical imperfections, misalignments, and miscalculations predominate: lines, marks, and brushstrokes all become an extension of the artist. Adibi pushes this bodily connection with her work further by choosing organic materials, such as rabbit-skin glue, graphite, and even her own urine, which seeps into the thick, welcoming ground, streams down its surface in rivulets, or radiates outward in stains that suggest cosmic nebulae, meaning that the imagery "develops" as the urine interacts with a copper-based paint that coats the support like an emulsion.

6.14

For decades, Ha Chong-Hyun (b.1935, Kyeong-Nam, Korea) has forced paint through the weave of hemp cloth to create the possibility for transcendence through the manipulation of matter, as in his monochromatic *Conjunction* paintings; only recently did he move into primary colors. For Juan Uslé (b.1954, Santander, Spain), who applies paint in pulsing brushstrokes in time with his own heartbeat, repetition becomes a form of translation. His small-scale *In Kayak* works (2012–present) achieve parity between method and theme, on account of his technique—bands of dark, narrow strokes laid side by side—which reflects the repetitive movement of oars.

6.15

Tomma Abts (b.1967, Kiel, Germany) instead shuns references to nature, her body, and identity, and, indeed, anything that lies beyond the canvas, aiming for a work that "becomes congruent with itself." Her compositions—all aproximately 18⁷/₈ × 15 inches (48 × 38 cm), vertically oriented and titled with proper names from an obsolete German dictionary—emerge from the give-and-take that comes with numerous layers of paint. In some works interlocking linear elements float across densely layered fields, while in others the surface is bisected by delicate webs of faintly protruding ridges, which give them an oddly sculptural effect at close range. This somewhat protracted process reveals her commitment to creating the object and giving it an identity, but Abts stops short of making her intentions directly accessible.

6.16

Rather, in insisting upon the primacy of form, she asks whether abstraction can negate, or at least forestall, meaning.

6.17 Sigrid Sandström (b.1972, Stockholm, Sweden) works with formal abstraction, and, like Abts, who crosses seams produced by multiple paint layers with illusionistic shadows, she manipulates spatial effects and creates pockets of depth. Sandström uses the visual cues of collage, but through paint rather than paper—as if torn, cut, or glued to the surface; her hyper-realistic depictions of masking tape and other studio implements reflect on the practice of painting as a haptic process through which, in varying degrees, compositions emerge. Sandström describes her paintings as "areas of under-determinacy; white expanses that could be suggestive of beginnings or as reconsiderations: literal blank sheets."

6.18 Zak Prekop (b.1979, Chicago, IL) similarly employs collage: brown paper bags or heavy-stock paper affixed to the reverse side of a canvas so that it shows up on the face as subtle relief. Prekop also relishes the pallet knife, using it to produce expanses of unmodulated color, which sometimes become the ground for patterns applied with a stencil. Even when the genesis of Prekop's works is apparent, the paintings do not readily reveal their means of assembly. Prekop paints many canvases from both sides, often re-stretching the linen so that paint seepage turns the back into the front, thereby exploiting the possibilities of positive and negative space. And like Abts and Sandström, he supplies illusionistic signs of the underlying support, such as a painted stretcher bar that echoes the real form.

Hence abstraction is now flourishing, though often regardless of the characteristics of medium specificity, and without the underpinning of a progressive ideal. Instead of emphasizing the flatness of the canvas, artists revel in conjuring illusionism and shadow, as well as in creating narratives of the process by which works come into being (often by analogies with other **6.19** methods and technologies). Jacob Kassay (b.1984, Lewiston, NY) has made a large body of elemental, chemically produced abstract paintings, using a photographically derived electroplating technique that produces a mirror-like surface, capable of reflecting—albeit imperfectly—the space around them. Also pertinent here is the example of Australian artist Tim Maguire (b.1958, Chertsey, UK), for whom issues of process and materialization of an image are central, and who paints digital imagery through a method indebted to printing: first selecting and cropping an image, he then splits it into the three primary print colors (yellow, magenta and cyan), which he applies in layers covered with solvent. In a different vein, the rigorous paintings

6.18

Zak Prekop
Untitled Transparency, 2012
Oil and paper on canvas
182.9 × 121.9 cm (72 × 48 in.)

6.19

Jacob Kassay
Installation view at EXPO 1: New York,
MoMA PS1, 2013

6.20

Sonia Almeida
Diagonal Pathway, 2011
Oil on canvas, 198 × 147.3 cm
(78 × 58 in.)

6.21

Tauba Auerbach
Untitled (Fold), 2012
Acrylic paint on canvas on wooden
stretcher, 182.9 × 137.2 cm
(72 × 54 in.)

of Sonia Almeida (b.1978, Lisbon, Portugal) contain separate layers that open up space. Also taking her cue from the printing process, she uses restricted colors, or highlights their artificiality. Her interest in color theory has led her to query the impossibility of converting between light- and pigment-based color models (RGB and CMYK), and to experiment with after-images, and repeated or reoriented forms, through complementary colors.

6.20

Visual complexity is also a feature of the works of Tauba Auerbach (b.1981, San Francisco, CA). Following her diagrams of the semaphore alphabet and patterns derived from the binary language of digital technology, in 2009 she began her *Fold* paintings. These appear three-dimensional, but are, in fact, charged after-images of their pre-stretched state, in which the folded, crumpled canvas was spray-painted with an industrial gun before being re-flattened on the stretcher. As clues to these prior configurations, each crease is both illusionistic and literal, as a 1:1 relationship exists between the surface and its image. In her *Weave* paintings, the support becomes an instigator of form: strips of canvas bound into geometrical patterns imitate the architecture of the wooden stretchers. Taking the image of the corner as her starting point, Auerbach unfurls a field of intersecting planes to create an undulating monochromatic pattern in which two overlying grids intersect at an angle.

6.21

Dana Schutz's (b.1976, Livonia, MI) commitment to narrative-based figurative work operates according to different but equally palpable notions of pictorial complexity, which involve pairing subject matter with the style chosen for a particular region of the composition: scrapers, squeegees, and oil crayons might be employed to highlight characters, gestures, and moods. Through this, Schutz achieves a coincidence between the "how" and the "what" of the painting. A recent work, *Assembling an Octopus* (2013), images a figure-drawing class through a variety of vignettes. The drawings—layers of representation, one upon the next in a kind of *mise-en-scène*—block the view of the space while also constituting it, in a kind of allegory of representation.

6.22

As these artists show, the challenge to the medium—to the easel picture, to the convention of covering it in paint, and so on—can just as productively come from within, rather than rely on an exceptional presentational format, like those explored in the previous chapter. Laura Owens (b.1970, Euclid, OH) made this point powerfully when she presented twelve large-scale paintings covered with bold, computer-generated motifs in a warehouse near downtown Los Angeles in 2013. Long invested in the possibilities for painting (which conflicted with the conceptual orthodoxy of the California Institute of the

6.23

Arts, where she studied in the 1990s), she has filled canvases with lush landscapes and astute, ambitious but playfully wonky abstractions, for which she employs a variety of techniques and media, ranging from impasto to silkscreen. But her show at 356 Mission, her first in Los Angeles since her solo exhibition at the LA Museum of Contemporary Art in 2003, additionally argued for the alignment of production and consumption. As well as a site-specific installation, the building houses an open studio, a pop-up of the art bookstore Ooga Booga, and an event space for readings, performances, and other exhibitions. Importantly, while the space itself is flexible and destined for multiple uses, Owens's graphic paintings remained on the wall as affirmatively flat canvases.

Paintings about painting become a site for both material and conceptual elaboration for others, like Alex Olson (b.1978, Boston, MA), who plumbs the history of marks, finding in each instance of a brush making contact with a ground a received history of past usage and reference—a thing and its image. **6.24** Differently engaged with historical conventions, Lesley Vance (b.1977, Milwaukee, WI) photographs still-life arrangements of shells, horns, coral, or a ceramic jar, which she turns into abstract compositions over the course of a single sitting. Her earlier still lifes of flowers and bivalves betray self-consciousness in heavily worked passages where the brush has lingered and gone sketchy, thereby obscuring some detail that it might have clarified; more recent abstractions foreground material process—how the work came into being, rather than to what it refers. Knowing that a still life culminated in a non-objective image offers little help in identifying its references, even if in rare instances a shape or color hints at a source. More commonly, Vance highlights the role of the paint and her approach to painting, to call attention to, rather than conceal, the nature of her art.

Vance's restriction of the act of painting to a particular scenario or period of time means that there is neither a specified objective (as in a composition determined in advance) nor a knowable outcome. There is only a provisional ending that results from her calling it quits for the day, and leaving the painting permanently in whatever condition it has reached. In this respect, her works are built on the logic of suspension. Each painting depicts—and comes to rest in—a state poised between what brought it into being and where it might still go. Caught where it is, at a specific moment, each one is emblematic of the fleeting precariousness long associated with still life, a condition that is also highly suited to the privileging of means above ends. Despite this, the painting in and of itself matters to Vance a great deal.

6.22

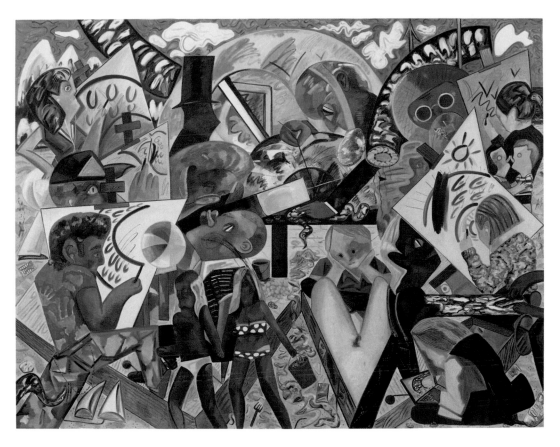

Dana Schutz
Assembling an Octopus, 2013
Oil on canvas, 304.8 × 396.2 cm
(120 × 156 in.)

6.23

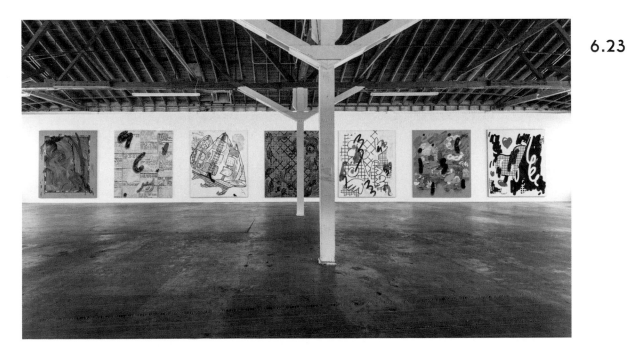

Laura Owens
Installation view of "12 Paintings by
Laura Owens and Ooga Booga #2 12,"
356 S. Mission Road, Los Angeles, 2013

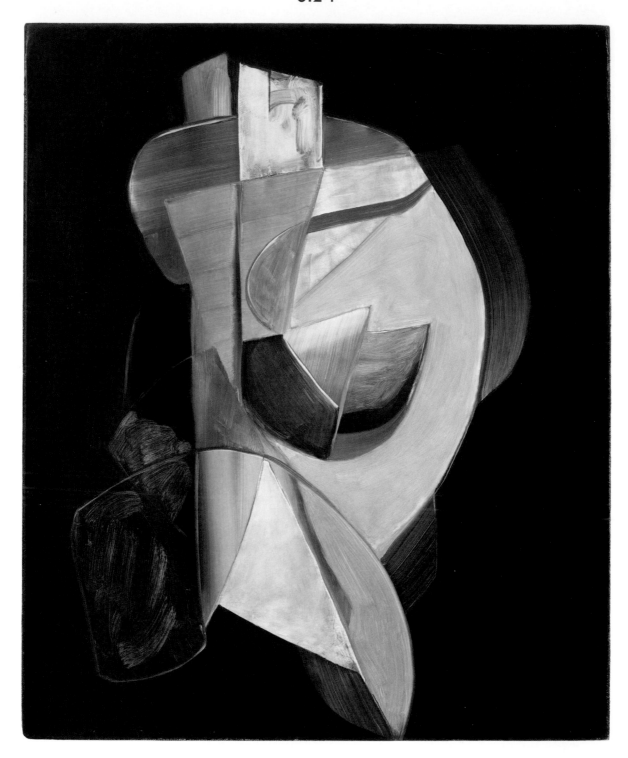

Lesley Vance
Untitled (26), 2009
Oil on linen, 43.2 × 35.6 cm
(17 × 14 in.)

6.25

Josephine Halvorson
Sign Holders, 2010
Oil on linen, 101.6 × 76.2 cm
(40 × 30 in.)

6.26

Ruth Laskey
Twill Series (Robin's Egg Blue/
Yucca/Light Green), 2007
Hand-dyed and handwoven linen
50.2 × 46.4 cm (19¾ × 18¼ in.)

6.28

Anna Betbeze
Loam, 2012
Acid dyes, watercolor on wool
248.9 × 152.4 cm (98 × 60 in.)

6.27

Dianna Molzan
Untitled, 2013
Oil on canvas on poplar
109.2 × 73.7 × 20.3 cm
(43 × 29 × 8 in.)

This is also true for Josephine Halvorson (b.1981, Brewster, MA). Her small 6.25 oils of newspapers, book spines, tombstones, machines, and domestic and industrial surfaces embrace the lost tradition of American still life, creating tightly cropped records of the material world depicted at arm's length (making an object by hand is, for Halvorson, "a radical act with ethical implications"). Like Vance, she usually completes a piece in one stint, meaning that looking and painting are coincident, or that painting is the precondition for looking. Halvorson paints on site, although her titles do not connect canvas and place; but her lushly applied paint, speckled with globs and textured with bugs stuck to the wet surface—as in *Sign Holders* (2010), which displays a viscous mingling of gnats and paint—marks the duration and place of creation. Likewise, other compositions reveal the investment of time—the close observation that causes an object to develop into a collection of colors and shapes. Many of Halvorson's newer paintings crop surfaces into illusionistic openings, and often include rectangles, which, in a form of reflexive mirroring, can be understood as allusions to the canvas's periphery. These are paintings about paintings, but also about how the medium trains us to see.

Halvorson's conflation of painting and the obsolete tools that are her subjects reveals a desire to overcome novelty via patience, and banality through sincerity. Although they differ in approach, many other artists explore the ethical dimension of craft, particularly as a way of revaluating painting as a manual–conceptual activity. After becoming dissatisfied with more traditional painting materials, Ruth Laskey (b.1975, San Luis Obispo, CA) began to make 6.26 paints from scratch and to weave her own canvases. She now uses a loom to make her pieces, the individual threads of which she paints and then laces into the structure of the canvas. The resulting effects—which follow preparatory sketches (each titled *Study for Twill Series*) on graph paper to ensure mathematical exactitude for her color fades and designs—show figure and ground to be inseparable as part of the woven matrix. Once complete, Laskey's woven paintings recall the maligned "women's work" of fireside embroidery. But in their strict geometries, they also make clear their origin in modernist formal experiments. Laskey does not engage in explicitly feminist critique, yet her appeal to the intimacy of process and her insistence on her own laboring body foregrounds such concerns.

Less interested in techniques such as sewing, weaving, or knitting than in understanding the infrastructure of the canvas itself, Dianna Molzan (b.1972, 6.27 Tacoma, WA) takes the weave as her starting point. Instead of treating this as a ground to be covered, she reveals it, as well as the paint and stretcher, in strikingly physical ways. Her sliced, twisted, unraveled, and draped canvases

expose the wooden armature underneath, and behind it the wall, which the paintings actively frame. She has dressed the support in ruched fabric, strung cans from its armature, and draped ropes across its face. Addressing both the norms of painting and the trends that determine their understanding at specific moments, Molzan titled a recent show "La Jennifer," using the American name, once ubiquitous and now out of favor, to insist upon such historicity.

6.28 A similar motive underpins the work of Anna Betbeze (b.1980, Mobile, AL), who eliminates the canvas altogether, using woolen Flokati carpets as grounds to be razed: saturating the rugs with acid dyes and burning them; pulling or shearing their tufts; or washing them before hanging them on the wall, sometimes with their matte undersides facing out. Despite the violence—the "near destruction" of painting, in Pollock's terms, with which this chapter began—that Betbeze enacts as a means of renewal, the works nonetheless depend entirely on the convention of the support as critical, even, paradoxically, inviolate. (For a notable precedent that reveals, though by different means, a similar reliance on the canvas, see the abject *Carpet N*

6.29 [2009–11] by Paul McCarthy [b.1945, Salt Lake City, UT], an array of soiled rugs from his studio floor, littered with condoms and brushes, clearly trammeled underfoot, and otherwise destined for landfill.) The support, then, is a mental habit as much as a physical structure, as demonstrated by Sergej Jensen (b.1973, Maglegaard, Denmark), who makes abstract paintings without paint, constructed from found textiles, the imperfections of which nod to their prior lives which are recuperated as pictorial effect.

By mental habit, I also mean to imply the daily routine of making art. By way of conclusion, I intend to return to questions of time as broached in the book's title and described in the introduction, but also to allow for the registration of time's passage within the painting itself. Although he was

6.30 trained in a state-sanctioned form of realism, since 1988 Ding Yi (b.1962, Shanghai, China) has made large-scale abstract paintings with patterns of × and + symbols—a homage to Piet Mondrian's grids, which he developed from breaking up the natural world into a series of horizontal and vertical lines, as well as a nod to the publisher's cross (a symbol used to check the alignment and color in publishers' proofs)—so dense that they warp the picture plane with an intense optical effect. His first paintings in this vein were produced with the aid of a ruler: in 1991, Ding retained the grid, but began drawing it freehand, while also turning to other materials (charcoal, chalk, watercolor, pencil, and pen) and supports (corrugated card, paper, folding screens, fans, and tartan cloth, in addition to canvas).

6.29

Paul McCarthy,
Carpet N, 2009–11
Carpet, clay, and debris
5.1 × 142.2 × 182.9 cm
(2 × 56 × 72 in.)

6.30

Ding Yi
Appearance of Crosses 2008–17, 2008
Acrylic on tartan, 140 × 200 cm
(55⅛ × 78¾ in.)

6.31

Roman Opałka
OPALKA 1965/1-∞,
DETAIL 5157847–5175777, undated
Acrylic on canvas, 196 × 135 cm
(77³⁄₁₆ × 53⅛ in.)

6.32

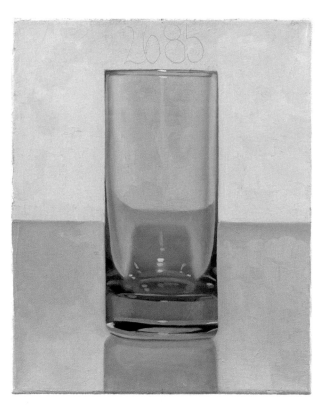

Peter Dreher
Tag um Tag guter Tag (Day by Day
good Day) Nr. 2685 (Night), 2013
Oil on linen, 25.1 × 20 cm (9⅞ × 7⅞ in)

In 1965, the Polish–French painter Roman Opałka (1931–2011) began to paint **6.31**
numbers, starting at one, with the impossible goal of reaching infinity.
As though writing on a sheet of paper, he began in the upper left-hand corner
of a canvas and worked his way in horizontal rows to the lower right. Opałka
referred to each new painting as a detail, standardizing their size to the
dimensions of his studio door and their title to *1965/1–∞*, to indicate an
unending project. Within his prodigious output changes materialized over
time, from white numbers painted on a black background, to a gray
background, to a background progressively lightened with each successive
detail. Opałka soon incorporated a tape recorder into the process, speaking
each number into the microphone as he painted it, and also took passport-
style photographs of himself standing before each completed canvas.

Like Opałka, On Kawara (1933–2014) worked in a serial format, marking
the course of time through the production of paintings: monochromes on
standard-sized horizontal panels with the date on which each was made
written in the language and calendrical norms of the country in which he was
working. If a work was not finished by midnight, it was destroyed. Though
a continuous process for Kawara, viewers see a single day, or the erratic lapses
between them—the conditions of collection and display, as well as of history.
Peter Dreher (b.1932, Mannheim, Germany) is engaged in an ongoing **6.32**
experiment whereby the world comes to be known through painting. In the
early 1970s, Dreher began painting a single empty water glass: the series now
contains over 5,000 individual paintings of the same subject, within the same
surroundings and from the same angle, sometimes during the day and
sometimes at night. A habitual activity yields a serial structure within which
differences—in light or reflection, or the artist's touch—assume subtle if
profound significance in the context of the whole, which he has named *Tag
um Tag guter Tag* (*Day by Day good Day*, or *Every Day is a Good Day*). Presupposing
another day, there is always another surface, another support, onto which
more paint can be applied, and another painting to be made. Though
tomorrow, it will have become a thing of the past.

This book has attempted to present a response, in medias res, to the recursive
and deeply generative contemporaneity of painting, as exemplified by the
artists brought together in this final chapter, and throughout its pages. It has
stood against taxonomy and for looking, reading, and thinking, as well as for
imagining. So, to finally cast my lot: in all its multifaceted and rich variety,
yes, painting now.

Further Reading

Armstrong, Philip, Laura Lisbon, and Stephen Melville, eds, *As Painting: Division and Displacement*, Columbus: Wexner Center for the Arts, 2001.

Badura-Triska, Eva, and Susanne Neuburger, eds, *Bad Painting: Good Art* (Museum of Modern Art, Ludwig Collection, Vienna), Cologne: Dumont, 2008.

Bell, Julian, *What is Painting? Representation and Modern Art*, London and New York: Thames & Hudson, 1999.

Benjamin, Andrew, *Contemporary Painting*, New York: St. Martin's Press, 1992.

Bois, Yve-Alain, *Painting as Model*, Cambridge, MA: MIT Press, 1990.

Bois, Yve-Alain, et al, *Endgame: Reference and Simulation in Recent Painting and Sculpture*, Boston: ICA, 1986.

Bonami, Francesco, *Infinite Painting: Contemporary Painting and Global Realism*, Udine: Adienda Speciale Villa Manin Passariano, 2006.

Buchloh, Benjamin H.D., "Allegorical Procedures: Appropriation and Montage in Contemporary Art," *Artforum* 21: 1 (September 1982): 43–56.

Bürgi, Bernhard, *Painting On the Move: Kunstmuseum Basel*, Basel: Schwabe, 2002.

Crimp, Douglas, "The End of Painting," *October* 16 (Spring 1981): 69–76.

Curiger, Bice, ed., *Birth of the Cool: American Painting from Georgia O Keeffe to Christopher Wool*, Deichterhallen Hamburg, Ostfildern: Cantz, 1997.

Darling, Michael, ed., *Painting in Tongues*, Los Angeles: Museum of Contemporary Art, 2006.

de Duve, Thierry, *Clement Greenberg Between the Lines: Including a Debate with Clement Greenberg*, Chicago: University of Chicago Press, 2010.

Dumbadze, Alexander, and Suzanne Hudson, eds, *Contemporary Art: 1989 to the Present*, Wiley Blackwell, 2013.

Eberling, Knut, *Painting Pictures: Painting and Media in the Digital Age*, Wolfsburg [Germany]: Kunstmuseum Wolfsburg, 2003.

Eklund, Douglas, *The Pictures Generation, 1974-1984*, New York: Metropolitan Museum of Art, New York / New Haven: Yale University Press, 2009.

Elkins, James, *What Painting Is*, New York: Routledge, 1999.

Essl, Karlheinz, *Made in Leipzig: Pictures from a City*, Vienna: Sammlung Essl, 2006.

Evans, David, ed., *Appropriation*, London: Whitechapel, 2009.

Fibicher, Bernhard, and Suman Gopinath, eds, *Horn Please: Narratives In Contemporary Indian Art*, Ostfildern, Germany: Hatje Cantz, 2007.

Fogle, Douglas, ed., *Painting At the Edge of the World*, Minneapolis: Walker Art Center, 2001.

Folie, Cher Peintre, Lieber Maler, Dear Painter, Pompidou, 2002

Foster, Hal, "Signs Taken for Wonders," *Art in America* 74:6 (June 1986): 80–91, 139.

Fricek, Anita, "Contemporary Painting as Institutional Critique" in Stephen Zepke and Simon O'Sullivan, eds, *Deleuze and Contemporary Art*, Edinburgh: Edinburgh University Press, 2010.

Gao, Minglu, *Total Modernity and the Avant-garde in Twentieth-Century Chinese Art*, Cambridge, MA: MIT Press, 2011.

Geers, David, "Neo-Modern," *October* Winter 2012, 9–14.

——"The Gold Standard," *Brooklyn Rail*, May 6, 2014.

Gingeras, Alison M, ed., *Dear Painter, Paint Me…: Painting the Figure Since Late Picabia*, Paris: Centre Pompidou, 2002.

Godfrey, Tony, *The New Image: Painting in the 1980s*, New York: Abbeville Press, 1986.

Gohr, Siegfried, and Jack Cowart, eds, *Expressions: New Art From Germany: Georg Baselitz, Jörg Immendorff, Anselm Kiefer, Markus Lüpertz, A.R. Penck*, Munich: Prestel-Verlag Munich in association with the Saint Louis Art Museum, 1983.

Graw, Isabelle, Daniel Birnbaum, and Nikolaus Hirsch, eds, *Thinking through Painting: Reflexivity and Agency beyond the Canvas*, Sternberg, 2012.

Green, David, and Peter Seddon, eds, *History Painting Reassessed: The Representation of History in Contemporary Art*, Manchester: Manchester University Press, 2000.

Greenberg, Clement, "Modernist Painting [1960]," in *Clement Greenberg: The Collected Essays and Criticism*, Chicago: University of Chicago Press, 1993.

Harris, Jonathan, *Critical Perspectives on Contemporary Painting: Hybridity, Hegemony, Historicism*, Liverpool: Tate Liverpool, 2003.

Hicks, Alistair, *The School of London: The Resurgence of Contemporary Painting*, Oxford: Phaidon, 1989.

Hudson, Suzanne, *Robert Ryman: Used Paint*, MIT Press, 2009.

Huhn, Tom, ed., *Between Picture And Viewer: The Image In Contemporary Painting: An Exhibition* (SVA), New York: Visual Arts Press, Ltd., 2010.

Joachimides, Christos M., Norman Rosenthal, and Nicholas Serota, eds, *A New Spirit In Painting*, London: Royal Academy of Arts, 1981.

Joachimides, Christos M., and Norman Rosenthal, eds, *Zeitgeist: International Art Exhibition*, Berlin 1982, New York: Braziller, 1983.

Joselit, David, *After Art*, New Jersey: Princeton Press, 2012.

—— "Painting Beside Itself," *October* Fall 2009, 125–34.

Kantor, "The Tuymans Effect" *Artforum* Nov 2004

Köb, Edelbert, ed., *Painting: Process and Expansion: From the 1950s to the Present Day*, Cologne: Walther König, 2010.

Krens, Thomas, *Refigured Painting: The German Image, 1960–88*, New York: Guggenheim and Williams College Museum of Art, 1989.

Levén, Ulrika, and Sven-Olov Wallenstein, *Painting: The Extended Field*, Stockholm: Magasin 3 Stockholm Konsthall, 1996.

Lind, Maria, ed., *Whitechapel Documents of Contemporary Art: Abstraction*, MIT Press, 2013.

Lord, Catherine, ed., *CalArts Skeptical Belief(s)*, Newport Beach, CA: Newport Harbor Art Museum, 1988.

McShine, Kynaston, *International Survey of Recent Painting and Sculpture*, New York: Museum of Modern Art, 1984.

Marshall, Richard, *New Image Painting*, New York: Whitney Museum of American Art, 1978.

Moss, Avigail and Kerstin Stakemeier, eds, *Painting: The Implicit Horizon*, Jan van Eyck Academie, 2014.

Moszynska, Anna, *Abstract Art* (World of Art), London: Thames & Hudson, 1990.

Mullins, Charlotte, *Painting People: Figure Painting Today*, London: Thames & Hudson, 2006.

Myers, Terry R., ed., *Painting*, London: Whitechapel Gallery, 2011.

Nesbitt, Judith and Francesco Bonami, *Examining Pictures: Exhibiting Paintings*, London: Whitechapel Art Gallery, 1999.

Nickas, Robert, *Painting Abstraction: New Elements in Abstract Painting*, London: Phaidon, 2009.

Obrist, Hans-Ulrich, *Urgent Painting*, Musée d'Art Moderne de la Ville de Paris, 2002.

Obrist, Hans-Ulrich, Uta Nusser, and Kasper König, eds, *Der Zerbrochene Spiegel: Positionen Zur Malerei* [The Broken Mirror: Positions in Painting], Kunsthalle Wien, 1993.

Paulson, Ronald, *Figure and Abstraction in Contemporary Painting*, New Brunswick: Rutgers University Press, 1990.

Petersen, Anne Ring, et al, eds, *Contemporary Painting in Context*, Copenhagen: University of Copenhagen, 2010.

Robinson, Walter, "Flipping and the Rise of Zombie Formalism," *Artspace*, April 3, 2014.

Rosenberg, Harold, "The American Action Painters," in *The Tradition of the New*, New York: Da Capo Press, 1994.

Rugoff, Ralph, *The Painting of Modern Life: 1960s to Now*, London: Hayward Publishing, 2007.

Saltz, Jerry, "Zombies on the Walls: Why Does So Much New Abstraction Look the Same?" *NY Magazine*, June 16, 2014.

Sambrani, Chaitanya, Kajri Jain, and Ashish Rajadhyaksh, *Edge of Desire: Recent Art in India*, London: Philip Wilson; 2005.

Schwabsky, Barry, *Vitamin P2*, London: Phaidon, 2011.

Searle, Adrian, and Linda Schofield, *Unbound: Possibilities in Painting*, Hayward Gallery, London. South Bank Centre, 1994.

Siegel, Katy, and Dawoud Bey, eds, *High Times, Hard Times: New York Painting, 1967-1975*, New York: Independent Curators International, 2006.

Smith, Karen, *Nine Lives: The Birth of Avant-Garde Art in New China*, New York: Timezone 8, 2008.

Smith, Terry, *What is Contemporary Art*, Chicago: University of Chicago, 2009.

Sussman, Elisabeth, and Caroline Jones, *Remote Viewing: Invented Worlds in Recent Painting and Drawing*, New York: Whitney Museum of American Art, 2005

Tannert, Christoph, and Jens Asthoff, eds, *New German Painting: Remix*, Munich: Prestel, 2006.

Tuchman, Maurice, *The Spiritual in Art: Abstract Painting 1890-1985*, New York: Abbeville Press, 1986.

Tucker, Marcia, *"Bad" Painting*, New York: New Museum of Contemporary Art, 1978.

Tuymans, Luc, and Narcisse Tordoir, *Trouble Spot: Painting*, Antwerp: MUHKA/NICC, 1999.

Vogt, Paul, *Contemporary Painting*, New York: Abrams, 1981. Wallis, Brian, ed., *Art After Modernism: Rethinking Representation*, New York: New Museum of Contemporary Art, 1984.

Wallis, David, *Hybrids: International Contemporary Painting*, London: Tate Liverpool, 2001.

Wei, Lily, *After the Fall: Aspects of Abstract Painting since 1970*, Staten Island: Snug Harbor Cultural Center, 1997.

Weibel, Peter, *Pittura, Immedia: Malerei in den 90er Jahren*, Neue Galerie am Landesmuseum Joanneum Graz, Klagenfurt: Ritter, 1995.

Woodall, Joanna, *Portraiture: Facing the Subject*, Manchester: Manchester University Press, 1997.

Picture Credits

2.7 Courtesy the artist and Petzel, New York.
2.8 Private Collection. Courtesy the artist.
2.9 Courtesy Wallspace Gallery, New York.
2.10 Courtesy the artist and Galerie Max Hetzler, Berlin. Photo def image.
2.11 Courtesy the artist and Petzel, New York.
2.12 Courtesy Galerie Buchholz, Berlin/Cologne.
2.13 Collection Phoenix Art Museum. Courtesy the artist and Metro Pictures, New York.
2.14 Courtesy Gagosian Gallery. Photo Matthias Kolb. © Anselm Reyle.
2.15 Used with permission of MOBA, www.MuseumOfBadArt.org.
2.16 Courtesy New Museum, New York.
2.17 Courtesy the artist and Metro Pictures, New York.
2.18 All rights reserved. Courtesy Mike Kelley Foundation for the Arts. Photo Fredrik Nilsen. © Mike Kelley Foundation for the Arts.
2.19 Courtesy Gladstone Gallery, New York and Brussels. © Carroll Dunham.
2.20 Courtesy the artist and Pilar Corrias, London.
2.21 Private Collection. Courtesy the artist and Rossi & Rossi Ltd, London.
2.22 Courtesy the artist and Rossi & Rossi Ltd, London.
2.23 Private Collection/Christie's Images/The Bridgeman Art Library. Courtesy the artist and Mah Art Gallery, Tehran.
2.24 Courtesy Sikkema Jenkins & Co., New York. © 2001 Shahzia Sikander.
2.25 Collection Dong Phong Gallery, Hanoi.
2.26 Courtesy David Zwirner, New York.
2.27 Courtesy Gagosian Gallery. Photo Robert McKeever. © John Currin.
2.28 Courtesy Mary Boone Gallery, New York. © Will Cotton.
2.29 Chateau de Versailles, Jeff Koons Versailles, October 9, 2008–April 1, 2009. Photo Laurent Lecat. © Jeff Koons.
2.30 Courtesy Sikkema Jenkins & Co., New York. © 2011 Merlin James.
2.31 Courtesy the artist and Gavin Brown's enterprise. Photo Jason Mandella.

3.1 Courtesy the artists.
3.2 Courtesy Koenig & Clinton, New York. Photo Thomas Mueller.
3.3 Courtesy the artist and Paul Kasmin Gallery, New York.
3.4 © Damien Hirst and Science Ltd. All rights reserved, DACS 2015. Photo Prudence Cuming Associates Ltd.
3.5 © 2006 Takashi Murakami/Kaikai Kiki Co., Ltd. All Rights Reserved.
3.6 © 2012 Aya Takano/Kaikai Kiki Co., Ltd. All Rights Reserved. Courtesy Galerie Perrotin, Paris.
3.7 Stephane Cardinale/People Avenue/Corbis.
3.8 Courtesy the artist and Roberts & Tilton, Culver City.
3.9 Courtesy the artist and Hauser & Wirth.
3.10 Bobby Yip/Reuters/Corbis.
3.11, 3.12 Courtesy the artist and Galerie Urs Meile, Beijing-Lucerne.
3.13 Courtesy Lisson Gallery, London.
3.14 Commissioned by the Center for Icelandic Art, Reykjavik. Courtesy the artist, Luhring Augustine, New York and i8 Gallery, Reykjavik. Photo Rafael Pinho.
3.15 Courtesy the artist and Luhring Augustine, New York. Photo Benoit Pailley.
3.16 Courtesy the artist and Greene Naftali, New York. Photo Martha Fleming-Ives.
3.17 Courtesy the artist and Bortolami Gallery, New York.
3.18 Courtesy Seth Price.
3.19 Courtesy the artists and Swiss Institute, New York.
3.20 Courtesy neugerriemschneider, Berlin. Photo David Franck, Stuttgart. © Michel Majerus Estate 2000.
3.21 Installation view at Kukje Gallery, Seoul. Photo Ohyoul Kwon.
3.22 Courtesy the artist and Pedro Cera, Lisbon. Photo Teresa Santos and Pedro Tropa.
3.23 Courtesy Galerie Gebr. Lehmann, Dresden and White Cube, London. Photo Werner Lieberknecht.
3.24 Courtesy the artist.
3.25 Courtesy the artist and Petzel, New York.
3.26 Courtesy Miguel Abreu Gallery, New York. Photo Jeffrey Sturges.
3.27 Courtesy the artist.
3.28 Courtesy the artist.
3.29 © David Hockney.

4.1 Courtesy Zeno X Gallery, Antwerp.
4.2 Private Collection, USA. Courtesy Galerie EIGEN+ART Leipzig/Berlin, David Zwirner, New York/London. Photo Uwe Walter, Berlin. © Neo Rauch courtesy Galerie EIGEN+ART Leipzig/Berlin/DACS, 2015.
4.3 Courtesy ZieherSmith, New York.
4.4 Courtesy Pace Gallery. Photo Kerry Ryan McFate. © Tim Eitel courtesy Galerie EIGEN+ART Leipzig/Berlin and Pace Wildenstein/DACS, 2015.
4.5 Courtesy the artist and GRIMM Gallery, Amsterdam. © Mathias Weischer courtesy Galerie EIGEN+ART Leipzig/Berlin/DACS, 2015.
4.6 Courtesy the artist and Pace Gallery, Beijing.
4.7 Courtesy Yue Minjun Studio.
4.8 Courtesy Klein Sun Gallery, New York. © Fang Lijun.
4.9 Courtesy Mary Boone Gallery, New York. © Liu Xiaodong.
4.10 Courtesy Sikkema Jenkins & Co., New York. © 2007 Kara Walker.
4.11 Courtesy the artist and Schwartz Family Collection. © The artist.
4.12 Courtesy the artist.
4.13 Courtesy CAAC – The Pigozzi Collection, Geneva. © Chéri Samba.
4.14 Courtesy the artist and Goodman Gallery, Cape Town/Johannesburg.
4.15 Courtesy the artist and Thavibu Gallery, Bangkok.
4.16 Private Collection. Courtesy Aeroplastics Contemporary, Brussels, Upstream Gallery, Amsterdam, Galerie Bernard Ceysson, Paris.
4.17 Private Collection, Beijing. Courtesy Pablo Alonso and Schwarz Contemporary, Berlin.
4.18 Courtesy the artist.
4.19 Courtesy Ana Cristea Gallery, New York and Pizzuti Collection, Columbus.
4.20 Courtesy David Nolan Gallery, New York.
4.21 Courtesy the artist and Deák Erika Gallery, Budapest.
4.22 Courtesy the artist and Petzel, New York.
4.23 Courtesy Miguel Abreu Gallery, New York and Karma International, Zürich.
4.24 Courtesy Mary Boone Gallery, New York. © Tomoo Gokita.
4.25 Courtesy Ruiz-Healy Art, San Antonio.
4.26 Courtesy Susanne Vielmetter Los Angeles Projects. Photo Robert Wedemeyer.

4.27 Courtesy the artist and Blum & Poe, Los Angeles.
4.28 Courtesy Gavin Brown's enterprise. © Elizabeth Peyton.
4.29 Courtesy Pace Gallery, New York. Photo Kerry Ryan McFate. © Chuck Close.
4.30 Courtesy Rokeby, London. © Gideon Rubin.
4.31 Courtesy the artist and Marianne Boesky Gallery, New York.
4.32 Courtesy the artist, Victoria Miro, London and Cheim & Read, New York. Photo Stephen White. © Chantal Joffe.
4.33 Courtesy the artist, LOYAL, Stockholm and CANADA, New York.
4.34 Courtesy the artist.
4.35 Courtesy Gagosian Gallery. Photo Robert McKeever. © Richard Phillips.
4.36 Courtesy Cheim & Read, New York.
4.37 Courtesy White Cube, London. Photo Todd-White Art Photography.
4.38 Courtesy the artist and Hauser & Wirth. Photo Barbora Gerny.
4.39 Courtesy Mickalene Thomas, Lehmann Maupin, New York, Susanne Vielmetter Los Angeles Projects and Artists Rights Society (ARS), New York.
4.40 Courtesy Galerie Jocelyn Wolff, Paris. Photo François Doury.
4.41 Courtesy the artist and Greene Naftali, New York. Photo Jason Mandella.
4.42 Courtesy the artist, Bob van Orsouw, Zurich, and Marianne Boesky Gallery, New York.

5.1 Courtesy Carl Freedman Gallery, London. Photo Pieter Huybrechts.
5.2 Installation *Forever Young*, 2008. Courtesy the artist and Anne+ Art Projects, Paris. Photo Remy Lidereau.
5.3 Courtesy Pace Gallery, New York. Photo Bill Jacobson. © 2015 Robert Ryman/DACS, London.
5.4 Courtesy the artist.
5.5 Courtesy the artist and Jack Shainman Gallery, New York.
5.6 Courtesy White Cube, London. Photo Jens Ziehe, Berlin.
5.7 Courtesy the artist and Corvi-Mora, London.
5.8 Courtesy Waddington Custot Galleries, London. Photo Prudence Cuming Associates, London. © Ian Davenport. All Rights Reserved, DACS 2015.
5.9 Collection The Scottish National Gallery of Modern Art, Edinburgh. Courtesy the artist and The Modern Institute/ Toby Webster Ltd, Glasgow.
5.10 Courtesy Lisson Gallery, London. © The artist.
5.11 Courtesy the artist and Tanya Leighton, Berlin.
5.12 Courtesy the artist and The Suzanne Geiss Company, New York.
5.13 Courtesy Brant Foundation and 303 Gallery, New York.
5.14 Photo Art Evans. © Katharina Grosse and VG Bild-Kunst Bonn, 2015.
5.15 Courtesy the artist and Maccarone, New York.
5.16 Courtesy Reena Spaulings Fine Art, New York. Photo John Kelsey.
5.17 Courtesy the artist and Algus Greenspon, New York.
5.18, 5.19 Courtesy Overduin & Co., Los Angeles.
5.20 Courtesy Nick Mauss and 303 Gallery, New York.
5.21 Courtesy Scaramouche, New York and Golden Parachutes, Berlin.
5.22 Courtesy the artist and Balice Hertling, Paris.
5.23 Courtesy White Cube, London. Photo Ben Westoby.
5.24 Courtesy the artist, Hauser & Wirth and 303 Gallery, New York.

5.25 Courtesy the artist, Dispatch and Peter Freeman Inc., New York/Paris.
5.26 Courtesy the artists and Petzel, New York.
5.27 Courtesy the artist.
5.28 Courtesy the artist and Bortolami Gallery, New York.
5.29 Courtesy Mika Tajima. Photo Tom Powell.
5.30 Courtesy the artist and Galerie Catherine Bastide, Brussels.

6.1 Courtesy the artist, Marian Goodman Gallery, New York, Galerie Emmanuel Perrotin, Paris/Hong Kong and Galleria Massimo De Carlo, Milan/London.
6.2 Courtesy the artists. Photo Emily Fahlén.
6.3 Stefan Altenburger Photography, Zurich. © DACS 2015.
6.4 Courtesy Galerie Gisela Capitain, Cologne, and Maureen Paley, London. Photo Lothar Schnepf, Cologne. © The artist.
6.5 Courtesy Miguel Abreu Gallery, New York.
6.6 Courtesy Merlin Carpenter. Photo John Kelsey.
6.7 Courtesy Campoli Presti, London/Paris.
6.8 Courtesy the artist and Greene Naftali, New York. Photo Luca Campigotto.
6.9 Courtesy CANADA, New York and Herald St, London.
6.10 Courtesy the artist and team (gallery, inc.), New York.
6.11 Courtesy Peres Projects, Berlin.
6.12 Courtesy White Cube, London. Photo Stephen White.
6.13 Bettina and Donald L. Bryant, Jr Collection. Courtesy the artist and Sperone Westwater, New York. Photo Tom Powel Imaging. © Guillermo Kuitca.
6.14 Courtesy the artist and Churner and Churner, New York. Photo Jean Vong.
6.15 Courtesy the artist and Frith Street Gallery, London.
6.16 Courtesy Galerie Buchholz, Berlin/Cologne. Photo Lothar Schnepf.
6.17 Courtesy the artist. Photo Carl Henrik Tillberg.
6.18 Courtesy the artist and Thomas Duncan Gallery, Los Angeles.
6.19 Courtesy 303 Gallery, New York. Photo John Berens.
6.20 Courtesy the artist and Simone Subal Gallery, New York.
6.21 Courtesy Paula Cooper Gallery, New York. © Tauba Auerbach.
6.22 Courtesy the artist and Petzel, New York.
6.23 Courtesy the artist and 356 S. Mission Road, Los Angeles. Photo Fredrik Nilsen.
6.24 Courtesy David Kordansky Gallery, Los Angeles. Photo Fredrik Nilsen.
6.25 Courtesy Sikkema Jenkins & Co., New York. © 2010 Josephine Halvorson.
6.26 Courtesy Ratio 3, San Francisco.
6.27 Courtesy Overduin & Co., Los Angeles.
6.28 Private Collection. Courtesy the artist and Kate Werble Gallery, New York. Photo Elisabeth Bernstein.
6.29 Private Collection. Courtesy the artist and Hauser & Wirth. Photo Fredrik Nilsen.
6.30 Courtesy the artist and ShanghART, Shanghai.
6.31 Private Collection. André Morin/Banque d'Images de l'ADAGP. © ADAGP, Paris and DACS, London 2015.
6.32 Courtesy the artist and Koenig & Clinton, New York. © 2015 Peter Dreher/Artists Rights Society (ARS), New York and Jeffrey Sturges, Koenig & Clinton, New York.

Acknowledgments

I wish to thank my commissioning editor, Jacky Klein, for her steadfast support of this project, and Celia White for her astute guidance. Davina Thackara improved every page through her deft editorial insight, and the manuscript would be absent of illustrations were it not for Jo Walton. My sincere gratitude extends to Ginny Liggitt, Sarah Newitt, and Jenny Wilson—and everyone else at Thames & Hudson who has helped to produce this volume with such expertise and tact.

The book owes much to my students and colleagues at The Center for Curatorial Studies at Bard College (CCS Bard), the University of Illinois, and the University of Southern California. I wish to laud in particular Margaret Ewing and Jenny Jaskey, both of whom helped with research at key stages. Recognition also goes to Anne Byrd, Emily Liebert, and Jenni Sorkin, and especially Agnes Berecz and Julia Robinson. Closer to home, this book very literally would not have been possible without Ivania Vilchez.

Painting Now is dedicated to my family. My son came into the world in the midst of its achievement and my daughter has been my companion throughout. They show me how transient is the titular now, and encourage me to realize meaning within it.

Index